Popular Theatre in Political Culture

Britain and Canada in focus

Tim Prentki and
Jan Selman

intellect™
Bristol, UK
Portland, OR, USA

First Published in Hardback in 2000 in Great Britain by
Intellect Books, PO Box 862, Bristol BS99 1DE, UK

First Published in USA in 2000 by
Intellect Books, ISBS, 5804 N.E. Hassalo St, Portland, Oregon 97213-3644, USA

Consulting Editor: Masoud Yazdani
Production Editor: Robin Beecroft
Cover Illustration Julie Payne
Copy Editor: Julie Strudwick

A catalogue record for this book is available from the British Library

ISBN 1-84150-015-1

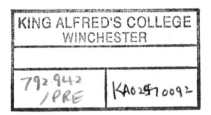
Printed and bound in Great Britain by Cromwell Press, Wiltshire

Contents

Preface

My journey into popular theatre has been a search to rediscover a potential for social transformation that has been inherent in the form since the dawn of performance. This search has been goaded by an increasing sense that the formal performance of theatre in purpose-built spaces, viewed by passive audiences and consumed by them as a commodified leisure activity will never engage the art form on the level of social transformation. Had I been deceiving myself about the potential of theatre? Was I caught up in some mythical notion of what theatre had once meant to certain people in certain places? Maybe. Perhaps I still am. Nevertheless I cannot let go of the idea that theatre as the most human of art forms, starting as it does with the body of the actor, offers a space in which life can be tried out, rehearsed, without the damaging consequences that such experiments might have if tried 'for real'. Theatre affords the opportunity to try out the ideal and to explore what might be necessary in order to achieve it in the world of material reality. Often, in trying out an alternative, a process of change, within the constructed rules of the theatrical fiction, the individual or the group finds the strength and confidence subsequently to have a go at change. This connects popular theatre to the essence of all human activity: its susceptibility to change. Those forces dedicated to the maintenance of the *status quo*, and most European and North American theatre of the last five hundred years falls into this category, are lined up against the poor, the dispossessed and the victims of capitalism across the globe. Popular theatre, by contrast, is about ways of employing the force of art in the service of change, about ways of putting the levers of change in the hands of those who would otherwise be its victims. Popular theatre, and theatre for development in particular, has restored my faith in theatre to be a force for social transformation.

– Tim Prentki

I 'found' popular theatre by chance, really. Involvement in this field has challenged me, has moved me politically: it has taught me and demanded that I think more clearly about how people change, about the inequalities in the world and how they are perpetuated, about how societies do and don't change, and why. The 'discovery' of popular theatre has demanded that I look at why I make theatre, how I make it, and with whom. Key moments in that journey:

Standing ovations, offered not because of the beauty of the poetry or the fine artistry of the performances, but because of the direct connection between the content and the audience when a piece is made out of direct research and involvement with the particular audience for whom it is going to be performed. We love hearing and seeing our own stories on stage; our lives are validated when 'people like ourselves' are performed on stage.

Witnessing a moment when the ENTIRE audience knew the performer, a member of their community, and knew the courage it was taking for her to stand before them and perform a story that was no one's and everyone's, to perform a story that was usually

1

silenced, usually hidden, usually ignored, but that was true. That everyone in that moment acknowledged was, though fictional, true.

Working in partnership with women to create the theatrical situation which embodied the immediate dilemma in their lives. Working in partnership with them to play and replay options for action within that stultifying life circumstance. Trying many 'impossible behaviours'. Witnessing many 'failed attempts'. Learning that the attempts *revealed*. That seemingly impossible situation reformed and revisited, revealed and altered.

Experiencing myself and others dare to tell stories usually hidden, dare to face one another, via theatrical expression, via the power, the danger and the safety of theatrical process, about our differences, our unequal opportunities, our unequal privilege. And to stay in the room together, via the theatre image, and tell the truth, listen and hear each other as we hadn't before.

– Jan Selman

As co-authors of this book, we have attempted to combine our understandings of what constitutes popular theatre in the countries where we live, Britain and Canada, with examples of popular theatre practice written by others who are directly involved in it. We asked our contributors to write in their own voices, in the hea(r)t of the creative process. We seek to communicate the variety, richness and excitement of popular theatre in a wide range of contexts. These contributions are inserted into the more measured discourse of the co-authors as unmediated interventions, as rocks breaking the smooth surface of argument. This book settles nothing and proves nothing; instead it offers provocations to practitioners, students and academics.

The book is intended for anyone with an interest in changing the world, in changing their world. Among those will be theatre workers of all kinds, people engaged in community education and development, and academics and students from a wide variety of disciplines such as performing arts, sociology, anthropology, education, environmental sciences, geography, probably all aspects of knowledge that lodge within the humanities and social sciences.

The Lawnmowers
Geraldine Ling

Founded in 1986, they have established a unique reputation for high quality productions which address issues of concern to people with learning disabilities . . . Forming and running the company has been a fundamentally empowering process for the members . . . The Lawnmowers' experience provides a benchmark of empowerment, but the time and commitment such achievements demand should not be underestimated.

<div align="right">

Francois Matarasso:

Use or Ornament? - The Social Impact of Participation in the Arts

</div>

The Lawnmowers are Sharon Harrison, Nick Heron, June Keenleyside, Paul King and Andy Stafford. They are five adults with learning disabilities from Gateshead who create theatre relevant to their lives and the lives of their peers, touring day centres, community centres and theatres. They run workshops and drama clubs and have recently branched out into night-clubs. They are well respected by the Disability Arts Movement within which they firmly place themselves. They have proved themselves many times to be both nationally important and internationally significant.

As a drama/theatre practitioner of more than twenty-five years and worker with Lawnmowers since 1986, there have been many opportunities to witness the power of theatre as a tool for cultural intervention. Research shows us that developing theatre skills leads to increased confidence and greater ease in coping with complex social structures. For people with learning disabilities in a society where their culture is often marginalised, participatory theatre offers a model where space is created for Learning Disabled culture to be honoured, exchanged and developed.

What have been the lasting benefits for Lawnmowers themselves? One of the group passing the driving test; one becoming an independent traveller; one feeling able to speak; two of the group getting telephones with earned money; bank accounts for all; the ability to plan and run drama clubs; organise night-clubs; devise hard hitting, politically relevant plays and participate in debates about community arts and learning disabled people. The chance for them to develop literacy, deal with camping out, cooking, shopping and travelling.

They have, over the years, had a programme made about their work, appeared on several television programmes; two were presenters in a BBC education series for teachers; a programme about the civil rights bill. Wider benefits are the impact they have made on others, regular drama clubs and night-clubs in Gateshead. Sex education given a higher profile with groups they have worked with. Starting a regional practitioners' network. They have used theatre as an effective way of creating a cultural identity. Time will tell how much of a lasting difference they will have made.

The Lawnmowers were asked the following questions:
1) Why do you do this work?
2) Why is your work important?
3) Do you think it makes a difference?

These are the replies:

Paul

Q.1 Well I do the work because it makes me feel important and proud of myself for what I do. Going round and meeting people like other Learning Disabled (LD) groups like Heart 'n' Soul and Lung Ha. I don't think there's enough LD actors going about in the world and there's normally none on the telly. I want to get better as the years go on. If I didn't do this I'd be sitting at home bored stiff. It keeps me occupied.

Q.2 It's important because as a learning disabled group we teach other LD groups to do theatre work so they can carry on where we left off - if they want to. I think they don't get a chance otherwise, especially LD actors. We train on issues like about homes. The recent one has been the *Right Wrong* that people with learning disabilities should have a chance to be in government if they want. We want to give everyone equal opportunities like being on the telly.

Q.3 I've learnt a lot that's made a difference. We haven't just been doing theatre work but work with Dorothy Heathcote. I did an education programme for the BBC. We took shows around to Manchester and other LD groups. We did a joint production with another LD group, *Love, Death and Freedom*. I've learnt new stuff about HIV, what it is, so if I hadn't been in the drama I wouldn't have learnt so much. It makes me feel great what I do.

June

Q.1 It's just to get the message across to people with LD. We are a LD group and we go away places and we work with people with LD as well. I like working with people with learning disabilities.

Q.2 The shows are important. We take them out to different places, different centres so people can sit and enjoy what work we do. It's important that they can get the message that the show we do is for LD groups. I say in the play I would like to see people with LD learn the law more.

Q.3 Yes it's important. People are there if they want any questions from us - like how long we've been acting.

Nick

Q.1 It gets you out of the centre and then it makes you do stuff I hadn't done before. Workshops and exercises. I do it because I haven't anything else to do.

Q.2 We can show people what we can do. It gets us out of the house so they can take example from what we've done and show people what we can do, theatre work, workshops, exercises, games, so other people can join in and get a chance to do other things. It's important to show people abroad what we can do. We did the *Big Sex Show* in Poland and the *Right Wrong* in Canada. It shows other people what we can do and gives us a chance to go places we wouldn't go to.

Q.3 Yes to convince other people that if we can do it they can. The *Right Wrong* shows what people want.

Sharon
Q.1 To get the message out to people with LD. It's important doing workshops and meeting different people, different groups. It shows people with LD that you can do workshops and shows.
Q.2 It's getting people independent. It gets me more independent. I like doing it. I say my lines out to the workshops. I like doing drama games and getting people into groups. I like doing the Forums and we do role work.
Q.3 I think it makes me feel a lot better. I can understand it properly. When we work with groups they come up and they've liked the show and liked working with us. It might start them off acting and doing drama. When we did the *Big Sex Show* people didn't know about safe sex till we did the show. It could change things.

Andy
Q.1 'Cos I enjoy it and there's not many acting groups like the Lawnmowers doing this kind of work. It gets us around the country and abroad and meeting different kinds of people.
Q.2 It's important to let people with learning disabilities know that they have the same rights as anyone else in the whole country, in the whole world in fact. We did the *Right Wrong* 'cos there's five of us. Each of us have a personal thing we want to see happen, what people with LD can do. To get the message across in a humorous way but with a serious message behind. People who haven't got a LD don't think we are interested in Parliament but some of us are. A member of the group listens to the news, anything to do with Parliament or politics, he listens to that. So they can't say people with LD don't want to know. This gives people with LD the power to speak up for what they want in their own life.
Q.3 Yes people with LD should have the same rights in relationships, money, just like everyone else. It makes people with LD think - if they can do this so can I - and people without disabilities - I didn't know people with a LD could work like this - makes them change their ideas.

Canada
An invitation from Mixed Company to attend a Theatre of the Oppressed International Festival - and some financial support from Northern Arts - enabled the Lawnmowers to travel, for the first time, outside Europe. There were many memorable moments: getting Tony Blair, Joan Collins, the judge and the policeman safely on the plane; meeting Mixed Company for the first time; meeting up with Barbara and Geo from C.T.O., Rio; technical rehearsal; seeing Boal; gigantic pizzas; meeting our host families; being awake for twenty-three-and-a-half hours . . . and that was all on day one!

Nick
We got tickets to go to the conference and do our show for a week. I could go back again. The people and the place we were at welcomed us.

Sharon

> I liked staying with that family. We looked round the place and went to the Tower. I was a little nervous at first because of the height but when we got up to the top I looked around at all the country.

Andy'

> We went across to Greenland and saw icebergs in the water. We saw Augusto Boal. We got a standing ovation from the audience and that was just brilliant.

Paul

> Everyone liked our show. Not just the show but the workshops about how we would run the country. Some countries are run different to other countries. I had on my Teddy Boy suit. I met Jim from Canada and I still get in touch.

June

> I liked looking around the school, seeing different people and flying.'

Legislative Theatre and the Right Wrong Workshops

During the year Lawnmowers have been conducting an action survey using theatre as the research tool. The workshops around their show were about 'Who is running the country' and 'How we would run the country'. Nick: 'We are doing workshops about Parliament and how it is run and what happens in Parliament.'

The workshops used a mixture of role - voting for Mr Nice or Mr Nasty - then running Forum Theatre to invite participants to create changes in five key areas. These Forums reflect obstacles faced by learning disabled people and are based on real life stories like the Forum dealing with the media.

Paul

> I ring up the BBC and say: 'Do you do programmes with people with learning disabilities?' 'No, sir. We just deal with the news.' And I say: 'We're not on the news either' and he says: 'phone London'. So I phone London and the receptionist says: 'Sorry, I'm just the receptionist but personally I think there should be more people with learning disabilities on the telly. I'll put you through to the drama section. Hold the line please' . . . Answer phone message: 'Nobody is here to take your call but you can leave a message after the beep' and I slam the phone down.

Sharon

> Then someone steps in and says if they can solve it . . . well steps in and says what they can do.

From these participatory methods the workshop moves on to encourage the participants to set up the kind of government they would like. The workshops conclude with bringing Tony Blair, a cut-out, to listen to what learning disabled people would like our government to change. Many statements have been gathered and a few are included below. Lawnmowers

wish to present all of them to the Labour Party and start a meaningful dialogue which may address these issues:

'More job opportunities for people with learning disabilities' - *David*

'Keep schools and colleges open' - *Nazir*

'Parliament should not put us down. Tony Blair, you're a person who's got a lot to learn about us' - *Carol*

'I was in a sheltered workshop for six months and I did not like it. If you could demolish them . . . it's slave labour and we should not have it' - *Jes*

'To be treated as equal. Not to be pushed around'- *Pat*

'People to be less cruel' - *Claire*

'Records for the disco once a fortnight at the centre' - *John*

'More places at college' - *Paul*

'More cooking at the centre' - *Wayne*

'More shows and games' - *Alan*

'More Counselling for people who needed help' - *Raymond*

'I would like to see more wedding rings' - *John*

1 Defining Popular Theatre

What is it?

Popular theatre is the practice of theatre as an expression of specific communities' stories, issues, knowledge and needs. The term implies certain things about a project's intention, about the process engaged in to create it, ownership, the relationship of the performance to the audience, and about the project's accessibility. The term sometimes, but not necessarily, also implies things about its form, content, and the venue in which it is played. Popular theatre is a *process* of theatre which deeply involves specific communities in identifying issues of concern, analysing current conditions and causes of a situation, identifying points of change, and analysing how change could happen and/or contributing to the actions implied. The theatre is always part of the process of identifying and exploring how a situation or issue might be changed. It is sometimes part of the resulting actions.

Theatre makes concepts concrete and real for people. It involves its audience both intellectually and emotionally, it sensitises audiences to issues, ideas and people portrayed, and it engenders a personal connection with the events and characters watched on stage. Community based theatre goes a step further; when a play is directly relevant to audience members' lives and concerns, a process begins which can lead to deeper understanding and change. Observers recognise the character(s) and their dilemmas and identify with the people portrayed. And because they can watch rather than live the experience, they also objectify the problems, and in so doing begin to be able to think about possible solutions or alternative actions. The combining of empathetic involvement with the opportunity to observe, analyse and form opinions regarding the characters' actions creates a condition where an audience both wants to think and has the opportunity to problem solve in a safe but vital environment. Popular theatre engages in this powerful activity and it goes one step further.

Popular theatre is based on the Brazilian community educator, Paolo Freire's principles of education: it embraces the notions of exchange, participant ownership, reflection and action. 'Popular' refers to the attempt to work with the forms and contents of the specific cultural context in which the process is situated. It is theatre created with, by and for the communities most involved in the issues it seeks to address. When the *process of making the theatre* is given over to community members, communities can come to control the content and the form of this powerful medium. A space is created where groups and individuals can afford to work on dangerous issues. They can use the process to clarify their views, to investigate dilemmas, to analyse their social, political and economic situations, to challenge assumptions, to strategise,

8

to 'rehearse for action', and to share their insights with others within and without their immediate community.

The term 'popular' is problematic, but here is used to imply that this is a people's theatre, a theatre that belongs to the community. A theatre which expresses and grows out of the immediate social context. There is an implication of engagement in the popular culture of the society, a use of forms which are recognisable, attractive and accessible to the community most involved in the issues. Of course this idea has been shown to be highly problematic in numerous ways, however, each label given this form of theatre (theatre for development, community-based theatre, theatre for change, etc.) holds its own set of limitations, and this one continues to be used, particularly in Canada.

When used to describe this work to those unfamiliar with it, it leads to some natural confusions. It is often taken to mean 'popular' as in 'a lot of people attend'. While this may or may not be the case with this community based social and theatrical endeavour, in Canada this idea leads to an assumption that the megamusical is the current 'popular theatre'. However, better described as 'populist', this form contradicts almost every principle of popular theatre: despite its popularity, it is inaccessible to the majority due to prohibitive ticket prices; it is imported culture, created and controlled by interests external to the local community; it is seldom about anything of immediate concern to its audience; it is escapist and entertaining, but of little relevance. The Fringe Theatre movement is also sometimes seen as 'popular'; whereas it is more accessible (prices) and more 'user friendly', with its festive street life and community spirit, it would not be seen as popular theatre in the sense we mean here. While there may indeed be popular theatre projects which hold performances at a Fringe, there would need to be several other elements in place aside from this friendly venue.

In the case of popular theatre, 'popular' implies that the *process of making and showing the theatre piece* is owned and controlled by a specific community, that the issues and stories grow out of the community involved, and that that community is a vital part of a process of identifying, examining and taking action on matters which that community believes need to change. There is also an implication that the communities involved are little heard from in the mainstream media, that they are in some way disenfranchised or powerless. The 'popular' refers to 'of the people', *belonging* to the people.

So, another definition. *Popular theatre is theatre process and performance which is used as part of a process of change.* It sets out to be part of a movement towards greater empowerment on the part of participants. It tries to be part of social and political change as well as individual change. It tries to enable those who are marginalised in some way to examine collectively their issues from their perspective, to analyse causes of these issues, to explore avenues of potential action about the issue in question, and to create an opportunity to take such *action*.

Popular theatre is practised by those who sense there is an urgent need for change in the society and conditions in which many live. It seeks radical change. It questions the social and political structure, and presumes that there is a more egalitarian social makeup possible. It seeks to be part of social movements which pursue justice and

equality. As such, it tends, in Canada and Britain, to pursue change within and for a variety of sectors of society including: immigrant communities, senior citizens, specific neighbourhoods, prisons, women and violence groups, native communities, poverty groups, etc. It is used as a form of resistance, and as a tool for strategising for change.

Where has it come from?

A variety of influences have led to the upsurge of interest in popular and other community-based theatre approaches over the past thirty years.

Theatre artists in Europe and North America with an interest in social justice have observed decreasing attendance in mainstream venues, particularly by the audiences they most hoped to reach.

They have wanted to explore alternative, and more accessible locations and therefore different styles, styles suitable to these varying locations.

Some theatre artists who embrace the German playwright Bertolt Brecht's intentions looked for other ways to reach their intended audiences. Artists and groups such as Armand Gatti in France, Welfare State in England, Bread and Puppet Theatre in the United States and The Mummers in Newfoundland, Canada sought alternative venues, forms and processes of theatre making in order to reach and impact audiences not served by current mainstream theatre of the day.

The increasing dominance of television and film encouraged theatre artists to explore the ways in which live theatre is unique. Part of this exploration led to deep investigation of the communal potential of live theatre, the potential for two-way communication, community building and active participation.

Adult educators and community organisers sought participatory and emancipatory approaches to education and community research.

Meanwhile, theatre was being used increasingly as a social and educative tool in southern countries. In Latin America, Africa, and South and East Asia theatre artists, development workers and adult educators saw theatre as an effective technique to embody and make culturally specific development messages. With the increasing belief in the importance of two-way communication and deep involvement of communities in decisions affecting their own development, theatre practice shifted in some areas to a highly participatory process, with members of communities participating in the making and performing of theatre about their community, its problems and possible solutions. In other areas trained actors continued to perform, but emphasis was placed upon the interactive and participatory nature of the performance.

These sets of ideas found their way to northern countries, were blended with theatre artists' and community educators' agendas, and took root. Some of these 'southern' ideas were (problematically) applied with little or no change to the vastly different circumstances. However practitioners have increasingly adapted and invented to suit northern contexts. Popular theatre workers' application of such work in the 'north' still seeks to embrace these development roots, but also to reform them to suit very different social and cultural conditions.

The South will Rise Again

The different applications of the labels 'popular theatre' and 'theatre for development' are indicative of the attitudes which underlie their usage. 'Popular' or 'community' theatre is variously employed to describe activities in North America and Europe which are conducted outside of the theatrical mainstream and their purpose built spaces. Similar activities occurring in other parts of the world attract the tag 'theatre for development'. The implication is clear: people from these regions need to be developed and are using theatre as a means to assist in this process. People in North America and Europe need to discover what it is that makes them into 'a people' and how the action of 'community' might assist them in their explorations. First World resistance to the term 'theatre for development' echoes the division of the globe into 'developed' and 'underdeveloped' regions, first created by President Harry Truman in his Inaugural Address of January 20th 1949:

> We must embark on a bold new programme for making the benefits of our scientific advances and industrial progress available for the improvement and growth of underdeveloped areas. The old imperialism - exploitation for foreign profit - has no place in our plans. What we envisage is a programme of development based on the concepts of democratic fair dealing (1967).

So the old imperialism gave way to the new: attaching the label 'underdeveloped' to large areas of the world and then proceeding to determine their economic, social and cultural needs according to the decrees of the institutions established by the United States Government to administer those needs; namely the World Bank and the International Monetary Fund. Western governments set up departments of overseas development and non-governmental agencies mushroomed in the new spirit of righting the ancient wrongs of the colonial era, whilst ensuring that the old power relations remained in place through devices such as interest payments on loans and a series of economic policies like the notorious structural adjustment and the cynically named 'free trade'. Having firmly placed these nations in the camp of 'the other', the strategy was to impose development imperatives upon them intended to make them more like 'us'.

In the 1960s development communications generally meant the transmission of messages from the centre to the periphery. This period, referred to in development history as the 'modernisation' phase, was marked by a belief that development was mainly a matter of economics. Where cultural aspects appeared at all, they were in the service of economic goals. Agitprop style sketches might have a role to play in proclaiming the advantages of a certain type of fertiliser or in urging people to trust western forms of medicine. The forms harked back to the European and US movements of the 1920s and 1930s but there was no element of dialogue; merely experts addressing peasants as parents to children. The model, consciously or not, was colonial. Thus theatre contributed to the stream of monological communications from

the centre to the periphery, ignoring or devaluing local knowledge and promoting the knowledge developed in western metropolitan centres without regard for the effects of specific local conditions and cultural contexts.

These contexts have figured a little more prominently in development methodologies of more recent times when the cultural component has been identified as a key factor in effective strategies for community intervention. Just as notions of participation began to figure in the policies of development agencies, the work of Paulo Freire, was gaining recognition in the 'developed' world in the wake of his book *Pedagogy of the Oppressed*. Freire emphasises the importance of dialogue in any transformative educational process, an emphasis which has found frequent echoes in the rhetoric of development, if not always in its practices. This emphasis was given a specifically theatrical application through the theory and practices of Freire's compatriot Augusto Boal as outlined in his book *Theatre of the Oppressed*, the very title of which reveals the major influence of Freire. Boal's work has enabled a direct line to be drawn, linking development education to theatre. Although many people in the First and Third Worlds were already working with the techniques described by Boal under other names, his work, and more especially the fact that he has written about it, has been a substantial factor in the growth of theatre for development as a distinct set of practices at the radical end of the popular theatre continuum.

An obvious advantage of using theatre performances in this kind of development work is that they attract crowds; in the case of rural contexts they frequently attract the entire available community in places where whole villages are in the habit of attending meetings at designated places, such as a prominent shady tree or the space in front of the head-man's hut. For practitioners in these circumstances there are none of the familiar North American and European problems of deciding who constitutes the community and then agonising about how to involve them in a drama process. Here the presence of a community is guaranteed, no matter how difficult issues such as democracy and participation may prove to be in trying to draw in the most marginalised sectors of that community. Although the process of engaging with targeted groups may be more problematic in urban centres, the tendency for life to be lived out on the streets usually means that people are quite at ease in the role of *ad hoc* audiences for street theatre and other open-air manifestations of popular theatre. The very 'backwardness' of many Third World societies means that they have retained the habits of a co-operative public life at a time when the fragmented, privatised west has destroyed the communal basis on which a mass, public event such as a popular theatre performance can thrive. Ironically in 'developed' societies it is now often the case that it is only groups of the socially excluded who can be identified as distinct communities by the labels of otherness that have been attached to them such as 'homeless', 'mentally disabled', 'drug users', 'travellers', etc. Therefore it is frequently these kinds of groups which attract the attention of community drama workers who are at least spared the pain of trying to establish who to include in the project. Theatre is a social process; if there is 'no such thing as society' in Margaret Thatcher's infamous words, perhaps there can be no such thing as theatre. If we are now separate islands of private people making our own individual meanings out of images and statements set before

us, we are fit only to be post-modern fragments, occupying segregated cells in front of television screens that offer myths about virtual communities through the genre of soap opera that we, robbed of other evidence, increasingly mistake for the thing itself. Popular theatre plays a role in resisting this anti-social impulse.

Defining the Territory

The field of popular theatre is growing and changing rapidly; it is relatively young in its current manifestations. Definitions and careful use of terminology can serve to clarify our work, including our intentions, methodology, process, and use of theatrical forms.

There is a need to encourage a clarity of language in this field. While some separations may be seen as merely based in semantics, rather precise delineation among the variously socially interested theatrical activities seems worthwhile. To acknowledge the commonalties, overlaps and grey areas around and between these various kinds of theatre is to clarify intentions and assumptions. While we are rather disinterested in picky divisions and in the exclusivity of some definitions and criticisms, we see it as valuable to discuss further the clarification of our terms.

So in this book we will assume the following definitions. They are not intended as value judgements, so much as an attempt to clarify usage, and the general intentions of each kind of activity.

Throughout, we assume that 'theatre' implies that some level of performance is involved, whereas 'drama' is a process of activities and experiences which focus on the personal and group experience of doing dramatic activity rather than on a culminating performance.

We use the term 'community-based theatre' to refer to the broadest spectrum of theatre which embraces community, education and social concerns and which is located within 'community', be it a community of interest or one of geography.

While 'popular theatre' is part of community-based theatre, the term implies community involvement and ownership of the process and content of the theatre. This criterion is not always met in some related theatrical endeavours. For example, theatre where the content, messages and goals are defined by a health agency comes up beside popular theatre, but is better described as 'social' or 'educational' theatre because of the agenda being set from outside the community.

'Theatre for development' is closely related to popular theatre, however it is perhaps somewhat narrower and more strictly defined as theatre which is used as a tool in processes of community and social development. This use of theatre would tend to show up as part of a specific community development process. Usually the term is used in reference to work in societies that are little, or not at all, industrialised. And usually it is used when referring to direct, primary development. This work is certainly a significant part of the popular theatre sphere as we define it here. Some would see it as the most radical expression of popular theatre, as it is unquestionably grounded in long-term, grass roots development efforts. It is the overt use of theatre processes to achieve non-theatrical ends.

'Social theatre' is more inclusive than most of these terms. It is used to describe a wide variety of theatre and drama that addresses the social or educational concerns of a society. In Canada, it is often seen as a less threatening term than some, as it can include goals which are considered acceptable by a wide base of the population, and indeed by numerous governmental, social and political agencies. Popular theatre would embrace much but not all of the work in this category. For example, when an issue is identified by a social agency and when the content is defined by such an agency, the project, while perhaps being of great social value, would no longer be considered as pure 'popular theatre'. Much of the work in Canada falls into this category.

Ross Kidd, a Canadian adult educator who has used and encouraged the development of popular theatre as a tool for conscientisation throughout the world, described Canadian popular theatre very inclusively. However, he further proposed some very useful categories with which to view and understand the movement: community docu-drama; theatre as a tool for community development; theatre as a tool for raising political awareness; theatre as a means for remedial education; and people's theatre as a tool for conscientisation and community organising (1981). It should be noted that these delineations are based for the most part in a project's *intentions*, whether acknowledged or not, rather than in a project's *theatrical form*. They provide a significant critical tool when considering the nature of this work.

A conversation with two practitioners – Darrel Wildcat and Jane Heather

Jan Selman

> Both of you had and have social commitments, and meanwhile found theatre as a love and a passion and a need in your lives and have been lucky enough to put them together.

Darrel Wildcat

> In a way that's how things started . . . I got excluded eh, from the reserve, and I was growing up just fine in town eh, but around junior high or high school all of a sudden I realized something's happening, I woke up. The more I realized what was happening to me - the more I realized what happened to us as Indian people - the only thing I wanted to do was tell people: what you're saying isn't true, you don't know about this story, you don't know about me . . . 'cause I didn't I didn't know about these stories either . . . and then suddenly I found theatre. And I really think that when those two poles are put together that then it makes sense, eh. Because when I did a lot of theatre at university it was neat and interesting to learn about European styles and stuff like that but that's what it was, eh. And so all of a sudden I realized that these stories are valid too. You can take all these stories and you can tell them in theatre.

What I tell people now is that the theatre is sacred. It's a sacred ground. And the reason I call it sacred ground is you can take something like incest and put it in front of five hundred people, that's how sacred this thing is. Society won't you let you do it anywhere else. Or very few other places.

Jane Heather

This is very interesting because I feel that I have come to a very similar place but from a different route. I think I first did theatre because with theatre I discovered I could do something as a young person. But also recognising that from what I could see around me, those doing theatre, particularly for women, was about display stuff. I couldn't find a place for myself there. I was very engaged in student politics and I was saying this is an art form that needs to be in the hands of all the people, not just this really narrow group. I spent a long time in my life saying there has to be theatre for my dad. Working class guys.

Wildcat

Yeah.

Heather

There has to be stuff that calls to them. And speaks to them. And anyone can do it and let's get in there and make it. And over time, some of that still works for me, but I've come more and more to see it as an activity that you engage in with absolute commitment and seriousness. What I say to students is that if you don't have that you can't come and worship at my temple. You can go to other people, but if you want to come here and do this work with the community you have to be there, absolutely in it. We are in the presence of the goddess. It is hard to talk about . . . But it will change them . . . We are talking about concrete real world issues, injustices, things that theatre has a role to play in - to articulate their stories, their pain, their joy, their struggle, their desire to change, and to do that as a group. All those things . . .

Wildcat

The conflict eh, everything comes from conflict, but I think that part of the challenge is to find what people can agree on. I've been thinking a lot about this word community. Common unity. I've been really thinking hard about those two words. Common. Unity. I've been thinking on the Indian reserve - are they 'community'? And I really wonder. I'm not sure if they are yet. I think they are prefabricated. At the turn of the century a bunch of surveyors came across western Canada and started mapping out these communities and said these people will live over here and these people live over here. So all of a sudden these independent communities were shoved into an area where they lived together but they had no social control, they had no political control, no education, no religious control. And so then you have this power on top, the Indian Agent, who controlled everything. And the more I learn about that, yeah it makes sense where reserves are today. Because what happened was, in these communities no one controlled them except the Indian Agent, and so you don't have anything called legitimate power

15

eh, there's nothing like that on a reserve. And I think of a place like Yugoslavia, as soon as you take the central authority out, no legitimate power, so everybody becomes a warlord, eh. And that's what's happened on reserves now, you pull Indian Affairs out or the Indian Agent, and now nobody recognises anybody's authority. Like even on my reserve last year we had a bunch of people saying the council wasn't the real council and where that comes from is true because the word we use today for Chief in Cree, is 'acting chief' or 'phoney chief', that's the literal translation. So if you were going to refer to that person you would say, 'this is the phoney chief of Hobbema'. And everyone would understand that. And the reason for that is in 1926 they changed the rules from traditional to democratic and nobody wanted to run as a democratic chief, so the Indian Agent picked the person, so in reality yes, you *are* the phoney chief. You are the 'acting' chief.

Selman

As opposed to the traditional hereditary line.

Wildcat

Yes and there you say 'head man' or 'the leader'. So those are the terms. Real different. And that's why I think: if we don't control these aspects of our community and we have a phoney chief, do we have a community? And that's what I wonder. So sometimes I wonder if we are not *developing* a community on our reserves, but we are actually *making* one. You know what I mean? Like I don't know if there is a community there to develop yet.

Selman

And that that's your job if you will.

Wildcat

If you want to put it that way. See again there's that sacredness of the theatre. To legitimise the community. By having everybody speak of something and using that theatre for discussion then, that's your forum, eh. So you could maybe build a legitimate space, I mean I really think that's almost what could happen with the theatre on reserves. The theatre of open space, the theatre of open discussion. Then that's where democracy is, in that openness.

Selman

What would that look like? What would the theatre work look like?

Wildcat

I see it as, just for lack of terms, a series of open discussions. Because there is no public discourse on reserves. All band council meetings are closed to the public. There's no reporters.

Heather

It's very dangerous what you are talking about. To demonstrate a fictional band council meeting. I mean using fictional names for these people that are really the band council.

Wildcat

Yeah.

Heather

It goes back to Boal. It's rehearsal.

Wildcat

Yeah.

Heather

Rehearsal for the revolution.

Wildcat

Yeah.

Heather

I want to see this show, Darrell. I want to see people come in and say 'oh that's so and so - he used to be chief' . . .

Wildcat

It would be wild. 'Cause I kept thinking: social action theatre, popular theatre, and I like *community* theatre the best because I like those two words eh, common unity.

Heather

I think that the theatre in many places actually *creates* community. Not always in earth shattering ways. But the *act* of creating a piece that is based on talking to people or having people in the community performing their own stories or creating scenes about issues that go on in that community, actually does create community. The show that I did with the unions is very interesting for that because there are different groups that tend to be mutually exclusive, there's a lot of mutual ignorance and a bit of suspicion and maybe some hostility between organised labour and arts groups. Not exclusively, but historically it's not two worlds that meet up with one another very much. And through the process of creating the show a sense of community between those groups developed. In that physical space. Common unity. It may not be very long lasting, it may not have a community that goes on and does a whole bunch of stuff, but for a period of time, what happens is people *see* one another. And the act of seeing one another and one another's lives is . . . I don't know how you make anything change until *that* happens.

Wildcat

Yeah.

Heather

In the early days of this work I know that I was pretty romantic about the way that theatre could make social change, could make communities more cohesive, help get people moving towards co-operative action. And it's not like now I don't believe that this could happen, but I see this as a much *looonger* process. *(Much hilarity and agreement)* A six-week project is not going to do it eh? *(More laughter)*

Selman

Let's pick up on a couple of things. One is, does the six-week project have any place in this work? And the other is, given that change of view, what kinds of theatre projects can count?

Wildcat

Yeah because like you I've been changing my mind, telling people six months, at the very least six months. And of course the accountant turns around and says, 'Gee, I don't know . . .'

Heather

You'll have to take it to the economic development guys.

Wildcat

We'll have to talk about it *(laughter)*. I know for a lot of reserves they have a lot of stress and you have to accommodate for that. Like that's real cost. At a workshop on the first day I'll get twenty people and then I'll come back the next week and five people, eh. And then the next I'll come back and four people - so I'm not so linear any more. I say, 'come for a time', then whoever's there we work on something.

Selman

You mean a one off workshop?

Wildcat

We tried to rent this hall for a project for four weekends in a row. Every weekend there was a funeral. So a community of three thousand people and four dead people in one month. And out of those four dead people, two of them are suicides, eh. And out of those suicides one of them was a mother with two children. And that's what I mean, those are real stresses. Those are real things that happen to those people.

'Let's just get these Indians and we're going to tune them up and we're going to fix them.' But then you realise: for me to function in that community I have to respect all those people before they start to respect me, eh? And part of that respect is that if they don't make it that day and somebody's died or their cousin's died or you know the guy was so drunk last night I couldn't sleep, that's real eh. And that's what I mean it's a longer process now. Much longer.

Selman

> In the 1980s, Jane, you worked in an isolated native community over a long period.

Heather

> Wabasca Desmarais, yeah. If we are actually going to make some long-term impact, if we are going to be able to develop leaders in the community and start to penetrate some of the structures of power in this community then that's a ten year process.

Wildcat

> Yeah.

Heather

> The project was clear for the first bit, nice liberal white chick handing over the theatre stuff to the community was fine, but then I got confused - what are we trying to do here? Are we trying to create a theatre company and have a place where people can perform their theatre, or are we trying to create social change? And I got kind of balled up in that.

Wildcat

> Yeah . . .

Selman

> Isn't that the dilemma we hit time after time?

Wildcat/Heather (*simultaneously*)

> Absolutely.

Heather

> I know that I have found myself in the middle of the forest saying 'where the hell am I, what am I doing here?'.

Wildcat

> Yeah.

Heather

> So in some ways, the short six-week project, particularly where you go in and create a show about a specific issue, it's clearer that you are not *trying* to pass on theatre skills, train people to be actors or writers so they can go on to make more theatre.

Wildcat

> Yeah. Some of those projects are good too, eh. I say to the young people who show up, 'What happens after the play you can't control but during the play you can control it.' And because people are so conditioned to sit down and listen at theatre, I tell the young people, 'this is one of the few times that five hundred white people are going to shut up and listen to you. So use it!'

Heather

And in another kind of community, six-week projects might be just fine. I'll go back to this union project, because it is not a community that is in crisis in the same way. And it's not a community of the same kind. Its objective is social justice, that's what it is a community *for*, if you will (although there'll be lots of unionists who say, 'no it isn't, it's getting that 2% wage hike.') But why it's there in the world is to protect people, so it's a very different kind of community. It's the difference between a community that you choose to belong to and one you're born to.

Wildcat

Yeah.

Heather

Some of that community building comes from celebration, a big theatrical event. We shouldn't say that celebration isn't an important part of creating community.

Wildcat

Yeah.

Heather

But when communities are in extreme crisis which so many aboriginal First Nations communities are, then yeah, you are going to be adjusting all the time and sometimes you have to let go of the notion of the culminating event.

Wildcat

Yeah.

Heather

And hope that you can over time be building something else *(nods, silence)*. But the other one, the longer project. It seems to me that we have lots to learn from different parts of the world about that one - where companies are attached to agencies and government organisations. I know that there are problems with that . . . but I wonder if we have other routes . . . If we are an independent theatre company what else can we produce but more theatre companies? Maybe we need to be attached to different community organisations that are about community change. And where do you find those, I mean are they the centres of power, like the band councils or the government agencies or the communist party, or are we looking for something else?

Selman

Some of the organisations I can think of that might be that, as in not the power structure yet there for the long haul, seem to centre around social movements, like the environment movement, feminist movements . . .

Wildcat

But there are other things about theatre too. I look at body a lot. The sexual abuse of people is really high, eh, some people say incidences of up to 75% of all Indian people have been abused . . . For the longest time I never wanted to talk about what happened to me eh, but it happened to me too. And then . . . all that to me is a colonial experience - so theatre becomes a decolonizing experience that brings people back together. Because you can't do theatre unless you use your body. And you can't express from your body unless you know how to do it. I always say that to people on the reserve. Every time you do theatre you are decolonizing people. 'Cause every time you are breaking that separation between body and self, reconnecting it back. And so maybe its naïve, but I think my community is so defined.

There is Ermineskin. And this is where I have to live and this is where I have to work, this is where theatre has to work, it's real clear to me. So if I can get kids to run around and play and talk about their bodies and feel their bodies and touch each other and there's no sex involved, that's all decolonizing these kids. What's happening is they're all connecting back to themselves and if we get a whole bunch of people connecting back to themselves, then to me that's community work. Because what we are doing is: these kids can belong back to their bodies, that's a powerful thing, eh - the body. I guess for me it's not such a question of who do I work with, I just see all these kids, eh - that's all I see.

Heather

You know who you work with.

Wildcat

Exactly! 'Ahhh, they're coming! Thousands of them!' . . . And what are we going give them? And if we give them this wrecked community - when the Indian Agents left and the priests left they were giving them nothing, eh. What I get real scared of too, is what happens when these kids get tired of killing themselves, when they go out and kill all the old white farmers in Wetaskiwin, that's what I mean. I see this work with all these young people. We have to make a community with them, we have to *make* a community, we have to.

It's real simple sometimes. Maybe that's too simple. You have to make community for these people. We gotta.

Issue shows, like shows on suicide, they're still useful, but to me the development now is to have the kids play the games and to become physical beings. That is real development for me now. Because if they can become . . . because what kind of community can you have if you have these people that aren't attached to their bodies and their minds, eh? See that's what I mean, for me it's the *real beginnings* of making a community.

Heather

Because you are who you are, it is very clear where you need to work. For white folk like me, it's a different set of circumstances because the most immediate thing, I mean the thing that is most urgent in terms of community change in Canada right now is probably

aboriginal. I suspect that if I had to make a hierarchical tree, I guess it would depend on the day, but it would be in the top two. And frankly, I can't work there any more. I mean it's even a little dodgy about whether we ever could. But at some point nobody was doing it, so us white folks, a bunch of us, kinda charged in and did a bunch of popular theatre work. But now there's a lot. So I can't work there anymore and that's a good thing. I shouldn't have to work there. And our government shouldn't have to. It's not my world, it's not my community - hire me some time man, I'll come and teach a workshop, but I'm not going to come and initiate a project . . . So then we spent some time saying: where do we place ourselves, as white folk? Well my answer right now is with unions. Working with unions on labour arts projects is one way that I can pull those two worlds together. Talking to union members about May Day celebrations, opening opportunities for them to work with big puppets for marches and banners, that kind of thing. And going to those meetings - they are so excited about how through their union they could be engaged in art that *they* create - from *their* life circumstance . . .

Selman
> We need to keep doing this.

Heather
> Talking about what we do.

Wildcat
> Yeah.

Ways of Looking at Popular Theatre

At its most basic, community based theatre work and perhaps all theatre work, if we are to claim that theatre is about engagement with an audience, needs to be looked at in terms of: its *intentions*; the *context* within which the work is being pursued; the *process* that is undertaken; *the relationship of the creators* to the material and to the community which is most involved; the *form*(s) used; and the nature of the *audience*. It is the blend of these elements, and their integration with effective educational and development organisation, which adds up to a popular theatre project's level of success.

Further, or more to the point, it is the blend of these elements that adds up to a meaningful view of a project. They should be highly interdependent. In project planning, if one element changes, so should the next and the next. It is important to set up useful critical criteria with which to consider this work; it is important to have a way to 'unpack' the work, and to describe what worked and what didn't, what was and wasn't achieved, and ultimately, why that is so. While some of the standards which are applied to evaluation of serious mainstream theatre events may well be useful, there are other agendas, other intentions, and therefore there must be other considerations when creating, planning and evaluating popular theatre. The full

picture cannot be seen without recognising all of these elements: intention, context, creators' relationship to the community, process and product, the theatrical form and the nature and relationship of the audience to the work. Once examined in full, these elements and definitions might indeed lead to a new kind of 'standard' and indeed to a useful way to evaluate popular theatre work critically. However, at this stage we will look at these elements in terms of a set of choices.

Risking friendship in a play about landmines
Julie Salverson[1]

Recently I was invited to see a short play presented by a community college. Student actors and their director had drawn on stories from Bosnian children to create a twenty-minute performance about land mines. The piece opened with the actors lying on the floor doing breathing exercises and inviting the audience to call out thoughts evoked by the idea of land mines. Phrases such as 'incomprehensible', 'stop it', and 'dead, dead' were grimly and vigorously taken up by groups of young performers and turned into tableaux of disaster, which segued into first person narratives declaring stories of loss and dismemberment tempered with heroics. My disenchantment with this play is not at the expense of the student actors, who no doubt approached the project with sensitivity and the preliminary skills their level of training would allow. What disturbed me was a sense that the students were not present in the performance, were not seeing themselves in the picture; and, consequently, that we as audience members were not asked to implicate ourselves. Audience and actors together were looking 'out' at some eroticized 'other'. Even more discomforting than the voyeurism I felt a participant in, was the almost erotic quality of the manner in which the actors portrayed pain. There was pleasure in it. Perhaps this is not as surprising as it might seem. Depths of feeling participated in without cost provide such pleasure. Several audience members expressed being extremely moved by the whole thing. But what, I wondered, was our obligation as witnesses to this story, to this unacknowledged pleasure? Yes the audience was moved, but by and towards what?

The problem of how to tell the story of land mines in the theatre is not an abstract one for me. In the spring of 1997 I received a telephone call from the Canadian Red Cross. Would I be willing, someone asked, to write a play about young people and land mines? This play would be presented at an international conference in Ottawa in December . . . but more significantly, would be made available to schools and youth groups across Canada and beyond to be performed as part of a land mines awareness campaign. The man on the end of the phone wanted to know what I thought. The man on the end of the phone thought he was calling a playwright. He didn't know how much I work with communities creating theatre that performs testimony and risky stories. He didn't know I am trying to think about ethics and what it means to witness such stories, asking questions about voyeurism and the danger of presenting survivors of violence in the role of 'victim'. Fairly quickly I said three things. I would not want to present stories that said 'feel sorry for those children over there and give money'. I would not write a play where youth in Moose Jaw, Saskatchewan

pretended to be youth in Bosnia or Cambodia. And, finally, I thought it was an ambitious and challenging project and I was probably the person to write it.

Months later I found myself living and breathing land mines and the extensive problems of the task I was immersed in. The challenge for co-writer Patti Fraser and myself was to create a script performable by non-professional actors that encountered difficult knowledge through an empathy not based on pity or a simplistic standing in for another. What follows are a series of notes from two stages of the project. During the first stage, a workshop was carried out in a class of pre-service teachers at the University of British Columbia. A group of almost forty teachers spent three weeks (together with myself as instructor and Patti) exploring what land mines meant to them and creating theatrical material for a short presentation. After this Patti and I went away and wrote the script for the play *Boom*. During the second stage, the play was rehearsed with a cast of thirteen high school students from a small town three hours east of Toronto. The rehearsal period also involved Toni Wilson (the drama teacher from the school who directed the play), professional designer Ruth Howard and Aleksandar Lukac, a Toronto-based director from Sarajevo who acted as consultant on the project.

1. The Workshop

Teacher

What would you do if I told you something you don't want to hear?

Clown #1

Is this about what happened in the newspaper yesterday?

Clown #2

Which things? The horrible made up ones, or the horrible ones that are true?

Clown#1

I guess that depends what happens after you hear a bad story. I mean, do you have to feel BAD about it?

Clown Queen

Oh, you'll feel bad when you hear this!

The facts and figures about land mines, the cost to human life and the life of farmland, villages, communities, all of this is staggering. The student teachers began the workshop (held within a course in drama across the curriculum) by reading, watching and listening to accounts of the devastation caused by mines in many countries. On the first day I asked them to make sculpted body tableaux of their responses to entering this project. What did they feel and think knowing they would be immersed in land mines for three weeks? The images from the first day included: dread, horror, pushing away, pushing towards and isolated figures switching channels on television sets. One image that stood out for all of us was of a figure being photographed while surrounded by onlookers. People in the group thought this might be a child land mine victim being shot by journalists; 'pin-up victim' of the

month. The onlookers could be family, the soldiers who planted the mines, together with the governments, armaments dealers and international agencies posing in different roles behind the scenes. The visual of this child in the eye of the camera became our key image for the creation of the play, and formed for us the overriding question: how could we know the story of land mines when we learn it through the mass media? More importantly: in what ways could we know this child?

In an article about teaching risky stories, Roger and Wendy Simon ask what it means to listen to accounts of cruelty. What is it to not only hear, but actually understand things which disturb our sense of who we are and perhaps dangerously underpin how we create meaning in our lives and communities? Children hearing such stories will ask, 'Is this really true?', 'Why did it happen?', 'Could it happen to me?' Listening is a very social event, and how we listen changes depending upon who we are with and what the context and expectations are. When and how is it 'OK' for adults to ask 'could this happen to me?' It became evident in the class that some questions were easily asked, while others were met with anything from group confusion to outright disapproval. For example, a speaker from the Red Cross spoke categorically about the need to ban land mines. One student asked, 'but why are they in the ground?' The other classmates kept cutting him off, saying, 'obviously to terrorise', 'obviously to win the war', but these answers did not satisfy, and still the student asked the question. This young teacher is trying to find his way into the head of a soldier or guerrilla fighter who makes, buys or sets a mine. He is trying to understand a world where land mines makes sense. Perhaps the other students have difficulty admitting that such a world exists. Or perhaps they know too well, and have their own conscious or less conscious reasons for refusing such a question. Finally the visitor answered. He said, 'I know why they are there . . . but I don't know WHY they are there'.

Ana

> You want to know about my country, read about it. You've got a million t.v. channels, do you watch them?

Roger

> But that's just TV. You know about it, you were there.

What is going on when we ask questions about testimony that try to make sense of what's been said in the context of our own lives? Are such questions a way of empathising with a hurt person, or a way to appropriate someone else's story to my own concerns? Is it all right to question the story, and if so on what terms? If I wonder about the facts (e.g. how many land mines really went off, who is responsible for them?), can I also question the emotional terms of the story (e.g. why is this boy so cheerful when he speaks about losing his leg? Why isn't he sad? Why do I expect him to be sad? Why do I expect him to show his sadness to me?) Which emotional stances, which values, which facts will allow him to speak on prime time television? What are we all looking for, we in the class, in the west, or at home in our living rooms?

Patti and I have been colleagues for a number of years, and much of our work involves using theatre exercises to encourage people who have experienced marginalisation to tell

their stories. This time we were using the same techniques to ask people to speak from positions of relative safety and comfort about what they are learning about land mines and what it is to be a witness to this destruction. Both Patti and I, and the teachers, had to find a way to listen to the testimony of land mine survivors, and their accounts of fields where they could no longer gather water or pick their crops, in ways that made the speakers of that testimony real to us. But 'real' in what way? I said at the outset that I didn't want the play to be about 'victim stories'. In many institutions within western culture - medicine, law, the Christian Church, for example - there is a built-in relationship between the person who tells a story of difficulty and the person who listens. This relationship is related to that of confessor and priest in the Church, and implies several things about the listener: a person 1) has knowledge or expertise that the storyteller does not, 2) has a kind of immunity from, or impartiality towards, the story, and 3) passes judgement of some kind over the speaker. It is easy for a theatre which testifies to stories of violence to get caught in this kind of dynamic. Anita, one of the teachers in the course, was visibly upset by what she was learning, and took home a book about Bosnia to read. She came back into class with a monologue she had prepared about a woman who had lost several members of her family. When Anita performed this monologue to the class, she spoke in a low hushed voice filled with sadness. The performance had an air of falseness. Anita, with the best of intentions, could imagine nothing of the Bosnian woman's strength, her possible humour, even her courage, caught as Anita was in her almost romantic identification with what the woman had lost. Anita's performance was, in a sense, confessing to the other teachers and to the audience. Waiting to be confirmed as wearing the nobility of the victim.

There are several problems with this type of performance. One is the matter of how an audience will identify with this character. The student teachers I work with relate almost immediately to the issue of land mines on a feeling level, that is in fact what has them paying attention to it for the first time. One student said to me 'I never noticed enough to feel anything before. Maybe it's time to notice more.' I agree with Joan Holden of the San Francisco Mime Troupe when she writes that we need to analyse the importance of both emotional and intellectual appeal in theatre work: 'The purpose of political theatre is not only to make people think but to make them act. For most people this requires emotional engagement' (282). If we write a play that presents an uncomplicated portrayal of victims, villains and heroes, what choices do we give an audience as to how to relate? What are the connections between each individual audience member's relationship to land mines (as Canadians, as war veterans, or perhaps as immigrants or refugees?) and questions of identification and even victimisation? If empathising with characters in the play slips too easily into substituting myself for them - putting myself in their shoes - will I want to empathise with a victim? I believe this to be a serious question for a theatre which desires to have an educational component. If understanding what it means for land mines to exist means I must substitute myself for either the victim or the soldier who put them in the ground, is it any wonder I will resist this knowledge. Oversimplifying how characters are presented offers the listener few choices for response: guilt yes, pity yes, but probably not some feeling of equality or connection.

Ana:

> You see this experiment I am designing? I have to learn what these instruments do, put my hands on the cold metal, feel the tension in my body waiting to balance the magnetic force. Carefully, so carefully. A wrong move and it dissipates or explodes. My breath learns to move with the water sliding down the tube. I shut out the other noises in the room. I listen to the crystals, the tiny particles moving. But first . . . before I can try the experiment, I have to read. Everything, all the scientists. I learn how much the container can hold, I respect the instruments, the delicate balance I must achieve. The molecules are alive, they breathe. I know this before I use them in my experiment. It's my life you're asking about, Roger. Go find something out. Anything.

Both Patti and I agreed that the play must focus not on the land mine survivors, but on what it is for Canadian youth to encounter land mines. Somehow we wanted to respect the separateness and dignity of survivors, relegating them a distinctness within the play and the creation process that did not put them in that 'spotlight' we had identified in the class image. And yet that reluctance posed problems. In our concern over being voyeurs or positioning survivors in the role of victims, we can cringe when the teachers ask if they might search for someone who has been really hurt by land mines, a 'real person'. Perhaps we are protecting the privacy of people in Canada desiring to not be continually called to perform as victims. Or perhaps we patronise survivors and don't respect their right to say yes or no, their desire to speak to Canadians about what they have known and seen, to pass on their story. Patronise also the teachers, assuming they will make an approach clumsily or unfairly. Even the framing of this problem re-constitutes the survivor as victim, this time (as absurd as this begins to look) victim of either Patti and me, or the students.

Is our desire to respect the integrity of survivors who we cannot fully represent – and our wish instead to focus on the response of Canadian-born youth – perhaps a slippery new way to make the conversation about us? In my concern that showing 'just the facts' too easily reduces lives into terms of true and false, victim and villain, I may miss the opportunity to tell people that thousands of mines, so tiny they would fit into your child's hand, fall from helicopters in the shape of butterflies. Butterflies that float silently to earth, settle onto a field, a grove of trees, a village square. A sea of brilliant colours attracting curiosity, tiny mines who are not in a hurry, who do not know the war is over.

Clowns:

> This is a play from beginning to end
> So don't take things too seriously

2. The Rehearsals

During the writing of the play a character appeared who would not go away. Her name was Ana, and she was a Croatian girl from Bosnia who had moved to Canada one year before the play takes place. Writing is a strange and unruly process. The character I refused to write moved in and took centre stage in the script. Consequently, this forced the problem of how to portray Ana to also take centre stage. But perhaps this shouldn't have been surprising at all, considering our overriding question in the workshop: could we know the

child in our classes image, the young land mine survivor? This became our play, the story of that question, played out in a difficult friendship between two young people. The first is Roger, a Canadian grade twelve student who doesn't really want to know. Why should he care about land mines? Chances are he'll never see one. He didn't put them there, he's only in grade twelve. The second is Ana, a Croatian girl who wants to be Canadian, to be a scientist, who doesn't want to talk about her homeland and tries to control her trauma by designing a land clearance device that will rid the earth of land mines. The story of these two kids' attempt at friendship is punctuated by a clown chorus, which continually pulls the story out of its narrative, defies it, names the illusion of identification and constantly reminds us: this is a play from beginning to end, don't take things too seriously!

On the first day of rehearsals in the small high school drama room fifteen miles north of the city of London, Ontario, a presentation by the Red Cross was followed by a first reading of the script. Alan, a farm boy who had never done any drama or theatre before, was to play the teacher. He asked a question which echoed throughout the rehearsal period: 'Why are there clowns? Isn't the play just supposed to tell people how terrible everything is?'

The function of the clowns in *BOOM* is to name the limit, the limit of identification, the trick 'mirror of representation' (Diamond). Roger must reach Ana through the clowns, they tease him, confront him, but they also listen and encourage him to keep going.

Play the game of contact, of relationship, say the clowns, but understand that it is a deadly serious game with no guarantees. Enter, engage, risk, but know the story can be pulled from under you at any point. Disrupted by any number of things. The structures of trauma and the roles and hiding places where in our vulnerability we seek safety. The shock of hard facts that disrupt our understanding of who we are in the world. The story is broken, and what will you do? Will you still risk contact? Will you risk friendship?

BOOM follows Roger's journey of coming to know Ana beyond his assumptions about what being a victim of land mines has made of her. He presses her to talk. She keeps trying to speak through her experiment - that is her way of telling, but he, expecting another language, hears little. This is a play about difficult friendship. Across different losses. Across land mines. Our question as students, as artists, was 'how do we approach?' What do we say, create, pass on? This is also Roger's question. If I am not there to 'help' Ana, what am I? What does it mean to be a witness?

Roger: *(sung)*

 I know I'm no one special, but maybe I could listen
 Maybe you could trust me, maybe I could know you
 I wish I could be bending to pick for you a flower
 Cause everybody has to leave the darkness sometime

The students working out how to perform this play were faced with questions about their own role in the story of land mines. What did it mean for them to perform this play? What further might they do, could they do, would they do? How did their thoughts and feelings evolve during the making of this play? Although it is helpful to distinguish between blame and responsibility when thinking about what it means to witness, it is also possible to accept feelings of guilt without being shut down or crippled by them. Feelings of connection come in

all forms. Unni Wikan is an anthropologist who tried to write about the people of Bali. In her rigorous efforts not to exotify them, she lost track of what a Balinese poet and professor told her was the most important thing - to create resonance (*ngelah keneh*) between herself and her readers. But first, they said, she must create resonance in herself with the people and the problems she sought to understand. Westerners, this man told her, have no idea of resonance because they use their thoughts only, and so ideas and understandings do not spring alive. Resonance, he said, 'requires you to apply feeling as well as thought. Indeed, feeling is the more essential, for without feeling we'll remain entangled in illusion' (463). The Balinese say that thinking without feeling is like 'reaching for the sky with a short string' (above).

I would like to propose the concept of resonance as a space within which I as playwright/teacher and the students involved in the play might meet the reality of land mines and stay in contact. Resonance does not answer questions, it holds them open, and holds all participants within the structure of the question, the structure of the engagement, the structure of the class. If characters in a play are not entered as a strict form of realism, the truth of representation, can they be entered instead in a way that brings the student actor into the picture? The danger, of course, is that emotion becomes an eroticized narcissism. This was what I felt was happening in the college production I mentioned at the beginning of this essay. It is what happened perhaps to the student teacher Anita, and to the high school student portraying Ana. The concept of resonance, however, offers connection and detachment, a way to hold feeling and thought together. It is the generosity of approach that does not recycle in melancholic repetition, does not ask for returns.

But what is the point of friendship if there is no assurance? What is the point of a play about land mines if there is no guarantee it will teach me something, change the students' behaviour in the world or give them enough information? But perhaps friendship, and popular theatre, are not about outcomes. What if the passing on of stories, the translation process itself, is not to produce meaning or truth but simply, but not at all easily, to attend. To engage in a relationship of attention.

The students in the process of doing this play talked about a feeling of being off balance, of not quite getting the whole picture. Just when they thought they did, it shifted, like a trick mirror. And yet the group, as a whole, committed amazing amounts of time to the project, worked on their own during the teacher's strike, cancelled family trips to come to Toronto, became hugely committed to the project. And, in a way, became friends with the story of land mines. By which I mean they entered an engaged, invested relationship with it. All the play can do, I suspect, is raise this question. How can Roger and Ana meet? What are the possibilities for the nature of this meeting? What might a relationship with testimony look like where loss is held irreparable yet contact is maintained? Where there is a risk, a stake, and where attention is paid.

2 Intentions

Popular theatre practitioners place their goals firmly within the range of intentions which seek to effect positive community change. Of course this clarity of intent begs a number of questions, one of which is: how does change happen? While there is significant anecdotal evidence of theatre's powers to affect change on a short and even medium-term basis, its powers are best realised when placed within a broader movement of organisation, education and development. One of the difficulties for popular theatre practitioners is that they need to know, and deeply understand, several fields. In addition to theatre practice, including a variety of styles, processes and theatrical expressions, the ideal popular theatre practitioner is also knowledgeable and practised in community facilitation, community development, and the theories and practice of community change. At the very least, we need to be conversant with the values and choices that are available to those working for change; we need to be able to name our stance(s) and to have a language that will enable us to collaborate with those who work (in other ways) in education and development.

Agents of Change[2]

After a lifetime of work, E. A. Corbett, one of the best known figures in the history of adult education in Canada, summed up his experiences and convictions in *We Have With Us Tonight*: 'I know from long experience that through study, discussion and planning together people can change their social and economic environment and in so doing change themselves' (220). Not everyone, even in the field of adult education, would share this optimistic view towards social change, but Corbett's words make the vital connection between social change and the impact on the individual resulting from being part of the change process.

We are in a time of what might most kindly be termed confusion, with respect to the definition of some basic terms in the social sciences. Such a condition is abundantly clear when we turn to a definition of the concept of community. As with many such terms, it is easy to assume that we know what they mean, only to encounter frustrating difficulties when it comes down to cases. Among the myriad of efforts to define the term is the following:

> There are at least four senses in which 'community' may be used, four social realities it may describe. One, the small community, local and with many areas of common life. Two, an association of people with common life who do not live in the same neighbourhood. Three, localised and large but with little common life throughout. Four, a process. (Milson 2)

Milson goes on to relate community to feelings of belongingness, pointing out that people belong to two broad types of human association. 'The first is primary, face-to-face, personal, small and intimate, like the family. The other is secondary, and often impersonal like our town or our national trade union (3). After stressing the importance of feelings of common interest as being at least as important as geographic factors in a sense of community, he concludes:

> A community is a social group, usually localised, in which there is manifest or latent, existent or potential, a sense of identification among the members: it is not simply a point on the map but an understanding to be found in people's attitudes and thinking. (11)

'Community work' has to do with the functioning of this entity, the community, however defined. Factors affecting these processes may range from the physical to the psychological; from the condition of the roads and sewers to the quality of citizen participation in decision-making; from the equity of taxation policy to the nature of day-care services; from the number and location of parks and recreation services to the costs of securing fair treatment from the judicial system.

> Community work includes: (a) helping local people to decide, plan and take action to meet their own needs with the help of available outside resources; (b) helping local services to become more effective, usable and accessible to those whose needs they are trying to meet; (c) taking account of the interrelation between different services in planning for people; (d) forecasting necessary adaptations to meet new social needs in constantly changing circumstances. (Gulbenkian Report 149)

If we accept this, or a similar definition of community work, it is clear that a wide range of specialists and professionals may be involved in these activities, including community planners, public administrators, social workers, adult educators, community developers and social animators, if the matter is seen largely in process terms; and a broad spectrum of specialists in particular 'content' areas, if we think of the enormous range of aspects of community life which the community may seek to change.

While it is clear that among the various kinds of specialists in the 'helping professions', there is widespread agreement on certain very general matters, such as ideas about human worth and betterment (see Gulbenkian), beyond this level of generality, it is difficult to find consensus. In his book on community work, Milson puts forward several statements which he feels sum up the most widely shared values among those working in the field:

1. Each individual is important.
2. The duty of democratic society is to care for the welfare and development of individual citizens.
3. Freedom is a goal to be sought.
4. Democracy and participation are ultimately to be preferred on the grounds of efficiency, as well as for their humanity.
5. Co-operation and fellowship are better than isolation (103-108).

Schools of thought about Community Work

Basic to the choice of approaches which may be taken to community work are the general beliefs which are held concerning the nature of society and the necessary and appropriate means of promoting change. For the last forty years particularly, the various forms of community work have functioned against a background of sharp philosophical and sociological debate about these matters. The lines have been drawn between the consensus or liberal view on one hand, and the conflict or radical view on the other.

The consensus paradigm has been, and remains the dominant view in Canadian and British societies. The consensus view sees society as an organism, with its various parts contributing to the functioning of the whole in much the same manner as the organs of the body work together, performing their necessary functions. Indeed this philosophical point of view is frequently termed 'structural functionalism'. This concept of society emphasises common beliefs and values and leads its adherents to approach social change in incremental and relatively optimistic terms. There is a belief that by continually making beneficial changes in our social arrangements, we can create an ever more equitable and satisfactory society. This view holds some comfort for practitioners of community-based theatre: the positive, on-the-spot experience which theatre can effect is seen as a significant step in a long series of such steps. Supporters of this paradigm also tend to be comfortable with the professionalisation of the various sectors of society, believing that 'the most able individuals are attracted to those positions which are most critical to the welfare of society as a whole' (M. Selman in Selman and Dampier 23). Rubenson has summed up the social implications of this view:

> According to this paradigm, an unequal society does not arise out of the vested interests of single individuals or groups, but out of the needs of society as a whole. Thus inequality is seen not only as inevitable but also as necessary and beneficial to all, since individual survival is contingent upon the survival and well being of society. In addition, the system of classification in any society is essentially an expression of the value system of that society. The rewards accruing to certain positions are a function of the degree to which their quality, performance, and possessions measure up to the standards set by society. (ctd in Merriam & Cunningham 54)

The conflict paradigm, of course, takes a very different point of view. Rather than viewing society as being made up of co-operating elements, adherents to the conflict view see social inequality as resulting from the fact that society is made up of groups with basically different, and frequently incompatible interests. Those with privileged positions are seeking to defend their entrenched interests. As Mark Selman has put it, 'For those who take this view, the belief that individuals succeed by equipping themselves better to fulfil roles important to society is seen as a myth, moreover as a myth which is useful for those in power as it tends to promote satisfaction with the *status quo*' (23). To return once more to Rubenson:

Those working within the conflict paradigm approach questions of social change, inequality, mobility, and stratification . . . from the standpoint of the various individuals and interest groups within society. Social inequality is seen as an expression of the struggle for power, privileges, and goods and services that are in short supply. Conflict theorists emphasise competing interests, elements of domination, exploitation, and coercion. The word conflict somewhat erroneously gives the impression that the theory focuses only on dramatic events such as revolution, war, and other forms of open conflict. Its main argument, however, is not simply that society consists of conflict but that open conflict is only the tip of the iceberg. (ctd. in Merriam & Cunningham 54)

There is another perspective on society which is useful to consider as a background to approaches to community work. It is an outgrowth of the emphasis in recent decades on human rights and of the approach to change reflected in what have been termed the 'New Social Movements'. Since at least the 1960s, and to some extent as a response to what have been perceived by some as shortcomings of the welfare state, there has been a resurgence of interest in and action on behalf of human rights. Such rights have been pursued in individual terms, and also on behalf of certain groups in the population. One form of the efforts to secure and safeguard human rights has been in the forefront of the political agenda of Canada as a result of its espousal by governments in power. This effort culminated in the Charter of Rights and Freedoms, which was in turn incorporated in the repatriated (from Britain) constitution of 1982.

A great deal of attention has been devoted in recent years by philosophers and social scientists to the contemporary efforts on behalf of human rights. Concern has been expressed in some quarters that as increased emphasis is placed on the rights of individuals and certain social groups, there has been a corresponding diminution in concern for the community. This trend has been referred to by philosopher Charles Taylor as 'atomist' and he has expressed concern about the erosion of a capacity to take the broader, community view (ctd. in Cairns & Williams). Political scientists Cairns and Williams report that the evolution of 'rights consciousness' has been profound in the last few decades. They comment: 'The breaking of the bonds of custom is accompanied by beliefs that identities can be chosen, social arrangements reconstructed, and society transformed by human action' (8-9). These authors make reference to 'centrifugal tendencies in state and society' which have encouraged the development of biculturalism, multiculturalism, single issue social movements and other regional and local interests. They add that 'the underlying social reality to which the state responds is increasingly fragmented, pluralist and centrifugal' (15, 42).

The growth of the New Social Movements in the most recent decades has been seen as a response to the loss of identity or rights by the individual which resulted from the welfare state or 'mass democracy' of the middle decades of the twentieth century. Recoiling from the horrors of two world wars and the world wide depression of the 1930s, western nations turned to the state and large social organisations to provide a safety net for those in society who required protection from the effects of economic and social forces. They created the 'strong remedial state', (Carr), and engaged in social engineering on a grand scale. But before long, this approach, in turn, was seen by

many to have harmful effects. There was a great deal of concern about the domination of individuals by organisations and a loss of self-directedness. Many in society came to feel they were being managed or manipulated by large organisations, most of all by the state, and losing the capacity, or at least the opportunity for acting on the basis of personal conviction.

The tendency to think increasingly in terms of the 'management' of society rather than in terms of actions grounded in philosophical points of view, as expressed in such works as Daniel Bell's *The End of Ideology* (1960), attracted increasing numbers of critics as various social forces came together in the 1960s. There was concern as well over the power of the managers, the power brokers, what W. A. Robson has termed 'the hegemony of the executive' (176). The 1960s brought a tumultuous and many faceted response to what were increasingly seen as evils residing in the nature of mass organisations - the state, big business, big unions, etc. Authors such as David Riesman, William White, Albert Camus, and perhaps above all, C. Wright Mills, made clear the pressures created, and control exercised, by mass organisations on the lives of individuals.

Out of this kind of thinking, and the entry of a 'new generation' (the baby boomers) onto the political stage, came a resurgence of a kind of individualism in society. There emerged a style of social and political action which aimed at maximising personal influence over public affairs. Thus arose what has widely been termed 'participatory democracy'. It placed great emphasis on direct action, as distinct from traditional ideas of acting through the ballot box and one's political representative. It was seen by many who participated in it as the insistence on a moral critique of our social and political institutions. A student manifesto of the day spoke of 'bringing people out of isolation and into community' (ctd. in Hayden 97).

The organisations created to advance and co-ordinate such action are in may instances 'single issue' organisations: human rights groups; the women's movement; peace and disarmament groups; environmental organisations; and those promoting the interests of a variety of disadvantaged groups in society, and are generally referred to as the New Social Movements. Though the activities of these groups have been judged to have been beneficial in many respects, there is a concern being expressed that one result of 'single issue' politics and concentration on the rights of this group or that in our society is having the effect of putting undue emphasis on individual and group rights, causing 'centrifugal tendencies in state and society', 'at the expense of more holistic conceptions of community and citizenship' (Cairns & Williams 42).

A final question to be examined in this 'schools of thought' section is the matter of whether social change should appropriately be seen as an aim of educational activity. There are at least two perspectives on this question: philosophical and functional.

Those espousing a liberal philosophical position are inclined to see education primarily in terms of its effects on the individual learner. The proper aim of education is to help produce a fully functioning individual. The assumption has been that if through education the person is assisted to acquire the knowledge and skills which enable them to function as a citizen of a democracy - powers of expression and of critical thinking - and if, as well, the person can be disposed, through education, to

play an active part as a citizen, then education has done its job. And in the view of many, if educators transgress beyond that role, they are acting improperly. The other view, which might be termed the social transformation view of education, holds that education should be harnessed to efforts to bring about social improvement and social change. Indeed Paulo Freire, one of the best known of those putting forward this latter view, holds that the educator does not have a choice of whether to take a 'politicised' role with respect to education; the educator is either a force for social change or a reinforcer of the *status quo* (*Pedagogy* and *Politics*).

The other way to examine the range of purposes of education relies on what may be termed a 'functional' approach. In terms of adult education, this is exemplified by the discussion in Hayden Roberts' *Culture and Adult Education* (1982). He sets forth a continuum of 'purposes' of education ranging from 'remedial' on one end, to 'counter-cultural' on the other. The terms he utilises move progressively from 'remedial' (making up for things previously missed, usually in formal education); to 'coping' (to enable one to respond to the challenges faced in everyday living); to 'personal development' (what Roberts terms 'stretching oneself beyond what is adequate for survival and social acceptance' (33); to 'social development', a reference to the individual turning outward to the environment and acting as a citizen or agent of change; and the 'counter-cultural', which he describes as 'a perspective that stresses social organisation as building and rebuilding a new social life-style with more regard to symbolism, myth and the inner identity of cultures, going beyond present social and political identifications' (33).

Such differences in approach have a bearing on all specialised areas of practice within the field of community work, including popular theatre; it is interesting to note the parallels with Ross Kidd's analysis of the kinds of popular theatre practised in Canada. The impact of these issues is particularly sharp in adult education, where an insistent debate rages between those who believe that the function of the field is to provide services to individuals on demand, leaving it to the person to decide what to do with the new found knowledge, skill or attitude and those who believe that adult education should be used as an instrument of social change and as a means of addressing what Griffin has termed 'the wider issue of knowledge, culture and power' (65).

Methodologies and Involvement Strategies

When considering community work, its intentions and strategies, two approaches need to be examined: community education and community development. In each case there are philosophical implications in the stance taken by the worker, or to put it another way, the philosophical beliefs of the worker will influence the choices made.

Community education is variously defined. In most cases, the term is used to refer to educational provision which attempts to serve a wide variety of learning needs in the community. The name is frequently adopted by the adult or continuing education unit within a local school board or community college, these organisations seeing themselves as attempting to offer a range of educational opportunities which serve all

segments of the community. In his well-known book about community education, Brookfield (1984) makes some useful distinctions when he examines such work under three terms, adult education *for* the community, *in* the community and *of* the community. We are reminded of the delineation of levels of popular theatre, as defined by Kidd and others: theatre *for*, theatre *with* and theatre *by* the community.

Adult education 'for' the community is the term Brookfield uses to refer to a range of services which are provided on the basis of some form of needs assessment of the wishes and desires of adults for learning opportunities. Under this approach, adult educators ostensibly remove themselves from any responsibility regarding the intrinsic merits of particular courses or content. What is provided is simply a response to needs identified by those in the community. (Brookfield goes on to point out, however, that it is not that simple; programmers must still make choices as to which needs will be met - and for which groups in the community).

By the term adult education 'in' the community, Brookfield means adult education which is offered on an outreach basis in the community. It differs from that provided 'for' the community partly on the basis of location. Educational activities are conducted in *community-based* or non-classroom settings. But the other, perhaps more important point is the different relationship between the educator and the learner. In this second category, the learners usually exercise control over the content and conduct of the programme, the *educator* becoming a *facilitator,* or consultant, as required. In this definition we can see a location of much *community-based* theatre work. Indeed theatre has come to be seen as a very useful facilitative tool for such educational approaches.

Closely related to this idea of education in the community is the concept of 'educative community'. This was elaborated in the early seventies by the UNESCO report on the development of education, *Learning to Be* (1972). The basic idea behind this notion is that the community in all its dimensions and through all of its institutions, economic, political, cultural, social, religious, etc. may be seen as and utilised as resources for learning. The resources for learning go much beyond those institutions which have traditionally been seen as the educational institutions.

Brookfield's third category is the *education 'of' the community*. Education of the community carries an overt normative and prescriptive element not present in the first two categories. Adult education of the community cannot be shaped solely by the results of a needs assessment; rather, it rests at least partly on the educator's beliefs as to the kinds of features he or she thinks a community should exhibit. The educator possesses a vision of a healthy community - perhaps one characterised by a populace possessing self-help, problem-solving skills and leadership abilities, and one in which democratic behaviours and virtues are vigorously exercised. (87)

He points out that in all kinds of adult education activity, the educator, implicitly or explicitly, exercises an influence over the programming process. In this third type, however, the judgements made by the educator may be more readily identified. In examining this, the third of Brookfield's categories, we come reasonably close to the community development approach.

There are, however, two important differences between Brookfield's third category, adult education in the community, and *community development*. The first has to do with

the general nature of the two phenomena. Community development is not contained within the field of adult education. It is a social process which involves educational components, but other elements as well, such as community planning, public administration and community organisation. The other all-important difference is that whereas 'adult education of the community', as defined by Brookfield, seems to take its lead from the educator's view of the community, the community development process begins essentially with the community's view of itself. Adult education may be just one of several areas of professional competence represented on the team of facilitators of the community development process.

Community development is aimed at bringing about improvement in one or more aspects of community life. Essentially it involves: the community coming to the view that there are aspects of community life which it wishes to improve; the community conducting a self-study and identifying areas for improvement; the selection of priority areas for improvement; efforts to reach those goals (frequently involving the use of outside resources, including government); the evaluation of results achieved and the setting of new goals. It is usual for the community engaged in such a process to have the assistance of at least one professional consultant or process expert, who works along with the local leadership and assists with the various stages of the community's efforts. Sometimes a decision is made outside the community to 'send in' such a worker, but frequently it is the community itself which makes the original decision and they seek a community development worker to come and assist with the process. In the former instance, a considerable period is sometimes required for the community development worker to gain support and acceptance of their role in assisting with community change. In cases where the community itself has sought the services of a facilitator, there is more readiness to proceed from the outset.

Popular theatre may be seen as an approach to such work, whether as a tool, useful at various stages of the community development process, or as a process which offers all of these steps, in and of itself.

Community development gained widespread recognition following the Second World War, when many territories which had been under colonial status gained independence or were being assisted to prepare themselves for independence. In most such cases, the colonial powers either sent community development specialists to the areas, or provided training for indigenous persons who were being prepared for such roles. As community development as a technique became more widely recognised, it was taken up for use in the more developed countries as well. There are many examples in Canada, as elsewhere, of pre-war activities which involved at least some elements of what came to be recognised as the community development process, but it was not until the post World War Two period that this approach to encouraging and facilitating community change was widely accepted.

There are significant differences in emphasis concerning the primary goals of community development among its practitioners and evaluators. Many attach priority to the 'efficiency' of the work; the focus is directed to whether conditions in the community were actually changed in the direction, or directions, which the community had established as the goals of the exercise. The other view of the process attaches

particular importance to the degree to which members of the community learned and grew; capacity building is seen as most significant. There is still a concern for the community reaching its goals, but great emphasis is placed on the learning of those involved. However, most see it as a social process which certainly involves adult learning and adult education, but which goes much beyond that field, involving as well public administration, community planning, social work, community organisation and perhaps others.

Two strategies for involving participants in community education and community development processes are consciousness raising and conscientisation.

Consciousness Raising The term consciousness raising refers to the process whereby an individual or group of people are enabled to see more clearly than they did before the nature of the social and cultural forces which impinge upon their lives. It may properly be seen to apply to a great deal of the activity of social movements, old and new. It is part of the strategy a group employs which is seeking to win adherents to a cause. In order, for instance, for an environmental movement to persuade others that the community, or the world community, is facing a dangerous or urgent situation, an effort must be made to convey to others just how urgent a challenge to the public welfare presently exists. Or to take a different kind of example, members of the women's movement are consistently trying to bring before other women an awareness of the ways in which society, consciously or unconsciously, is unfair in its practices towards women. The latter example is a particularly important one because the women's movement has devoted a great deal of attention to consciousness raising as a part of its activities. C. A. MacKinnon has stated: 'Consciousness raising is the feminist method: the collective critical reconstitution of the meaning of women's social experience as women live through it' (ctd. in Butterwick 6). With respect to the particular form of consciousness raising used in the women's movement, students of the movement have placed considerable emphasis on the fact that consciousness raising as they have employed it has been engendered within the movement itself, not brought in by leadership from outside (Butterwick).

Consciousness raising may be seen as a preparation for action. The New Social Movements use a variety of techniques intended to accomplish this objective, among them what are often referred to as 'media events'. The organisation will stage a demonstration, engage in 'street theatre', stand in front of an oncoming logging truck, or occupy a cabinet minister's office, the aim being to attract public attention to the issue, and also to show potential members, adherents or supporters that there is a danger or battle to be fought, and that there are persons who could be joined or supported in their actions to seek a change in public policy or institutional behaviour.

Other forms of consciousness raising are not as dramatic. For instance, those interested in the welfare of older persons in our society, most of all organisations of seniors themselves, are active in bringing to the attention of other seniors such things as their societal rights, the benefits available to them, and their emerging political power. There may not be any immediate call to action, or issue on which members of the age group are being asked to respond. It may rather be a general raising of awareness of common interest, or a group consciousness.

Conscientisation This concept has been popularised by Paulo Freire and incorporated into his process of education for social action.

> Conscientization refers to the process in which men, not as recipients, but as knowing subjects, achieve a deepening awareness both of the socio-cultural reality which shapes their lives and of their capacity to transform that reality. (*Cultural Action* 51)

Conscientisation goes beyond what is usually intended by the term consciousness raising, in that it includes not only an awareness of 'reality' (the injustices under which people may be suffering), but also a programme of action to change that reality. Freire comments further, 'Critical consciousness is brought about not through an intellectual effort alone, but through praxis - through the authentic union of action and reflection' (78). He contends that 'because men are historical beings, incomplete and conscious of being incomplete, revolution is as natural and permanent a human dimension as is education' (82). Freire did his early work in Latin America, in authoritarian societies, and so his rhetoric was based on the assumption that any significant social change would have to proceed by revolutionary means. His thought has been influential in many of the liberal democracies as well, especially among those who are working on behalf of the welfare of disadvantaged groups. It is probably fair to say that for the term 'revolution', many workers in these other countries have substituted the idea of social change, not necessarily by violent means.

Related to the idea of conscientisation has been Freire's contention that educators and other community workers cannot stand aside from the struggle to improve the lot of disadvantaged persons and from efforts to bring about social change. Most briefly stated, he contends that education (and educators) cannot be neutral. Either they are a force for change, or they have the effect of reinforcing the *status quo*. Freire thus tackles head on the assumptions of the liberal point of view in education, which holds that the educational system accomplishes its task when it helps the individual to gain the knowledge and skills they will need to be an active citizen. It is then up to the individuals to do what they will with the knowledge they have gained. Freire says that is not good enough, that if the educators, or the educational system do not actively advocate change, they are accepting the *status quo*, and training people to accept the world as it is.

A key link between adult education and popular theatre practice is forged by his critical pedagogy and those educators who have followed in his tradition, such as Henry Giroux. For Freire, education was essentially the process whereby those whose voices typically go unheard in any given society or community, discover the confidence and means by which to articulate their own unmediated sense of the material reality in which they are compelled to live. Knowledge is not the property of a ruling or professional class who deal it out in prescribed curricula but is the consequence of the need to know in order to develop, to move from one state of consciousness to another. The notion of self-development lies at the core of this pedagogy: a pedagogy which liberates the mind and the imagination and thus begins the process of social transformation which starts in the psyche of the individual. There is a natural affinity

between this transformative agenda and several features of adult education which are frequently characterised by the desire of the experienced adult to use an educational process to assist in an act of self-transformation which goes well beyond the search for qualifications, and into the areas of altered understanding and renewal. That which has often been confined to the spheres of institution-based adult and community education, Freire sought to make available to all ages and sectors within societies.

Some Thoughts about Techniques

It is perhaps useful to comment on, and indicate the relevance of, several techniques to the practice of community work and the methodologies which have been discussed. It should be noted that these techniques are employed with varying degrees of ideological thrust. They may be, and are, used by practitioners with a liberal philosophical point of view and by those aiming at profound social transformation.

Participatory research is a practice developed in recent decades in which people who are to be the subject of some form of research are consulted while the research is being designed, involved in the carrying out of the research process itself and engaged in consideration of the outcome and implications of the research. For some, this approach to research is seen to be beneficial because it gives those involved a sense of 'owning' the research and its outcomes, and increases the likelihood, therefore, that some action will be taken based on what the research reveals. At the other end of the spectrum, those of a social transformationist point of view see participatory research as a strategy for consciousness raising or conscientisation. The assumption is that if the people concerned can be involved from the beginning and taken through the investigation phase, injustice and inequality will be revealed in the process and the people affected will become strongly committed to working for change.

Participatory research may be seen to have been an offshoot of what is termed *action research*. Generally credited to the sociologist, Kurt Lewin, who developed it in the early 1940s, action research has gone in various directions since that time. The chief thrust of Lewin's thinking was that the social science researcher should begin with a situation or a problem rather than with a theory, create a collaborative approach to investigation with the people concerned and incorporate into the process *action* on the matters being investigated. As in the case of participatory research, those who support this approach vary widely in their philosophical perspectives, although the majority in this case fit comfortably within the liberal point of view.

The term *transformative research* is the latest of these three terms to appear on the scene[3]. Unlike the two previous terms, this one is located squarely at the social reformist end of the philosophical spectrum.

> Transformative research does not generate knowledge for the sake of knowledge, nor does it seek to uncover universal laws and scientific principles. Rather it produces reflective knowledge which helps people to 'name' their world and in doing so, to change their world (Beder 4).

Research is used to document the nature and extent of social problems and the disadvantage under which persons are suffering, as a basis for efforts to achieve social change.

Popular education is based in Freire's philosophical perspective and methodologies. As the name implies it uses participatory and 'two-way' approaches to an education process which seeks to engage marginalised communities in a process of naming their world (codification), analysing and uncovering injustices (decodification) and strategising for action. As with popular theatre, it struggles to define a process appropriate to specific community conditions (context) and to embed itself deeply within ongoing development movements. As with many of these 'techniques', practitioners and theorists alike attempt to use definitions and manifestos to place it at various points along the spectrum of change which we have outlined here. In practice, it is the politics, philosophical stance and social understandings of the facilitators, the sponsors and the community group which ultimately determine the outcomes.

It may be argued that community-based theatre, like participatory research, is a technique, which may be utilised within a wide range of approaches. The term popular theatre, however, like 'popular education', implies a greater affinity with Freire's social transformation ethic and methodologies than with the more liberal approaches. However, like popular education, this assertion requires critical examination on a case by case basis. Indeed, theatre may be used by a particular group to identify its concerns (as in one of the early stages of community development) or it may be used as a way of animating or energising a group of people as a means of stirring them to action. It may function perfectly comfortably within a liberal philosophy, identifying matters for adjustment within existing social arrangements, or it may be part of a conscientisation process which is preparing the way for a struggle for profound social change. It may even serve as a therapeutic experience, allowing people to express feelings and identify problems, leaving any action with respect to these issues to some other occasion. The function which is served by community-based theatre as in the case of other techniques previously discussed, will be determined by those involved, the groups which are engaging in the process, and the professional consultants who are working with them.

These delineations go far beyond rhetoric. As we will see in Cloutier and Dalgetty's discussion of a popular theatre process which linked teens from inner city Edmonton with peers from Nicaragua, facilitators, in embracing a commitment to 'give over' control to community members, can find themselves doing so at the expense of relinquishing an agenda that in other ways would be more critical, and possibly more transformational.

Popular Theatre, Cultural Awareness and Solidarity: Canada to Nicaragua
Alexina Dalgetty and Joe Cloutier

In February 1998 the musical group Lights of The Future spent two days at Inner City High School. Lights of The Future are a group of young people between sixteen and twenty-four years of age from Nicaragua who, with music, were able to leave their home in Managua's *barrio* and bring their musical light to Alberta. The Arts Jam was a celebration of various art forms such as music, poetry, sculpture, photography, drama, and the creation of a mural.

The plan was to break into groups: music, poetry, mural, clay sculptures, photography, and drama. Each group worked on a two day project which was then presented to the larger group and a few guests at the end of the two days. What follows is a dialogue about the drama (popular theatre) group between Alexina Dalgetty and Joe Cloutier. Before the dialogue begins a bit of background will help illuminate the project.

Alexina and Joe are popular theatre workers with Edmonton's Inner City Youth Development Association (formerly Inner City Drama). For 10 years they have used popular theatre to work with several different groups of young people between the ages of thirteen and twenty-four in Edmonton's inner city. These groups have used popular theatre to try and come to terms with the harsh realities of their immediate environment. At Inner City we have always been guided by a firm belief in the need for more long-term programmes for Inner City youth. This commitment to long-term programming has made it possible to follow some of the young people through several different stages of their development, development that grew out of the youth's own insights and realisations. For the youth, that development has followed a trail that has led from life on the street to finding a permanent place to live in the Inner City Drama house; to having food to eat; to much personal growth; to the shedding of destructive habits; and to being valued and respected for who they are.

The youth in Inner City Drama projects attended workshops and created popular theatre about the issues they faced, or had experienced. These plays were then performed for members of their community. The community was a community of experience rather than one bounded by geography. Inner City Drama charged for the performances and were then able to pay the group members for their hard work. Not only were many of the young people without funds, it was also important that others (i.e. the audience) showed that they valued their work in a tangible way. The performances explored topics such as racism, family violence, prostitution, various forms of abuse and many others.

In February 1993 some of the youth wanted to return to school. Most did not have much of a formal education. In many cases they had missed more school than they attended. Now, after using popular theatre to understand, and in some cases overcome, social issues that had blocked their development, they saw the importance of education and its role in breaking the cycle of poverty and violence. After an unsuccessful return to local high schools some of the youth asked us at Inner City Drama if we would start a school. We agreed and began the search for a home. The Boyle Street Community League offered their space and Inner City High School was born.

Intentions

The organisation now has a new name, the Inner City Youth Development Association (Inner City) which includes Inner City Drama and Inner City High School. The school began with 9 students, seven from the drama group and two of their friends. The population last year was approximately sixty students for each of the year's four semesters. The school is open during the summer but attendance is much lower than in the regular semesters.

Each meeting of the popular theatre groups begins and ends with a circle. In the circle the group sets the direction of the programme, everyone has the opportunity to speak, each person is on the same level and facing each other. Most decisions are made or confirmed by consensus in the circle. Each school day begins and ends with a circle. There is a high degree of student participation in the school. Popular theatre, along with other fine art disciplines, has been an integral part of the high school since the beginning. All students participate in a popular theatre introduction and continue to participate in popular theatre based drama courses in some form.

Vanessa was a member of Inner City's performing popular theatre group, and one of the first students at Inner City High School. She has been associated with Inner City since she was twelve or thirteen. Vanessa is now twenty-one. She first took part in Inner City's after school drama programmes at a local school. Then Vanessa became an important member of the Boyle Street group, Inner City's performing group. She worked with the performing group for several years. For the last few years Vanessa has been facilitator in an after school drama programme for children ages six to twelve. She plans to attend the University of Alberta. Vanessa was the facilitator in the popular theatre workshops over the two day Arts Jam at Inner City High School. Alexina and Joe observed the process. Vanessa was the key facilitator.

In the popular theatre workshops the group of six young people, some from Edmonton and some from Managua began by sharing each other's reality through images: group sculptures that gave insight into each other's cultures.

Joe

Martin, one of the youth from Managua found many similarities between the Edmonton based sculptures and his experiences with inequality in Nicaragua. For Martin, he felt like we were all connected.

Alexina

And his belief is validated in many ways. Cherry is going to visit Nicaragua this summer. The connection isn't going to be broken for this group. (Cherry is a 17 year old student at Inner City High School and was a participant in the popular theatre workshop. As a result of her participation in the workshop Cherry will be travelling to Nicaragua to meet the youth from Lights of The Future.)

Joe

Cherry's trip to connect with the group in Nicaragua is quite a step for her. Cherry's work in the drama group had a definite maturity about it. It seems important for her to continue the experience.

Alexina

I particularly remember Marvin's surprise that parents would throw their children out when they could actually afford to feed them. (Marvin is from Nicaragua.) And at the idea that young people would choose to leave home for reasons other than, essentially, starvation. I think his reaction to these two situations made the young people from Inner City re-analyse their situations.

Joe

Do you mean that Marvin's surprise caused the Inner City youth to think critically about such situations, but in that process they did not change the way they saw the world?

Alexina

I think it changed the way they saw the world in so far as things are different in other places, i.e. Managua. I think it made them look beyond the things that were happening to them and they were able to stand by their initial reactions and decisions, possibly understanding why they had made those decisions. What I'm trying to say is that Marvin's reaction, his genuine shock, might have led them to question the integrity of their situation; i.e. them leaving home. They might have felt they had made a bad decision. But instead they analysed why they left and came up with the feeling that the home situation was intolerable. They hadn't done anything wrong. At the same time there seemed to be a need to defend their homes and the people in them. It's different when everyone has an intimate understanding of the situation, there's no need to defend the parent, sister, guardian who has thrown you out. But when someone from somewhere else finds the situation incomprehensible, as Marvin did, the need to go beyond the individuals seemed to arise. The roots of the situation had to be addressed. It was just a scrape on the surface but it made the young people from Edmonton look closer at a situation that is normally accepted.

Joe

When I reflect on that session I wonder if we should not have explored the contradiction that the group exposed in more depth. I felt a certain tension in those sessions. On the one hand I wanted to say, 'Would you like to explore that a little more?' and on the other I was held back by the importance of not overshadowing Vanessa. It seemed to me that Vanessa would have given over to us if we had 'moved in'. It seemed that Vanessa had to go through the experience on her own, if she was to learn from it.

Alexina

Yes, I felt the same thing. Periodically Vanessa would list what had happened and the possibilities on the board. I remember her drawing pictures in order to include everyone. This was Vanessa explaining the situation. But I do think that given the natures of the participants, Armand and Cherry especially, that there is still room to explore these ideas.

Intentions

Joe

It seems to me that the translated narratives of the sculptures added to our growing understanding of each other's reality. The theme of our work and its guiding images then began to focus on quality and inequality.

Alexina

I found it particularly telling that for everyone, no matter where they were from, education was a key factor in taking control of their lives. Putting it in print makes it seem terribly obvious, but it was a similarity.

Joe

Yes, it seems that the goal of Martin at least, and some of the other youth from Nicaragua, was to get an education and then help others find their way out of the *barrio*. The theme of equality/inequality then was relevant to everyone's experience.

Alexina

With the overwhelming feeling that everyone was equal and inequality was seriously wrong. (I guess this is obvious.)

Joe

Armand was visibly moved. Armand said he never knew that we could be so similar yet live in a different part of the world. His sculptures on inequality connected his experiences to the racism he had experienced as a Metis youth in Edmonton schools.

Alexina

Armand has a very strong voice. He's also a natural listener. His sincerity, combined with a whole bunch of other qualities, make Armand a real asset to a popular theatre workshop. He's very honest and this honesty makes him very vulnerable.

Joe

It was that honesty that allowed him to be as open as he was and give the group an insight into his life.

Alexina

I found it quite amazing how the group ferreted out their similarities. They couldn't speak the same language but Vanessa and Marvin were discussing their small sons, Armand had similar interests to those Marvin was studying in university. Both had a genuine interest in other cultures and their institutions. I keep remembering - and this remembrance was jolted by Armand's participation in social classes too - Armand in the journalism course about a year ago and how he didn't do politics. He actually took a lower mark in the course because he just couldn't bring himself to read about the election. What a change! It seemed like he was beginning to apply those 'institutions' (can't think of a better word and it took me so long to get here I have to forge ahead as they say.) to his own life.

Joe

In social studies classes Armand was quite taken by the inequality that he felt in Canadian society. He had difficulty connecting his own experience to what he was learning about democracy. Armand was shattered by what he learned about slavery and angered by what he was learning about colonialism.

Alexina

So in many ways what he learned validated his earlier feelings. The whole process was in many ways worth his scorn, his scepticism.

Joe

It seemed as though you could see Armand processing those connections and every once in a while commenting something like 'this is amazing, it's changed the way I see things.' He was so taken by the experiences of racism and inequality in both Edmonton and Nicaragua. And Martin found many similarities between the Edmonton based sculptures and his experiences with inequality in Nicaragua. For Martin, he felt like we were all connected.

Alexina

It's odd but his belief seems to be validated in some ways by the fact that Cherry is going to visit Nicaragua this summer. Cherry's trip to Nicaragua means that the connection isn't going to be broken for this group. Although the product was much less tangible than some of the other workshops - I see the mural everyday, the sculptures are touring Canada, etc. - the link established here, and the concerns, seem to endorse Marvin's idea.

Joe

There was a real feeling of togetherness and solidarity among the young people. It seemed as though the young people from Nicaragua did not expect to find such examples of inequality in Canada. I think for them, Canada was covered with a veneer of affluence. That veneer was removed in the popular theatre workshops.

Alexina

I agree. I think the comment from Marvin about parents kicking their kids out probably comes from this place. Actually when Ron Brazen from Change For Children (a local NGO who was sponsoring the tour) first approached us to run this workshop, I had feelings that screamed 'a popular theatre workshop for one hundred! Aahh.' It was ironic that we ended up with only six, counting Jose and the other translator. I suppose the students at Inner City knew they'd have another opportunity to do theatre - though not necessarily with such an international flavour - and we'd probably never let them paint on the walls again, or work with unlimited quantities of clay etc. Music is always so popular too. It was odd imagining things would be on such a grand scale and then ending up in a room in the basement with six people. And of course it was made a little strange when they started the mural outside and we had to knock to leave. Unless we wanted to knock someone off their chair or table.

Joe

It does make you wonder. The mural is quite powerful, a twenty foot wall illustrating the search for community and in the process overcoming the negative elements and celebrating the positive values of love, learning, and finding oneself in community with others. A mural that dominates a part of our school contrasted with some popular theatre workshops that are but a memory now.

Alexina

I think the participants were very brave. They were really willing to put themselves on the line. I think it was their hunger to find a meeting point.

Joe

It's a memory that some people won't forget easily. For Cherry, if what she learned in those workshops is deepened by her trip to Nicaragua, it has the potential to change the way she sees the world.

Alexina

Cherry's presence was very grounding. Thinking back to the idea of equality I suspect that Cherry has the very rare and valuable ability of being able to treat each person with equal respect. Is that what I'm trying to define? Maybe it's in the way she listens to what each person has to say with equal courtesy. I think it goes beyond courtesy though.

Joe

It's important to have that quality. It's particularly valuable in a popular theatre workshop. The young people from Edmonton: Cherry, Vanessa, and Armand felt as though they had taken part in one of the more important experiences of their lives. Seventeen-year-old Armand's words reinforce this fact and bring this dialogue to a close: 'Marvin really taught me how his country is and how we could create peace among each other. Marvin gave me a better understanding of how the world works and how we can change it.' The world has changed for the young people who took part in the popular theatre workshop.

The Interplay of Intention and Popular Theatre Choices

Some would say that the *intention* can and should define all other elements. What are you trying to do and why? What is a community trying to do, and why? If the intent is at all obscure or undefined, then really all other decisions become arbitrary and grounded in a rather wishy washy because-it-feels-right stance.

On the other hand, some popular theatre practitioners would say that determining intentions long before some of the other elements are known will squelch both wide participation, deeply grounded grass roots ownership, and the creative potential of the process. One of the values of using theatre is that new understandings are discovered, sometimes because the process taps aspects of individuals and groups that are

unexplored: work with the body, for example, can open areas of knowledge that verbal work cannot; various methods of recalling and recounting story can also reveal hitherto unknown or unnamed aspects of a community issue; and sometimes the analysis of a *real life* story, or even the attempt to create a *'true but fictitious'* one, can reveal aspects and complexities of an issue that more rational explanations overlook.

Given that one of the basic requirements of effective community development and education is for community members to guide and own matters which impact on them, *intention must flow from context, from community-based processes.*

There are deep-seated problems within our culture over the tension, some would say contradiction, between the demands of an agenda which addresses social transformation and the creative impulses of the artist who makes theatre. Somehow the integrity of the artist, the truth to the art form, is held to be compromised by the need to put that art at the service of a given community. Alternatively, the agendas of the community are at risk from the potential of the art form to trivialise material in the process of making it entertaining. Both poles of this tension occupy positions which reveal fundamental misunderstandings. Intention is not the enemy of creativity, nor does expression of, or response to, creative impulses render the structuring of intent impossible.

The popular theatre practitioner is constantly working to maintain a dialectical relationship between their intentions as facilitator and the desires of the community as revealed through the process; between the needs of individuals to effect their self-transformation and the needs of the collective to achieve a jointly owned, coherent outcome, and also, in some instances, between the possibilities of theatre *as* a developmental process and those of theatre *for* the accomplishment of concrete, social actions.

In some ways, the longer the view of the development process, the more open to a wide variety of short-term choices a popular theatre worker can be. As we will see as we examine context and form, while intent will hugely impact these elements, they too can impact intent; a long-term *intent* may well be served by a number of shorter term theatre based projects which will take exceedingly different *forms*.

Intentions operate on many levels and within many time frames. A specific project may have to content itself with attempting to fulfil a modest intention but nevertheless that intention needs to be clear from the outset to all engaged in the process. Equally, the small-scale intention must find its place within a broader concept of cultural intervention and social change.

So, whether stated or not, intention will be impacted by a number of factors, including: facilitators' stated and unstated agendas; bias of the funding source; objectives of the community organisers; structuring of the encounters within the theatre process; the institutional agenda of any agency or development organisation; and even artists' knowledge and lack of knowledge, and preferences, for various forms of theatre process and performance.

However, while intention (aside from a basic to-facilitate-the-community-in-its-efforts-to-name-and-take-action) may not lead, if there is no firm and honestly articulated understanding of where the artist fits, or what their intention is, much

community drama flounders in its lack of long-term intention and strategy. Some would argue that ultimately people working in this field need to have a very specific political and social agenda and, moreover, need to state it clearly throughout a project's life. Without such a clearly articulated agenda community members, animateurs, and popular theatre workers are unable to be up front with the community with whom they work, and are unlikely to build a project of any lasting worth.

Popular theatre is about changing the world. That is its intention. Not just any sort of change but change in particular directions: changes to the structures which guarantee the unequal distribution of wealth; changes to the patterns of domestic life which systematise the abuse of women; changes to the political organisation which denies effective representation to most of the world's population; changes to the modes of production, wealth creation and life-style which are destroying the earth's environment. There is a constant battery of images in our lives, many created by theatrical means, that serve to buttress the *status quo*. These may invite us to laugh at it, to reform or to enjoy it, but they implicitly tell us there is no alternative. Popular theatre is dedicated to the depiction, exploration, representation and debate of alternatives, and one way to look at a primary *intention* is to examine where the impulse for the project is coming from; who initiated the project and why? Another key question in examining projects, before and after they take place, is *who benefits*? and *how does each player benefit*?

There is an apparent paradox here. Politicians, businessmen and media pundits are forever exhorting us to keep up with the pace of change; to plan ahead; to retrain; to be flexible. But these are representatives of institutions with a vested interest in controlling, or in their phrase, 'managing change'. As recent history amply demonstrates, their kind of changes are ones which exacerbate the economic, socio-political and personal differences between the powerful and the powerless, both at home and abroad. In other words, these are not structural changes which address the contradictions of the dominant discourses. Rather they are adaptations which assist the current hegemonies to maintain themselves. Popular theatre practitioners, whether they know it or not, are engaged in processes of counter-hegemony. This is why Brecht has been a seminal influence. His theory and practice is a continual exploration into theatrical models of counter-hegemony: hence the central role of *verfremdungseffekte*, theatrical devices by which the familiar can be presented to spectators in ways which show it to be capable of alteration by them. Popular theatre is a set of processes by which people are enabled to investigate the possibilities for change in their personal and social circumstances. This investigation is predicated upon an intention to transform society by collective and individual means.

The drama-making process can become a process of conscientization – of unveiling deeper and deeper layers of reality and of examining the implication of various courses of action (Kidd 32).

Whatever the specific brief of the popular theatre worker, be it director or facilitator, the key issue is one of co-intentionality between the artist and the community. Intentions on both sides must be known and then be shared as a prerequisite to any attempt to work using a popular theatre method. This should not be a case of one side imposing an agenda upon the other, but rather a negotiation to reveal whether or not both agendas are compatible. Thus the grounds upon which the theatre workers are placed within a community can be validated through a process of shared intentions, rather than left to chance, misunderstanding and reputation. Once this framework of co-intentionality is in place, the specifics of its realisation are a matter of methodology which itself has to relate to issues of context.

Whilst the fashion today is for methods to be as participatory as possible, some contexts can make productive use of non-participatory approaches in specific phases of a programme as a means of raising consciousness, or to operate catalytically where there may be high levels of alienation or low levels of self-esteem. Therefore within the larger co-intention many specific instances of the community declaring its intentions for particular projects may operate. Where the facilitator and community share a desire to change the world, it may be most appropriate for the community itself to determine the priority area for this change. It is more important that attitudes coincide and that there is an agreed understanding of whose interests are being served by a particular intervention than that everyone shares, unproblematically, the prioritised agenda of issues. Since many of the changes to the organisation of social life involve moving power from the centre to the margins, it follows that popular theatre projects need to ensure that the margins are represented, heard and acted upon in the production of local knowledge in order that the old hierarchical patterns of power which serve the *status quo* are challenged and replaced with structures which reflect the real needs, aspirations and desires of the hitherto marginalised.

This is where the complexity of social reality often collides with the desire for clarity of intention. As the development of Boal's work demonstrates, communities often resist the simple division of 'oppressed' and 'oppressor'. Individuals, even entire communities, constantly cross and recross the borders between these states. Intention is often moulded by a sense of what is, and is not, possible in attempting to change social realities. If there are external factors working over a long period of time to persuade you that your state is unchangeable, deserved, God-given or whatever, you will in all probability dismiss the intention to transform your world from your mind. The self-alienation which results from the destruction of identity and culture, such as that experienced by the victims of colonisation, cannot be overturned by a facilitator extolling the virtues of participatory theatre. Counter interventions have to be staged, consciousness has to be raised before it is practicable to start speaking of shared intentions and their realisation through participatory theatre processes. So Freire speaks of the two phases which constitute conscientisation: the first is the stimulating of a critical consciousness and the second is social action for transformation which arises out of the first phase.

Some clear statements about intent can be found in texts from 'the south'. For example, Michael Etherton, speaking to an international meeting on theatre for

development, held in England in 1996, stated that his intentions in using theatre for development were 'to improve the lot of the poorest in a sustainable way'. In the north, popular theatre workers find themselves in contexts which defy this clear, clean statement of intent. Such statements challenge our chosen sites for our work. On the one hand, given this bottom line statement, why would we find ourselves working a) in the north at all or b) with the myriad of groups which do not represent 'the poorest' in Canadian and British societies? Theatre, with its very localised impact, acting in a world of vast complexity, seems to encourage us to work from a sense of faith in the power of multiple small actions to impact the larger picture. And in the faith that the personal voice is worth contributing to, that theatre represents contact, which in and of itself strengthens participants' ability and resolve to resist the more impersonal machinery of mass media, globalisation and consumerism and the alienating experiences created by the loss of the sense of community which dominates our urban landscape.

Theatre for development has tended to operate in places where this phase of consciousness raising has been the major challenge for the popular theatre worker, after which the sharing of intentions and the agreeing of priorities has been relatively unproblematic. In southern contexts the sheer fight for survival frequently determines the agenda. In the north popular theatre often takes place among communities where intention is less easy to agree; where even the need for change is by no means a *sine qua non*. In the so-called 'stake-holder' capitalism of late twentieth century social democracy, the likelihood of mobilising large sectors of the population in outright opposition to parliamentary democracy through theatre or any other kind of cultural intervention is remote. Popular theatre in 'developed' societies is more likely to be found operating in situations where there is either a specific issue that is already on the agenda in a given community, such as the protest movements in Britain which have grown up in opposition to the environmental destruction of road building, or the Greenham Women (a group which formed themselves to oppose the siting of US cruise missiles on the air-base at Greenham Common) and where theatre is felt to have a role in representing these issues to wider audiences, or within a closed institution such as a prison, school or hospital where drama processes are felt to be valuable as capacity-building devices for the client group. Thus projects are developed where the nature of the community defines the intention for the work (e.g. bereavement counselling using drama techniques for a group of nurses) or whole popular theatre companies set up to work in a specific area. The latter instance now has a long history in the case of Theatre in Education companies who work only in schools (sometimes even specialising in a particular age range) but more recently other types of specialism, notably in Britain prison theatre, have emerged. Even among companies which describe themselves more generally as community theatre companies, there is an increasing tendency to accept project briefs to work with a specific group from within a particular community, such as 'the deaf', 'the homeless' or that often-employed, nebulous category, 'young people'. At a time when resources for the arts are virtually non-existent, this strategy can give popular theatre companies access to funds from sources such as education, health and social services in return for this direct targeting of project work.

This orientation of popular theatre brings with it acute questions about the primacy of intention. Can it be fairly assumed that the intentions of the popular theatre company or single facilitator coincide with those of the commissioning body such as school, prison or health authority? The question is especially pertinent in the case of prisons which commonly regard their function as being to normalise deviant individuals through punishment and then to return them to a society which is represented as just and without need of change. Yet popular theatre grows out of the contrary assumption:

> Drama and theatre work with offenders, however, is a rapidly maturing field. Its roots are in radical community theatre; a political theatre that sought to make theatre more accessible and relevant to the working class through a content and medium that was more relevant to the real pressures of living and aimed to raise consciousness of an unjust system. Much of our work with offenders has now become accepted and comfortable within prison regimes that are ineffective, discriminatory and oppressive. (Hughes 32)

In these circumstances it is easy to fall into the trap of complacency and to regard being permitted to work in prisons on any terms as some sort of success. Once in this kind of mind-set, it is a small step to being co-opted as an agent of those very structures of oppression that popular theatre practices were developed to oppose. In that moment intention has been betrayed with the consequence that the work undertaken is at best some form of temporary therapy for individual prisoners, at worst an instrument for the further lowering of self-esteem by resurrecting feelings of guilt, inadequacy and despair:

> The assimilation of drama and theatre into such a system and the need to hold on to the little financial support there is for the work has meant in many instances that the aim of political challenge has been neutralised. There is much pressure on practitioners to survive by conforming within the system, for example, through devising offending behaviour packages that have the single aim of confronting offending behaviour and reinforcing the idea of the individual's responsibility. This aim fits very well within a right wing government that does not want to address the real roots of crime in poverty, unemployment, lack of opportunity and the emotional and social devastation that material deprivation causes in individuals and working-class communities. The reactionary trends in current practice are the ones that have been assigned the funding to develop into more than one-off ventures and have become, in my view, dangerously close to acting as nothing more than a new tool in the system of exploitation and oppression. (Hughes 32)

We have quoted this example at some length because it exposes a constant problem for popular theatre, namely its relation to the dominant. The history of western theatre is a history of incorporation: the incorporation of popular forms by the mainstream. The street theatre of medieval Italy became, via incorporation, the elite court form of the *commedia del arte*. In Britain the popular, working-class entertainment of the melodrama

has subsequently been appropriated through cinema and television as a populist form of escapism. The point in all such cases is that the original intention has been lost. The desire and need to change the world has been replaced by a willingness to service the *status quo*. The aim of consciousness-raising has given way to instilling a sense of false consciousness which processes material and social relations as unchanging and unchangeable.

Therefore an effective popular theatre practice has constantly to check its intentions against those of an infinitely adaptable, incorporating, dominant discourse. The relationship is always dialectical, never static.

Furthermore the intentions of the facilitators or activists have constantly to be checked against those of the community in order to insure co-intentionality without which no social action initiated through popular theatre will be able to sustain itself. For this reason it is essential to fulfil intentions through appropriate processes which enable the community to have ownership of the cultural intervention that is being undertaken for its benefit and in its name.

3 Contexts

The experience of reading a novel or witnessing theatre which is 'about someone I know' or which 'takes place in my town' or which represents someone 'going through just what I face' is well known to us. It is hard to escape the buzz that comes from such a moment.

If theatre is about communication, and if the very definition of theatre is the exchange that takes place between performer, text/narrative and audience, then it follows that a necessary central understanding is 'the who' of the audience.

As feminists and popular theatre workers (among others) have shown, the notion of a universal theatre, a theatre that one and all will find meaningful and affecting, flies out the window when one begins with *context*. Some of the questions related to context might start with: who is the primary audience? and, what could be meaningful to them?

As the context changes, so the codes and short hands one can use vary/change, be they theatrical coding or subject/content specific coding. So *context* will certainly impact *content*. It will also impact *form* and *process*. The 'popular' in popular theatre implies discoveries of theatre forms and processes which are context appropriate, forms which resonate for a particular culture, a particular class, a particular age, in short, within the *context*.

If instead of defining theatre's intention as one of 'communication', but rather as playing a useful role in a process of community education and development, then context takes on even more specific meanings and impact (although we would argue that all theatre could benefit from this analysis).

Context, the milieu in which the work is done, should influence intention. As the social, economic and political, as well as individuals' contexts change, so will the needs and so should the intent of a development project. What needs doing? should be answered by the community, from within their context. What is needed down the road is not necessarily needed here now; we are struck in this work by, on the one hand how much people find we have in common, but on the other, how much the nuance and indeed the analysis of what is needed - what needs changing, what is in the way of a better place to live, a better way to live - changes from situation to situation.

Bottom line. The context, the details of social, political, cultural and economic conditions, should and will change the way a process of transformation will unfold. And the theatre's role in that must change too. So theatrical process, theatre form, indeed each of the other factors we are examining here, will all be impacted by context, if facilitators allow it.

An impediment to this responsiveness is: theatre practitioners who are stuck in one process, one form, etc., so recreate the same formula no matter what the needs are. This recipe approach to theatre, to popular theatre, is hugely problematic. It defies the central reason for using theatre for change: theatre's creative nature, its transience,

flexibility, responsiveness, its 'liveness', its ability to reflect and embody cultural realities. The context in this kind of work should impact the type of theatre that is used, as it clearly impacts the long-term strategies of the development process.

As context clearly informs intentions, so too should it inform the kind of process, the kind of theatre, and the nature of the theatre event - the *who* as well as the *how*, the content as well as the form.

We come back to communication: just as significant development grows out of a radical two-way communication process, so does effective theatre. An aspect of the effort to create two-way communication is the attempt by one to notice the other, to speak *with* rather than *at*, and *vice versa*. Popular theatre seeks a way to invite people to speak *with*, and to encourage the 'other' to do same.

The Development of Popular Theatre in Britain

The 1970s in Britain was a period of recession as the consequences of the oil price restructuring began to be felt with progressive force as the decade wore on. The expansionist tendencies of the swinging sixties gave way to a more pragmatic approach in politics and culture. It became increasingly clear that most of the artistic innovations of the 1960s, particularly those of an oppositional nature, were funded out of the economic surplus of the boom period. When the surplus declined, much of the art declined with it since artists, companies and organisations had not found the means of surviving outside the framework of subsidy. However, this was a gradual process and the inertia of the previous decade enabled many organisations in the field of popular theatre to either continue or to become established during these years. At the very moment when companies such as 7.84 were launching their most ambitious plans and declaring radical manifestos, the Labour Government was putting itself at the mercy of the IMF and thereby exacerbating the social divisions which were to prepare the ground for the advent of Thatcherism. In a sense the base and the superstructure were now moving in opposite directions leading ultimately to a sense of betrayal on the part of those who felt that their Government had let down those sections of society which they had traditionally represented in favour of conforming to the agendas of big business and the global economy.

One of the areas in which tensions surfaced most obviously was in the struggle between local and national government in places where the local government fought to hold on to artistic programmes which represented or reflected the life of local communities. The community arts movement which had grown up towards the end of the 1960s looked to the more progressive of the local governments to maintain the commitment which had allowed them to develop the initial phases of their operations. As the grant from central government began to diminish, however, arts subsidies were typically one of the first areas to feel the cold wind cutting back at them. In many instances the companies in question happened to operate in the locality rather than being the cultural expression of local communities. Thus they did not have any roots planted in the community and did not claim an intensity of local allegiance necessary

to secure public pressure against funding cuts. The Arts Council and the regional arts boards applied criteria of so-called artistic excellence to justify funding decisions, largely without regard for any local factors, and most of the companies played into their hands by producing artistic policies and company strategies which mirrored those of the heavily subsidised national companies. The cry was, and largely still is, access to 'the arts'. There was very little interrogation of what constitutes appropriate artistic activity in a specific, local context. Audiences were still conceived of as passive statistical blocks to be performed to; markets to be opened up; consumers waiting for the commodity to penetrate to the remotest region.

The one sector which was characterised by an interactive approach to theatrical creation was the Theatre in Education movement. TIE was at the forefront of child-centred approaches to education which had gathered pace towards the end of the 1960s. Many regional repertory companies, following the lead of the Belgrade Theatre, Coventry, established their own TIE groups as the outreach arm of the theatre. Local education authorities, especially those with a strong group of advisory teachers in Drama, established supportive relationships with their local TIE companies and introduced the work into the schools of their region. Whilst most of this work was theatre generated by a professional company and toured to schools, the programme frequently included workshops where the children could embark on active exploration of theatrical forms as their own response to the play text or improvisation that they had just watched. The limitations on the influence of TIE were set by the pedagogic frameworks of the schools where all too often the performance was seen as a one-off event which was not bedded into the curriculum and where all drama activities were the province of the non-academic child; the poor relation to both other art forms and to the 'serious', formal areas of the curriculum. So, as with other areas of popular theatre provision, the inability to take root firmly within the communities it was serving was to prove fatal to the sustainability of most TIE activity when the funding support collapsed in the 1980s.

When the assault on social structures was conducted with growing force throughout the 1980s by successive Thatcher governments, popular theatre practitioners lacked both the economic and the ideological means to mount an effective resistance. Tory Governments set about 'cleansing' public bodies in the cultural sector such as the BBC and the Arts Council by vetting the senior appointments to ensure that no potential pockets of counter-hegemony were lurking within them as residual traditions of the 'radical' 1960s. Where they encountered the intractable obstacle of democratic structures in the case of local government of a different political persuasion, they simply reduced local government's sphere of influence by seizing their power for themselves, and by both reducing their funds and determining for what those funds had to be used.

According to the traditional British way, where politics and art do not mix, decisions about withdrawing funds from popular theatre companies were always made on artistic and never on ideological grounds. By reducing the monies available to regional arts boards and by ensuring that like-minded people are presiding over the disbursement of these shrinking funds, it simply becomes a matter of establishing

funding criteria which the companies you do not wish to fund cannot or will not meet; thereby destroying themselves through their own recalcitrance. John McGrath's 7:84 Scotland Company is the *cause célebre* of this phenomenon.[4] Similarly, no one had to declare ideological warfare against a specific TIE company. By removing the management of schools from local government and declaring them autonomous, it became impossible for all but an ever declining number of TIE companies to survive when representations for bookings have to be made to each individual school at a time when school governors and head teachers are faced with budget reductions. Those taking the financial decisions are unlikely to know much about the philosophies and pedagogies of Theatre in Education and even if they do would rather commit those resources to supporting a school play which can be used as a vehicle for marketing the school. Thus local management of schools becomes in reality Government management of schools; an apparent move towards more local democracy is actually the opposite - a device for achieving centralisation towards a normative, monochrome culture.

Britain in the 1990s was a difficult place in which to establish structures which permit popular theatre to thrive. The familiar established funders of arts activities at both national and local levels have neither the financial capacity nor the ideological will to pick up where they left off in the 1970s. The return of a Labour Government has had, and will have, no impact on this situation since it is operating within the same financial boundaries as its predecessor and, more significantly, it is content to occupy a centre ground in British politics which is in fact far to the right of what used to pass for the centre in former times. The experience of the mainstream of the population within the dominant ideology is of progressive fragmentation in the face of a global economy and a global mass media. Working and leisure institutions based on collecting social groups together in one place are being replaced by virtual reality interfaces between individuals communicating electronically from the isolation of their separate homes. In most walks of life career structures have been broken up in favour of the casualisation of short-term contract workers and free-lance consultants who are forever on the move to where the pickings are richest. In such circumstances the opportunities to create stable interest groups from which common artistic practices of self-expression might emerge are non-existent. The arenas for collective action have largely disappeared.

Where popular theatre programmes are still felt to be needed, however, is among those groups who stand outside or actively resist the material blandishments of globalisation. Today groups who work in popular theatre are to be found among those who are classified as 'other' - beyond the normalising pale of the dominant. Several groups work full-time in prisons and other closed institutions. There are theatre projects with the homeless, the mentally ill, asylum seekers and an infinite range of special interest groups such as those who have suffered a particular form of bereavement or are suffering from a particular illness. Work in schools does still continue, almost always related to an issue of social exclusion perceived to be a problem which popular theatre can help to address.

Two major challenges confront popular theatre practice at the turn of the millennium. Firstly, in operating on the margins of British society, whose interests do theatre workers serve? For instance, where a group is funded by the prison education

service is it understood that its role must be to make prisoners better able to deal with life on the outside by normalising them to its demands? There is a crucial issue of agency at stake here, especially where it is the aim of a given practice to hand over the means of self-expression to the client group. Capacity building and empowerment are the corner-stone clichés of this type of work but who is to say that some people experiencing the possibilities of popular theatre may not be empowered to develop an alternative to the globalised mainstream? The original opposition positions of popular theatre have an awkward habit of resurfacing at inconvenient moments to remind us of the contradictions within which we operate.

Secondly, there is the daunting question of fitting a popular theatre practice to the needs of the mainstream itself. As the economic forces which drive people towards anti-social individualism grow ever stronger, so the need for people to make communal expression of their humanity becomes ever more difficult to deny. As a species we resist at a certain point where our socio-biological imperatives are threatened. Some aspects of our being can only find collective expression and the mass media are not always a satisfactory means of achieving it. As sporting events continue to demonstrate, people need collective moments in which expressions of identity can be forged or reaffirmed. There are also more complex and sophisticated areas of collective expression which might be served by a popular theatre practice which is fully participatory and democratic.

In tracing the roots of popular theatre in a European country, it is a case of how far back do you want to go? Given our focus on contemporary activity, we shall restrict our contextualisation to the twentieth century while acknowledging the importance of earlier popular forms in the search for appropriate ways of communicating effectively to a wide range of audiences with very different experiences and expectations of the theatrical process. The early recorded examples of vernacular theatre such as the Mystery cycles already demonstrate the capacity of the popular to exploit opportunities inadvertently given by the dominant as in the case of the so-called Wakefield Master who used *The Second Shepherds' Play* to explore the possibilities of locally-based, topical comedy to appeal to an audience steeped in the realities of their immediate social conditions. The majority of the pageant has only tenuous allegorical connections to the official purpose of the Annunciation. Ever since, the boundaries between the popular and the dominant have been both shifting and hard to discern. It is often necessary to make a distinction between form and content since the performance conventions of popular theatre can be a more reliable guide to its distinctiveness than any radical content mediated by the theatrical conditions of the mainstream.

The distinctive feature of the popular theatre movement in the twentieth century in Britain, as elsewhere, was the way in which it became linked to wider political movements of the newly class-conscious working people. The working-classes had enjoyed their own particular forms of theatrical entertainment in the nineteenth century, notably the music-hall variety programme, but the purpose of this was primarily to offer an escape from the cruelties of existence rather than to mobilise for social transformation. As early as 1832 John Walker had written the Luddite

melodrama, *The Factory Lad*, which was performed at the Surrey Theatre, Blackfriars. Despite raising the very real problems of industrialisation and unemployment, the play concludes, in common with many others in the prevailing genre, by dissolving the contradictions in a flood of sentiment. The form of the melodrama was not equipped to address the issues of social disintegration raised by the content as Ibsen was later to discover in his own dramaturgy. Questions of form are frequently at the heart of debates on popular theatre for the style of the communication profoundly affects not only how a piece of theatre makes meaning for an audience but also what that meaning actually is. The debate about whether bourgeois forms should be employed by popular theatre workers (the new wine in old bottles that Brecht spoke of), is more than an argument about aesthetics. What is at stake is the whole agenda for popular theatre: whether it is used for a reformist or for a socially transformative role. The latter cannot be achieved by using forms which have themselves evolved out of efforts to assert the supremacy of one sector of society, the bourgeoisie, over the rest.

When the Workers Theatre Movement began in 1926 these issues were dominant among those who saw the radical potential of theatre in mobilising the working-classes towards the transformation of society. The ending of the General Strike was a watershed in the politics of the Left in Britain. The Labour Party was implicated in the compromise which brought the strike to a close and which was viewed as a betrayal by the Communist Party in particular, and the broader socialist movement in general. The political split is reflected in the two approaches to theatre adopted by the reformist Labour Co-op dramas on the one hand, and by the Workers Theatre Movement on the other. The Labour position is clearly articulated by Herbert Morrison:

> The modern working class is not waiting for well-to-do people, however well-intentioned, to uplift them. We are going to uplift ourselves . . . We are going to force the doors open, we are going to take our place at the feast of beauty . . . There will be an Art for the people, produced by the people, played by the people, enjoyed by the people, for we will not be content with the commercialised stuff of modern capitalist society.
> (Donoghue and Jones ctd in Samuel, MacColl and Cosgrove 30)

Notwithstanding the bold claim in the second half of the quotation, the metaphor is of an impatient worker knocking down the élitist doors of bourgeois theatre to be allowed to share in consuming the product on offer inside. The demand is for equal opportunities to enjoy high art. In both political and theatrical terms the result might be a fairer world but it could never have been a world undergoing a structural transformation. Morrison draws the traditional distinction between art, literally with a capital 'A', and commercial art products created for the mass market of the proletariat by unscrupulous capitalists. He does not conceive of a popular art form as such; a form created for the purpose of social transformation by those with the biggest stake in such a change.

The development of such forms was the province of the Workers Theatre Movement which drew its inspiration from the Communist rather than the Labour wing of the socialist movement. Instead of the moral propaganda of the Co-op dramas, a tendency

which is still evident in the contemporary New Labour Government, the WTM used the forms of agitprop that were in use in the USSR and Germany: expressionism rather than naturalism:

> We decided very early on that it was vital to know for whom you were playing, for whom you were writing, for whom you were acting. And for us, that was a working-class audience. They were our teachers and our inspiration. Nothing that has happened to me in the last fifty years has altered that belief. (Samuel, MacColl and Cosgrove 254)

Ewan MacColl's recollection of the starting point for this movement carries with it implicitly the issue of how the work is to relate to and be understood by a popular audience. At times frustrations were created out of a sense of preaching to the converted. Agitation played an important role in consciousness-raising but once raised that consciousness needed the chance to apply itself to the question of transforming society. The movement was less effective at producing works of propaganda on behalf of alternatives to industrial capitalism that commanded any degree of popular support and developed beyond the specific sectarianism of the British Communist Party. Brecht's theories and practices of dialectical materialism within an epic form were not generally known in Britain before the 1950s with the consequence that few alternatives were available to the topical, revue-type sketches of the WTM on the one hand and the prevailing naturalism of the formal theatre on the other. Those innovations which were exploited usually came from either Soviet models or the work of the Federal Theatre Project in the USA., notably the work of the Living Newspaper Unit which directly influenced Unity Theatre's 1938 production *Busmen*:

> *Busmen* turned out to be a unique contribution to British drama - an original Living Newspaper on an indigenous dispute written collectively with the help of those who had led the fight and presented in the most challenging theatrical styles of the day. (Chambers 140-141)

But by this time the Communist Party's decision to move from its coherent anti-capitalist position to support for a Popular Front against fascism was having repercussions in the WTM. The vision and clarity offered by Tom Thomas' leadership as exemplified in his adaptation of Robert Tressell's novel, *The Ragged Trousered Philanthropists*, for Hackney's People's Players in 1927 was cut off in its prime by the international political events which gave rise to the triumph of expediency over class-consciousness. Nevertheless in its brief existence (finishing in 1935) the Workers Theatre Movement offered glimpses into the way forward for a British popular theatre with the confidence to find its own style. Digesting the lessons of a tour of Germany, Thomas coined the slogan: 'a propertyless theatre for the propertyless class'. Others besides Thomas understood the need for a flexible theatrical form capable of going beyond agitation and were prepared to consider how pre-bourgeois forms of drama might be adapted to this purpose:

What the drama was able to do for the Catholic Church, the Guilds and the ruling classes, it can be made to do for the working class . . . No longer will it be confined to a professional clique, no longer will it be merely an entertainment. (Edwards ctd. in Stourac and McCreedy 201)

Thomas' theatrical vision was buried under the pressing demands for coalition and nationalism and was not exhumed fully until the 1960s when Brecht had been translated into English and the political mood was one of challenge and alternative. Today his words read almost like a premonition of the aesthetic manifestos of many of the alternative theatre companies from the period between 1968 and 1979:

I am convinced that 'agitprop' - for want of a better term - is a far more effective method of conducting propaganda and the workers' struggle than closed theatre selling tickets to members and friends . . . it can speak to people's own experience of life, dramatise their troubles, present them with ideas. It is mobile - it can be taken to the people, instead of waiting for them to come to you. And it is a theatre of attack. 'Naturalistic' theatre gives you the appearance of reality, but it does not show what lies beneath it. (Thomas 113)

Thomas articulates a key feature of popular theatre when he talks of the need to develop forms which take the language of theatre beyond surface appearances which tacitly endorse existing power relations in society. Popular theatre is a theatre for social change which is made by, and watched by, those who have a vested interest in change. It does not follow that the forms of bourgeois theatre are useless for popular theatre practitioners but it does mean that a new aesthetic had to be forged within which the theatre could be used to explore the dialectical, material relations that inform all human activity at the macro social level and the micro personal one. In fascist Germany all such explorations were banned after 1933 and in the Stalinist Soviet Union the official state aesthetic of Socialist Realism suffocated all alternatives and demonstrated what popular theatre practitioners such as Thomas and Brecht had already claimed, that naturalism was most effective as a form of propaganda for the *status quo*. In Britain the decision of the communists to join the Popular Front resulted in aesthetic compromises which led to artistic confusion. The demise of the Workers Theatre Movement and the increasing professionalisation of leftist theatres such as Unity thwarted the opportunities for a new, syncretic popular aesthetic to be established along the lines advocated by Thomas. Although the fresh shoots of the 1920s withered before the frosty blasts of nationalism which blew across Europe in the 1930s, they did not die. Their sap invigorated the next wave of popular theatre which was developed in the 1960s.

The crises and contradictions which emerged in popular theatre during the inter-war years are essentially the same ones that have had to be confronted in both Canada and Britain in the period since the war. Central among these is the tension between the demands of community development and those of the theatrical process. Related to this issue are the questions which surround the function of theatre professionals in community contexts dedicated to social transformation. Again the key question

remains: whose interests are being served through the theatre process? The question permeates every aspect of popular theatre; not only the interests of those who produce and perform but also those who make up the audience for popular theatre. Is there such a thing as a general audience for popular theatre or does it only happen in front of those who are already hungry for change? From the opposite perspective do different production standards apply to popular theatre from those used in the bourgeois version? The questions surrounding the search for an appropriate form which surfaced within the Workers Theatre Movement remain pertinent to this day; particularly the controversies associated with naturalism which intensified in the wake of the translation of Brecht's theories and plays into English. Can naturalism which operates as a tool for maintaining the *status quo* in the bourgeois theatre, be effective in producing images and situations within community contexts that delineate the contours of changes that go beyond reform into the realm of transformation?

The political climate was, however, very different during the 1960s. In Western Europe capitalism was booming and many of the artistic movements such as alternative theatre were sponsored by its excess. Consequently the financial base of the work was always vulnerable to a change in the economic climate. The recession of the 1970s gradually eroded most of the companies spawned in the previous decade. In Britain public money spent on the arts has always been resented by majority opinion which has for long been encouraged to regard the arts as mere entertainment without connection to human development or educational purpose. Ironically the very types of theatre which the popular movement attacked as either élitist or crudely commercial were responsible for creating the public attitudes which thought of all arts spending as a waste of money. However, some significant developments occurred during this period, especially among those companies which built on the aesthetic initiatives of the inter-war years.

Initially attempts to broaden the social base for theatre were limited to the playwrights and topics for plays still constructed within the framework of the bourgeois pro-scenium. But the new wine did not settle comfortably into the old bottles and the ambitions to social transformation of writers like John Arden and later Edward Bond were ultimately not able to be contained within mainstream theatre. The history of European theatre is strewn with examples of avant-garde performances which have broken the existing moulds of convention and provoked riots among bourgeois audiences such as Samuel Beckett's *Waiting For Godot*. In these cases yesterday's sensation has become today's orthodoxy. But in the instance of John Arden the relations of production on which the mainstream is founded were themselves challenged. The happenings surrounding the attempts of the RSC to stage Arden's and Margaretta D'Arcy's *Island of the Mighty* in 1972 (Arden and D'Arcy) led to their departure from English mainstream theatre and the decision to work with specific local communities in Ireland. John McGrath opted to leave a mainstream career in theatre and television to form Scottish 7:84 in 1973. Serious, politically committed theatre artists discovered at the beginning of the 1970s that it was impossible to work effectively within the structures of professional theatre which they had inherited. Different organisations and forms had to be invented or rediscovered from the roots of

earlier popular movements which had found ways of using theatre that were inclusive, participatory and capable of depicting realistic alternatives to the prevailing hegemony. However popular was coming to be defined, it was in the process of carving a distinctive identity out of what it was not: it was not a populist, an avant-garde or a political branch of mainstream theatre. It declared itself to be its own separate tree with deep indigenous roots susceptible to reinvigoration from foreign sources.

In the 1960s the major influences were two-fold. Firstly were the Marxist theatrical analyses of Bertolt Brecht with the crucial perception that education and entertainment were not mutually exclusive in the theatre; indeed he was firmly of the opinion that theatre only educated when it entertained. The British mainstream theatre took up Brecht's influence as a matter of style and technique, instantly divorcing the form from the political imperatives which gave rise to it. The result has been the erroneous application of the tag 'Brechtian' to any performance that eschewed the confines of a box-set and its naturalistic accompaniment. Secondly, the period saw the growth of a movement in critical pedagogy which influenced the work of many educationalists while generally failing to make significant inroads into the formal educational system. The period was rich in ideas for child- and student-centred education emanating from abroad and home through the theories of educationalists such as Ivan Illich and John Holt but the most important theorist and practitioner in terms of his influence upon the subsequent practice of popular theatre was undoubtedly the Brazilian, Paulo Freire, and in particular his book *Pedagogy of the Oppressed* which was published in English in 1972. Progressive teachers who were attracted by concepts of child-centred learning were drawn to using drama and theatre as the medium most responsive to strategies for empowering pupils with the confidence to take responsibility for their own learning needs and for enabling children from the whole range of educational achievement to articulate both knowledge and feelings in terms which were meaningful to them; in the words of Freire, 'naming their world'.

The 'as if' space of theatre was used to provide the bridge between the imaginative play area of a child's personal reality and the public arena where all too often the child is perceived as an object without rights conforming to the agendas of adults with designated authority over them. Some time before the work of Augusto Boal was known in Britain, the Theatre in Education movement was establishing itself as a significant manifestation of popular theatre that gave priority to various models of participation in ways which were to resurface across the globe in the guise of what is labelled today as Theatre for Development. The movement began in 1965 at the Belgrade Theatre, Coventry and from the outset the pioneers were on a mission to radicalise both the education system and the theatre:

> If we draw the conclusion that much of what passes for education and certainly much of
> our theatre has the effect of clouding over real and important issues, social, political and
> personal, of distancing our children from them, then the priority for the deviser in
> choosing the content for the programme is to take up those issues. It becomes the
> responsibility of the devising team to raise those issues in the forum of the programme in

a clear, accessible and meaningful way that avoids mystification and so does not fail our children. (Pammenter 61)

If there was a danger that Theatre in Education might have carved out a discreet territory away from other forms of community theatre in the 1960s and 1970s, that danger receded in the 1980s when the theories and practices of Augusto Boal became available to European theatre workers and the forms of the Theatre of the Oppressed were exploited alike for educational and community development purposes. Although many of his practices subsequently became unhelpfully fetishised as *the way* to organise participatory theatre, Boal's work gave an important common focus to a range of practices which have benefited from being subjected to theorisation. At the time of working on his Major Pedagogy prior to the Nazis seizure of power in Germany in 1933, Brecht was already working in practice and theory on the abolition of the bourgeois divide set up between actors and audiences. Twenty years before they knew of Boal, Theatre in Education devisers were working on programmes that had been researched with the client group and which attempted to put their experiences at the heart of the theatre process. But community theatre practitioners are notoriously reluctant to theorise their practice in written forms and Boal has performed an important service in offering his reflections on his own practice. He has demonstrated how the critical pedagogy of his erstwhile mentor and friend, Freire, can form the foundation for a set of theatre practices designed to empower the participants with both the consciousness and the opportunities to 'rehearse the revolution'.

We are One Tribe: the theatre company Blah Blah Blah and Eileen Pennington
Bridget Escolme

The eight-year-olds working in role as Celtic villagers with The Theatre Company Blah Blah Blah are not asked to try to understand the Romans who attack them. They are not asked to step into Roman shoes, to see the world from a Roman perspective, to take on the role of a Roman soldier obeying orders. They are one tribe, defending their village from Roman invasion. When they are defeated, they must try to win an enforced peace by maintaining as much communal dignity as possible. Throughout this four-part drama in education programme, identification with the tribe is re-enforced through language and ritual. There is a constantly re-iterated call upon tradition and loyalty. As an observer and participant in the programme I am disconcerted; my liberalism is disturbed. It seems at first that the children are not asked to analyse their behaviour as Celts. The necessity for violence is unquestioned; loyalty to the leader in the face of attack is not to be challenged. They *are* asked to analyse what they have done in terms of whether they were able to help, share, co-operate…conform?

During the sessions, I am absorbed by the children's own absorption. They are required to concentrate intensely and intensively on two things: the meaning of signs and the meaning

of their own behaviour. In the Celtic village, signs and rituals are more immediately present than in the children's own lives; behaving 'appropriately' may be a matter of life and death. *We Are One Tribe* explores how a community makes meaning and makes itself meaningful. As I watch the creative leaps being made by these children, I forget my initial disturbance, though I will return to this issue of conformity.

Blah Blah Blah have broken from their usual schedule of Leeds-wide and national touring of youth clubs, schools and community venues. For this project they have targeted *We Are One Tribe* at their own community, the Leeds housing estate where they have their premises. This participatory theatre in education project thus serves a dual purpose for the company. Artistic Director, Anthony Haddon:

> We were keen to work with an experienced Theatre in Education practitioner like Eileen as a way of developing the company's schools work. But having been based at the East Leeds Family Learning Centre, Seacroft, for four years, we also wanted to become a part of every aspect of this community, schools included. It's easy to see youth clubs as 'the community' and schools as outside agencies forced upon those communities. Despite the fact that many schoolteachers now live outside the areas where they teach, school is central to community life. Parents meet there, friendship groups form there and it is part of our role as a local theatre company to ensure that links are made between education and other aspects of local life.

Blah Blah Blah have worked with Drama In Education facilitator Eileen Pennington to devise a participatory drama programme which creates the history of a Celtic village and its battles against Roman occupation in four days. Actor-teachers, facilitator, children, school staff and observers all work together. It has an overtly educational aim: children learn about Celts and Romans. But it is essentially a piece about living as part of a community, the 'tribe'. The children have to decide when that involves conflict and when conflicts can be resolved. Anthony Haddon:

> The children take on the roles of the tribes people, invest in their traditions, their loyalties. But we are asking them at the same time to reflect upon the meaning of those traditions and loyalties. They have to take on board that these are people for whom it is sometimes necessary to refrain from violence when they are at their angriest - but for whom it is sometimes necessary to kill.

Closely linked to both the specific educational content of the programme and its underlying philosophy is a specific approach to the imagination. A crucial aspect of the accessibility of this work to eight-year-old children and intrinsic to its educational aims is the *materiality* of every aspect of the drama. Anthony Haddon:

> It is my belief that we are living in communities that are increasingly bereft of imaginative resources. To ask children simply to 'imagine' another community, another period of history may be unrealistic, when they may not have had intensive access to books, to complex systems of signs and symbols before coming to school. We wanted to present the young people with building blocks for the imagination.

At the end of each session, the children make simple written records of the work and a 'self-esteem exercise' takes place. Here the children choose three from a series of notices representing positive things they may have said and done during the session: 'I sympathised with someone...' 'I shared something...' There are many to choose from and again the emphasis is on the tangible sign. In the last part of the exercise the children are asked to pick one last notice stating whether they 'did their best' some, part or all of the time. Behavioural as well as imaginative abstracts are concretised.

Session One –Learning to Sign
The first task of the first session is to 'draw our swords'. The imaginative act of drawing a sword on paper is fed by suggestions from the actor-teachers. Histories of past battles fought by the tribe emerge, as we are encouraged to individualise our swords. We make marks along its blade and tell the stories of how the marks came there. Individual responses to the task become shared responses to an imaginative stimulus. One eight-year-old girl's first reaction to paper and pencil is the predictable: 'I'm not very good at drawing'. Within ten minutes she is telling the story of how she saved her family from the Romans. (It occurs to me how much more productive my hours spent in primary school making desultory decorations in the margins of 'finished' work might have been, had there been motivations found for the drawings. Here every jewel and carved line has a meaning, every scratch a story behind it.)

As the artwork is completed there is a complete change of tack. Eileen is telling us that of course our swords wouldn't be any use for fighting as they are made of paper. She shares a joke with the children at the absurdity of this, attempting to stab a child with a paper sword. We are to turn our paper swords into real ones. We look at our drawings long and hard, as we are to remember exactly what our swords are like when we come to pick them up. We hold them outstretched in our arms as the first of the many rituals begins. Eileen taps each of us on the shoulder. We turn away from the circle of children, the circle of the tribe, lay down our swords behind us and return, hand on hilt, ready to draw out the 'real' sword from its sheath. When we do so it is weighty in the hand, it can be raised, swung, replaced only with care and concentration.

I am struck firstly by the investment that is instantly made by the children in these 'real' swords. On the three occasions I witnessed this first session there was not a flicker of doubt in the face of a single child that these 'swords' represented something more real than the paper ones. There was not the slightest tendency to swing the sword wildly as we practised using it together. The resonance of the actor's voice as the transformation took place, the ritualistic slowness and the sense of witnessing something of real significance as each child replaced the material reality of paper with the imaginative reality of the mimed sword was the first of many moments when a real understanding seemed to have been reached amongst the group. It was becoming evident that as a group we can create realities that have meaning for us, that bind us in positive spirals of self-esteem and appropriate action. It was one of the moments of the drama where children described as having 'social and behavioural problems' took on an attitude of awed surprise, as if to say, 'look at us not disrupting the work!'

The emphasis on ritual pace and formality prepares the children for the task of creating a sword salute to their queen. Whenever they work in small groups on a task, the children

have an adult working with them to facilitate and deepen discussion. The drama they are asked to produce is always very short in time but profound in terms of its attention to the significance of every movement, word, change of stance. Anthony Haddon links this attention to signing in drama not only to the development of the imagination but to literacy skills, and eventually to much broader notions of political empowerment:

> The very fact that things stand for other things is an important concept to grasp at this stage in a child's development, a crucial step in learning to read. Then there's the idea that signs and symbols are *created*. Every aspect of culture is readable. The person or group who has created a cultural symbol, who has an interest in its meaning, may want you to read it in a certain way. Understanding that gives you critical distance, the ability to critique both the ideas imposed on you from outside, and the ones that seem a natural part of your own community.

At this stage in the work, the children's ability to use a language register appropriate to the formality of the occasion and the sense of history the programme seeks to evoke is limited. One group suggests, 'Hallo your majesty, we'll kill lots of Romans for you' as an appropriate phrase to accompany their salute to the queen. The suggestion is taken up and formalised through its use with the salute. Later we hope the suggestions will become more sophisticated. At this stage it is enough to invest 'Hallo…' with formality, to allow it to mean something more than a casual greeting.

The actors now take up the technique of creating through drawing. Again with ritualistic formality, they chalk on the grey floorcloth an aerial view of one of the village houses: walls, a gap for the door, circles to represent food jars and a fire. As the actors finish their drawing they begin to turn it into reality as the children have done with their swords. A splinter of a scene is enacted in which the villagers prepare for a Roman attack. We are invited to speculate as to what is going on here. The group is particularly responsive to the hiding of the animals - a flurry of cackling chickens and stamping hooves - and the actor who seems to play a younger role. This girl is caught playing with a sword, then runs back to the house as the family leave to hide something. There is an immediate recognition of the child caught out and sulking at the family meal. The link with the children's own position seems to open up new possibilities for speculation as they try to decide what she might be hiding. 'Something special to her', 'something someone gave her that reminds her of them', 'the only precious thing she's got'. The children are struggling not only to decide what a mimed object might be but also to decide what its significance might be, to an individual, to a society, to an era.

The last drama activity of the session is another group depiction, this time a frozen image of the tribe defending their village from the Romans. They must decide exactly what it is they are defending and how. The children are not to depict the Romans themselves, a rule, which conveniently reduces the temptation to come out of the 'freeze' and start the battle in earnest. This also reinforces the roles the children are to keep throughout the project, their sense of the community, of the tribe. When the depictions are shown to the whole group, the actors join them in role as Romans. It is another way of bringing a picture to life, of realising the potential of the children's signing. A Celt with her sword outstretched suddenly has a Roman on the end of it. Another has failed to see a Roman towering behind him, weapon at the ready.

By the end of the first session I had watched a group of eight-year-olds work with a concentration and attention to detail of which many would consider them incapable. They had begun to relinquish the rivalries and hierarchies of their classroom society and were beginning to become One Tribe. The success of the session can be measured by the delight and confidence with which they pick up their papers in the self-esteem exercise.

They were also beginning to learn that everything they did in the drama had meaning and could be 'read'. A community makes decisions about what objects, places and actions are of special significance to its people. They were learning that things can stand for other things and that human beings can make interventions into what those things are, their value and meaning.

Session Two – The Meaning of Death

The children enter their school hall for the second session of the drama to find three human figures cut out of paper lying on the floorcloth, each surrounded by an oval of bark pieces and stones. Each has a notice beside it. They read:

Nessan – A woman aged twenty-two, the wagon guard.
Gretorix – A man aged thirty, the carrier of the battle fire pot.
Cadwan – A young man aged eighteen, the queen's chariot driver.

Already eager to read the signs, the children watch as the actors place pieces of the cloth they have worn as Celts in the previous session over these bodies. They are intrigued by this graveyard and readily enter into a discussion of the Great Battle in which it is revealed that these three figures died doing a particularly brave deed. When they come to work in groups today, they are asked to link the figure in its grave with their speculations about the Great Battle. Pieces of text describing the battle, 'some things people said when they were describing what the battle was like' are there to help them. They will be asked to depict the moment of the brave deed their figure carried out using this range of stimuli.

The text is challenging, rich in metaphor. I imagine a work of fiction written for much older children:

> The ground throbbed with the drumming of hooves and the fury of chariot wheels as our line of chariots swept on toward the waiting lines of Romans . . . All along the line of battle the women were making frenzied efforts to turn the wagons around and harness the oxen . . .

The text is placed in three parts by each of the graves and thus becomes another sign ripe with potential for interpretation by the children. Many are unfamiliar with notions of ground throbbing or wheels being furious, even with the words 'throbbing' and 'fury'. They approach the text without intimidation, however. Words acquire the same status as drawings and objects on the floorcloth; they are read then made 'real' through dramatic depiction. As we work on the frozen images of Nessan, Cadwan and Gretorix's brave deeds, I remark to one child that his warrior looks nervous. His friend suggests that this might be his first battle, that he is determined not to fail his more experienced brother who fights alongside him. The children are able to move with ease from text, to visual image, to ideas that clearly come from their own experience of social life. As they create the life experience of the Celtic

warriors, the children are also having their own experiences transformed into readable symbolic objects.

The children make a second depiction of what might have happened two minutes later. They move from one to the other, first in slow motion and then in 'real time'. Each child then adds one line of speech to the depiction, thus creating a tiny moment of live action from the Great Battle. Our three figures have fought bravely, often single-handedly, to defend the young, the injured and the things the community holds dear.

At this point Eileen begins to use the language of television and video; she speaks of rewinding and playing back, of pausing at the point of the frozen image. At first this jars, though I am sure it will seem perfectly natural to the children. The drama teacher in me wants the children to appreciate the power of drama as something quite separate from the screen images that impinge constantly and unchallenged on their lives. However, referring to the work as if it were a video film gradually begins to have the effect of transforming the television form rather than reducing the drama to an easy realism. We are beginning to treat television as the sign system it really is. It can be made to yield up its meanings frame by frame to those willing to go beyond the everyday acceptance of the medium's 'realism'.

The tiny scenes are re-enacted for the whole class - and the whole village - with an intervening chorus: 'All these things happened on the day of the Great Battle.' Children's individual contributions are made part of the village's history.

We return to the gravesides where the children are permitted to question the actors in role as the spirits of the three warriors. Eileen has explained that the graves cannot yet be filled in, as jobs related to the burial rites have not yet been completed. Many of the children seem quite overawed at the prospect, even though they have just been working alongside the actors as equals. Some find it difficult to conceive of a notion of an afterlife that does not consist of the Christian heaven and hell. I observe Nessan fielding questions about the long journey that she says lies ahead of her in the other world. 'Why would you need weapons? No one can hurt you now you're dead. Why would you need food in heaven?' Gradually the children understand that they are dealing with a different belief system. They offer bread and meat, chariots and swords. The funeral rites of the three warriors comprise laying in the graves the chosen offerings. For some, this part of the drama has been difficult: 'You can have my bike' is one startling offering in a session, which until now has been anachronism-free. Nevertheless, all complete their part of the ceremony with the appropriate solemnity. They have explored the meaning of death in this community with what is once again a surprising maturity.

The self-esteem exercise is done with the whole day in mind today. It seems we are not aiming to reinforce positive behaviour during drama projects only!

Session Three – Signs of Self-control

This session takes place in the morning and the children are asked to do the self-esteem exercise before starting the drama. At first this is baffling to some. How have they had time to do anything positive when they have only just got to school? The adults encourage them to think of moments at home getting ready to come here. A sense of delight pervades the hall. Parents and siblings have been helped, sympathy shared, tasks undertaken. It is possible, to borrow from Lewis Carol, to do three good things before breakfast. A child who

has entered the room angrily insisting that he will not participate because he has hurt his arm forgets he had ever considered dropping out.

Today we meet the Romans. The children speculate as to the meaning of a frozen image. The Roman governor of Britain, Ostorius Scapula, stands reading in a room in his home while a Roman woman looks on and a man in Celtic dress sits writing. Once again there are notices to read:

> I am Ostorius Scapula. I am the governor of Britain. I give orders to everybody in Britain, and I can do what I like.

> I am Caradog. Before the Great Battle I was a prince. Now I am a slave. I have to do as I am told all the time.

> I am Julia Sulla, a Roman lady. I am rich and beautiful. This is my first visit to Britain. I treat slaves with respect if they do as they are told.

This is the session of the four in which the children have to do the most watching and listening. There is speculation amongst the actor-teachers as to whether they are asking too much of an eight-year-old concentration span. In fact, of the sessions I observed this elicited the most investment and concentrated attention.

Referring again to the piece of action as a video film, Eileen stops and starts it so that the children may offer their speculations as to its meaning. The piece depicts a tense moment of subtle bullying as Scapula forces Caradog to drink. The children instantly recognise it as an instance of subtle bullying. It is distressing to note the familiarity of such a scene to many of them. As she stops the 'video' Eileen encourages the children to note every detail: the smile on Ostorius' face, Caradog's clenched fists as he struggles to remain civil. It is this struggle to remain civil that becomes the focus for the rest of the session.

Ostorius clearly holds the villagers in contempt: 'Smelly, dirty creatures all of them.' The children's affronted faces are affirmation of their belief in their roles. Eileen introduces a tension. If Ostorius comes to our village to collect our swords, how will we resist risking our lives by responding to his insults in kind? She practises receiving Roman insults. The adults in the group are invited to read such gems as 'Your sword's too big for a kid like you, stick to your toys!' and 'You'll never fight again, British pig!' The children both enjoy and are shocked at the insults, gasping and turning to check their teachers' responses to any that smack of racism. Their task is to decide what they would say in response to such an insult that would not endanger their lives when surrounded by Roman troops. Again a ritual is created as small groups speak their response. It is an extraordinary exercise in subversion and dumb insolence! The just-concealed sarcasm of a series of choruses politely accepting each Roman insult makes this more than an exercise in turning the other cheek. It raises questions of how to deal with no-win situations with dignity, how to remain calm under the stress of losing and live to fight another day.

Eileen acknowledges that the Celts may be harbouring quite other thoughts from those expressed in their tactful responses to the Roman insults. The children take great delight in suggesting what those might be and the adult with each group expresses them as a 'thought

track' the second time we run the insult exchange. Eileen as Roman throws her insult; the chorus of polite responses is followed by the concealed thoughts of the group. In terms of behavioural analysis, the message is obvious: it is possible and often tactical to conceal one's anger. Having explored the signing nature of text, the children are also being introduced in a simple and tangible way to the notion of subtext.

The session ends with a promise to our queen that we will hand in our swords without life-endangering angry outbursts. The promise is made together and the chorus is deafening.

Session Four – A Moral Victory

By now, the class is expert in reading signs; today they are presented with a glass drinking vessel, a stone pot of 'mead' and a notice which reads:

> We call this blue glass drinking vessel the Cup of Friendship. We drink mead from it together to promise we will always be friends.

Having brought their paper swords from session one they take them from the folders in which they have been keeping their written records and self-esteem notices and place them around the room. Today the swords are to be handed in to the Romans. We discuss alternatives. Could we perhaps hand in old swords, spare ones, broken ones? Groups work on what they will do to disable their swords and what they will say as they hand them in. Each sword is torn with loving care and placed in the cart. It is as if their destruction has made them more valuable, assigned the sword a real part in the drama.

The actors playing Ostorius Scapula, his regional governor and the tribe's queen enter through the gates the children have drawn. The tribespeople relinquish their swords with a dignity noted even by Ostorius and the queen offers him the Cup of Friendship. Eileen freezes the moment. Will he or won't he take the cup? The children's responses are sophisticated and there is no sense of a general opinion that all feel obliged to follow. He may take the cup 'because he's signed a peace treaty…because he wants to look good…because he's got all the swords now' or even, in a burst of class analysis, '…because he rules people and she rules people so they might have a drink together…' He may not take the cup 'because he doesn't really care about them…because he's just going to fight them again one day…because he's got an attitude problem!' He does not drink.

The children are permitted to question Ostorius. Perhaps this is too soon after seeing him in action in the drama; many seem somewhat overawed by the prospect. Gradually it emerges that Ostorius cannot promise to keep the peace. A public drink from the Cup of Friendship would seal a commitment he cannot make.

Our last contact with him is on paper as we write around pictures of the Roman governor exactly what we would like to say to him. At first the insults flow thick and fast; one boy who has mouthed 'cheeky bastard' in response to one of Ostorius' answers looks a little nervous for fear he will be asked to repeat the phrase for his teacher. (He is not.) Then more subtle analysis of the man's deceit and selfishness creeps into the phrases that the adults inscribe around the picture. We place the paper insults around Ostorius' red velvet cloak and feel we have left our mark.

The story of the tribe is at an end. We place our hands on the queen's sword and swear to keep the peace unless the Romans should break their promise and attack. The self-esteem exercise takes a good deal of heart searching today. Children I would have expected to run straight to the card marked 'I did my best all of the time' want to take time to choose the one that truly reflects their sense of their own achievement. There is an enormous sense of self-satisfaction amongst the children, a sense that a moral victory has been won. It is the class's victory, in the concentration they have invested in the drama. It is the tribe's, in maintaining its self-esteem before the bully Ostorius. A class that according to its teacher has fundamental social problems seems, at least for today, to have become One Tribe.

I do not come from Leeds and have never lived on one of the East Leeds housing estates in whose schools *We Are One Tribe* took place. It is difficult to comment upon the problems of self-esteem that might arise for children in this community, without resorting to easy clichés about life in the inner city. Tower blocks and boarded up houses that might support the clichés contrast with the efforts being made to support self-esteem in school. Successful work adorns the entrance halls; each staff member we meet shows a detailed knowledge of each class member. I have observed many teachers struggling to raise self-esteem, where society tends to equate it with the acquisition of things, rather than with a sense of being a valued member of a variety of communities. I have also watched a few teachers for whom that struggle has been lost, resorting to tactics of bullying and belittling to maintain order in the classroom.

We Are One Tribe allowed each child to experience being a valued member of a community. It went further, in exploring how a community creates value through its rituals, its art, its stories. It tackled the issue of 'behaviour', not shying away from the fact that, in every community, we ask children to conform to certain norms which that community regards as desirable, sometimes life-saving. The participants are asked to examine, to 'read' at every turn the conventions of narrative and behaviour presented to them. Children who experience this kind of work in their schools are surely being helped to question the norms of society as well as being taught how to move at ease within it?

How far will the children take their experience of being part of the tribe into their wider community? The stereotypical inner city community is one where tribalism rules, creating class, racial and inter-generational tensions. However, many children in Britain today may have little experience of belonging to a group with a strong history and local tradition. I do not think it is idealistic to imagine that the project will stimulate a search for communal ties and co-operation amongst the children it touched, as they grow up. Moreover, teachers told me that some of the more 'difficult' children had experienced a new found sense of success, of self-esteem, of inclusion that I hope will stay with them. But creating high self-esteem and a sense of belonging in the wider community is clearly a larger project than can be covered by a four-week programme in schools. At the time of writing it is a while since I have heard a British government spokesperson using the catch phrase 'the stake-holder society'. Maybe it is still a notion they are interested in promoting; community theatre whose content is the community itself could certainly explore what each member's stake might be.

Finally, I return to the issue of conformity. Can the role of theatre in the community be both to promote social cohesion *and* encourage political critique? 'Fitting in' promotes self-esteem, but do we want to create adults who are happy to fit in? Anthony Haddon:

In this drama, each child has a place in the imagined society; at the end of each session each child takes home concrete records of the contribution he or she has made. I want children like this to demand a place in our society as they become adults, to demand the recognition they deserve and which we have been able to give them in the few hours we spent with them. I don't know if our society is ready for children with that much self-esteem.

The Development of Popular Theatre in Canada

Popular theatre came to Canada in 1978. At least that is when we learned the term. Some of us discovered that that was what we were already doing, some of us heard that we were 'almost' doing it, and others of us were challenged to reconsider how and what we were doing. Who was 'we'? It was the group of theatre workers and artists who were creating theatre which concerned itself with Canadian themes, with Canadian social issues, with theatre as a social tool, with theatre as an educational force.

Why 1978? That was the year that Ross Kidd, a Canadian adult educator who had been using theatre as a development tool in Africa, 'came home' and started finding out what Canadians were doing in this area of political and social drama. He called it popular theatre. And he challenged us to take a deeper look at what we were doing and why. He worked very hard, in Canada and around the world, to encourage and critique popular theatre, his own and others', to push people to deepen the work, and to link people with an interest in theatre to those working in the community education and development fields.

In the fall of 1978 a number of people involved in such work gathered in Newfoundland. The occasion was Ross's visit; the hosts were the Mummers, a company which created a number of 'protest' collectives based in Newfoundland culture. Their recent work had included building a piece which contributed to a protest to save fishing village(s), to protest appropriation in the name of Gros Morne Park, and work developed in the downtown St. John's housing movement. There was much debate about the work, about all of our work, its intentions, the way we organised ourselves, etc.

Later Kidd toured the country with Ngugi wa Mirii. Together they offered workshops and gatherings an introduction to the kinds of theatre for development work they were pursuing. They taught us songs, told us stories, described living conditions of people with whom they worked, showed weavings from community-based arts co-operatives. In each community these sessions offered a gathering point for many artists both peripherally and deeply involved in social drama. In some centres it brought theatre artists interested in social and collective drama together with people from adult and development education agencies, sometimes for the first time. Some alliances were made. Some differences were defined.

In fact, popular theatre, in its contemporary manifestation, grew up in Canada as a result of a number of conditions and initiatives. In the late sixties this country's nationalism grew; the impact in the theatre world was that companies grew up that

were dedicated to producing plays about this country, they were sick of imported theatre which told stories, true and untrue, that were placed in England or New York. Canadian writers started writing plays about this country, but not fast enough to feed the nationalistically spirited theatre community.

Some groups, most notably Theatre Passe Muraille, directed by Paul Thompson, started researching specific communities and creating plays collectively. *The Farm Show*, first produced in 1972, and the many collectively created shows about specific communities which followed, offered stories about communities which never before had appeared on our stages. They also offered a non-linear form of theatre, since called the 'collective documentary'. The form reflects the process: a number of people research with people who live in a particular community and bring back characters, stories and scenes, often improvised, to the group. Eventually these scenes and characters are linked together theatrically, but not necessarily narratively. The result is a fractured structure which often employs a multiplicity of theatrical styles and which conveys a multi-voiced image of a certain community. They are often a celebration of the community; note is taken of certain characters' political or social views, sometimes varying points of view are expressed, side by side, but on the whole the pieces are empathetic evocations and celebrations of a particular community and way of life. In the early days of the collective, this was seen as both a political and artistic act. Canada was trying to find its own identity, separate from its powerful southern neighbour and separate from its largely British heritage. It was 'radical' to elevate our citizens, our neighbours, to the stage.

Of course predating and paralleling these events, others, many of whom were part of the radicalised youth movements of the late sixties which were very much in evidence across American and Canadian campuses, were exploring theatre as a tool for political action. Many recall agitprop theatre work which was created for protests and rallies.

Predating these events were several significant adult education and community development initiatives which provided models for development efforts in other parts of Canada as well as internationally. The Antigonish Movement, extension work which promoted co-operative organisations in economically depressed areas in northern Nova Scotia (Coady; Stabler); *National Farm Radio Forum* and *Citizen's Forum*, aimed at developing fuller participation in decision making (Selman et al.); and the National Film Board's *Challenge for Change* programme, which used film and later video in assisting communities to present a community view of itself as part of a community development process (*John Grierson Project* 1984), are all examples of Canada's long standing commitment to local involvement in community change. The growth of popular theatre activity forms a part of this picture.

One of the further developments of the collective was led by David Barnet (who is based at the University of Alberta) and some of his senior and ex-students. They applied the research methods of the collective documentary not to geographic communities, but to communities of social concern. Early projects included work with Edmonton's Rape Crisis Centre around issues of violence against women and with Alberta Alcohol and Drug Abuse Commission in the creation and performance of

Drinks Before Dinner, a play about alcoholics and their families. These plays were performed first for the people and agencies with whom the actors researched, and later for a wider public, many of whom confronted these issues in their daily lives. The partnerships with agencies that work on a long-term basis with these issues, in some cases, led to integration with ongoing public education and development programmes. The level of impact on development, the kind and level of analysis imbedded in the theatre piece, and the ongoing programming was highly influenced by the partner agencies. This theme continues throughout the story of popular theatre. One of the critical questions in evaluation of popular theatre remains the level and kind of analysis brought to bear by the facilitators, the funders, community programmers and artists, as well as by the 'community'.

A significant contribution to popular theatre process which this work made, was to deeply integrate a *checking back* with the community during the period of creation. As with many collective theatre processes, Catalyst Theatre (which the Alberta group soon came to be called) actor/researchers conducted community research, created theatre out of such research, then took it back to the community while it was still very much in development, to be checked, changed and deepened. There was an assumption that the work *would* develop further, would be altered, because of this mid-creation communication. This process of exchange, initiated by Barnet and his group, was central to the ethical relationship of performer to community. It was later extended and adapted as the company moved from 'theatre for' to 'theatre with', then to a period of theatre making which was increasingly 'theatre by' the people.

Imbedded deeply in such collective theatre work is an abiding interest in the humanity within an issue or community. One of the biases of theatre is to throw focus upon individuals and groups of individuals; the actor is interested in expressing another human in all their richness. One of the strongest elements in such work was a respect of actor for character, and largely, a respect for the community it theatricalised. On the whole, these pieces showed (and still show) a high level of commitment to honest and respectful depiction of people and times. On the other hand, one of the weaknesses of such work seems to be that often a point of view was avoided or not discovered. Critical analysis was not sought so much as the multiple stories which in some way added up to an impression of 'the story' of a community.

A possible early exception to this apparent hesitation to build an overtly activist perspective into such theatre is to be found in one of Canada's most enduring collective creations, *Paper Wheat*, created in 25th Street Theatre of Saskatoon. It chose to focus its collective research upon a specific and broad based community concern, the formation of the Saskatchewan Wheat Pool. As a result, this play showed a greater political focus and agenda than many of the 1970s and early '80s collectives. While still multi-characterised and segmented in structure and style, it has a unity of subject and a clearer point of view than many. The *Paper Wheat* example, however, raises one of the key areas of consideration for popular theatre: context. While the play argues, in a highly effective theatrical way, for the community based collective action of farmer controlled management of grain sales, the piece, when played years after the point of crisis or communal decision making, functions ultimately, as do many collectives from

this time, as a celebration of prairie life and a nostalgic evocation of a moment of drama and unity in the Canadian prairies. This is not to dismiss this significant theatrical piece, one that evoked strong reaction across the country, but to raise the notion of context as an important aspect of any look at the popular theatre movement. The story of this remarkable piece of Canadian history raises the question: can the celebration of remembered events indeed be a political act?

Another aspect of the influence of documentary theatre on later work was in the area of form and style. Often the documentary collective that gave itself to a community based research process led to a Brechtian sense of characterisation. The style was supported by the performers, the dramaturgy (dramatic structure) and the overt theatricality which was favoured. The actors could be seen to be 'offering' the character to the audience. Actors played more than one character and audiences were made aware of that overtly; they changed roles often and quickly and usually right in front of the audience. Further, texts often incorporated the act of personal research into the story; a performer might say: 'I was walking along the river one day when I met . . . and this is what he told me'; actor transforms into character and speaks the story as it was told to him/her. The process is revealed, and the debt to the community member is acknowledged.

Many of the collectives attempted to find theatrical metaphors for the community, issue, or facts they wanted to convey. In *Paper Wheat* we saw two tap dancers, each with only one shoe on, 'discovering' that together they could create a tap dance just as together farmers in Saskatchewan could increase their power through the co-operative movement. In *1837: The Farmer's Revolt*, a play about that previously little known piece of Canadian history, we saw five actors create the largest talking head you ever saw, the head of a politician. And in *They Club Seals, Don't They?* Department of Fisheries' methods of determining the seal population were satirised in a scene full of tall stacks of dishes, where each stack, according to the 'buffoon government man', counted as 'one' instead of 'fifty'.

These overtly theatrical methods supported and provided ways for the theatre, which in some cases was going to develop into popular theatre, to make use of popular forms (the square dance, the narrative ballad, Bingo, etc.) within the drama, to use them as metaphor and as a way to encompass local culture within the plays.

They also provided ways for 'non actors' and 'non writers' to start to create their own dramas. The collective documentary is now commonly seen in youth drama programmes; sometimes these are fictional creations, full of imagination, highly influenced by mass popular culture, and sometimes these deliberately reflect youths' day-to-day experiences. We also see its very effective use in certain aspects of popular theatre, where specific communities create their own theatre based in their own stories and concerns. The short scenes, the collage approach to dramaturgy, the segmented structure and the use of non naturalistic, sometimes metaphoric scenes and structures all allow for the relatively uninitiated to create usable and entertaining theatre.

Within only a few short years such processes were reapplied to popular theatre. Marginalised groups celebrated their community and protested treatment by others (Tununiq dramatised Inuit history in *Survival*); others spoke through their theatre to

those closest to them (native youth dramatised their lives and their dreams to their peers and elders in plays created at Saskatoon's Native Survival School); communities reached out with their stories to the broader community (Puente Theatre's *Creating Bridges* played out Latinas' emigration/immigration stories).

Another set of ideas was having impact. There was a political movement going on in North America which led to another set of collectively run theatre companies. Groups, such as Tamahnous Theatre in Vancouver and Mulgrave Road Coop in Nova Scotia were working collaboratively and collectively, not necessarily in response to the desire to represent Canadian stories, but because of their political and economic beliefs. I remember one member of Tamahnous claiming that they could be doing anything, running a grocery store or a theatre - the point was that they were operating collectively and that this mode of working was a political act, a restructuring of how things could be done. And organised.

So, on one hand plays were being created collectively, on the other, organisations were being created to operate collectively. Some organisations tried to model a more egalitarian way of structuring themselves. Others were focused on new ways to make theatre, but not necessarily on a new economic or political model. The debates around such issues were heated.

One result of the Newfoundland meetings was a commitment by Michael Sobota of Kam Theatre in Thunder Bay to host a festival of such work. Two and a half years later, in 1981, the Bread and Circuses Theatre Festival took place; it was the site of the founding of the Canadian Popular Theatre Alliance.

This event was the start of a series of biannual workshops and festivals that hugely influenced many of the people pursuing popular theatre in Canada today. Every other year familiar faces and new ones would show up, some to show theatre pieces, albeit out of their contexts, some to debate, argue and meet with people struggling with similar issues, some to offer and take workshops in topics of interest to those pursuing collective, community and popular theatre. Each festival took on its own specific focus and in many ways marked major stepping stones and points of change in the fast developing journey of Canadian popular theatre. And every Festival included the participation, to some degree, of popular theatre workers from the south. Via these festivals, and the following workshops and tours, which often came about as a result of the contacts made during these festivals, Canadians were hugely influenced by cultural activists from many parts of Africa, Central America, the Caribbean and Asia.

The Bread and Circuses' Thunder Bay, 1981 was the first major exchange between international popular theatre workers and Canadian theatre makers. Prior to the Festival there was an intensive ten day popular theatre workshop which examined the politics and economics of food. Through the efforts of Ross Kidd, as well as the Kam Theatre hosts, twenty practitioners, roughly half Canadian and half people from or with experience in working in the south, struggled with theatrical form, analysis which links southern and northern concerns and very disparate definitions of 'workshop'. In some ways, this misunderstanding and debate about the nature of 'workshop' tells all about this stage of the Canadian story. Canadian organisers had defined 'workshop' as a closed and essentially theatrical experience, an encounter between theatre workers from around

the world; the topic of food was chosen to focus the work and to allow for international links to be expressed via the theatre we made together. 'Community research' was planned as a series of brief interviews and visits to food outlets. On the other hand, many of the southern practitioners expected ongoing interaction with members of the Thunder Bay community, particularly those living in poverty. We would learn from and contribute to these groups and ideally the theatre workshop would be part of a process of analysis and action planning for community groups in Thunder Bay. To be a bit reductionist, Canadians expected to work on theatre process techniques, largely in the safety of the rehearsal hall, whereas our southern colleagues expected to be part of a political action and to work in solidarity with socially and politically progressive organisations, with 'the people'. The debates around this gap of expectation were hugely informative, and certainly challenging to the Canadians. The nature and ethics of effective community research, and the potential for social action within and as part of that process of research was underlined and, for some, discovered, during this encounter.

Of course other factors were at work. To my middle-class, white, female, northern eyes this international crowd was very male (entirely), very patriarchal, was dominated by the white men in their group and was very convinced that they had the answers. It was tempting to dismiss much. However, what remains dominant for me, almost two decades later, is that the experience was perhaps the most deeply challenging professional experience of my life. I could not look at my or others' work in the same way again. For me, theatre was redefined: as a political *process* within community, as opposed to, to be simplistic again, a well-intentioned expression of a community's social issues.

I think that many of us learned a lot, especially about the values of the use of narrative in exposing social contradictions, very significant to those of us working in the collage forms of the collective documentary. This powerful form, the use of story, the creation of narrative which enacts and reveals contradiction, remains central in much Canadian popular theatre work. It remains the skill most needed and perhaps least understood in creating truly provocative work; its lack is the source of much mediocre work, both presentational and participatory; its application moves much well-intentioned work out of the realms of naturalism and soap opera and into the realm of realism which exposes disabling social dynamics and asks hard questions about where our communities might move.

During this workshop process we worked beside facilitators with very strong political agendas, agendas that were pursued vigorously - analysis was shaped to reveal their economic and political points of view. This approach to animation raised ethical questions; Canadians, steeped in the tradition of 'deep listening' for well-intentioned evocation of community members' characters and stories questioned this overt manipulation; the 'neutral' animator was seen on one hand to be an impossible feature, whereas the cost of the 'biased' animator was seen as leading to one or all of: simplistic agitprop, a lack of respect for others, and the missing out of community story debates. Culminating projects ranged from bald agitprop pieces about power and corruption to narratives which were used to highlight choices and contradictions in bids for development, personal and national.

We also gained an appreciation for the meaning of making international connections. This is a major element in the story of Canadian popular theatre development. Be it via participating in projects or workshops in other countries or sponsoring and attending festivals, workshops and performances in Canada where popular theatre workers from other contexts performed or facilitated, the influence of the 'south' on, I would say, most people deeply engaged in popular theatre work, is huge. Skills, politics, dilemmas, analysis, process and form have all been hugely challenged and impacted via international encounters, as have our understandings of the links and relationships between north and south.

Joe Ruglass, from Jamaica, composed a song, whose theme, in addition to evoking some of the workshop participants' global aims, also rather speaks to the impact of this exchange on many Canadian theatre artists. It was called: *Turn the Whole World Bottoms Up.*

The Festival itself brought together many theatre artists from across this huge country, many with shows depicting stories from specific regions. The festival featured lots of short skills workshops, searched for but did not find a way to enable effective critiques of the productions presented, and led to the formation of the Canadian Popular Theatre Alliance. Much intense debate led to a founding document. The principles ratified were:

> We believe that theatre is a means and not an end. We are theatres which work to effect social change.
> We see our task as an ongoing process in which art is actively involved in the changing nature of the communities in which we live and work.
> We particularly attempt to seek out, develop and serve audiences whose social reality is not normally reflected on the Canadian stage.
> Therefore our artistic practice grows out of a social rather than private definition of the individual.
> Therefore there is a fundamental difference of purpose, priorities and aesthetics which separates us from the dominant theatre ideology in Canada today.
> (Canadian Popular Theatre Alliance, *Statement of Principles*, May, 1981)

The debates focused upon a worry that the principles imply that companies with a commitment to community in the form of traditional seasons with collective and playwright driven pieces about their lives, etc. could be excluded by this document. The desire, need and strength in telling local stories, in the celebration of local stories and local culture; suspicion of a restrictive demand for a radical, overtly leftist political stance in all work; a 'health' clause was proposed. Many humanist stances. Very Canadian. And such groups were hungry for a home, for a core of support, hoped this was it; artists had opted out of the mainstream regional theatre season to do such local work and were now being questioned regarding the right to belong to this fledgling organisation. Arguments centred around inclusivity versus principled commitment to social/political critique.

Each of the biannual Canadian Popular Theatre Alliance festivals was vastly influenced by the local organisers' bias and intention, and also by the usually intense reactions to the previous festival, its perceived message, focus, strengths and weaknesses.

Bread and Roses, Edmonton, 1983 responded in many ways to the debates of 1981. Again a pre-festival workshop was organised, this time at the nearby native reserve, Hobbema, selected because of Ross Kidd's association with Darrell Wildcat, a theatre worker and member of the Hobbema community. Attendance was very restricted and by invitation only; most participants were from Africa and the Caribbean and the focus was on engagement with that community.

The Festival itself involved more intensive and longer-term skills workshops, in recognition of participants' desire for training and skills exchange. Performances were not dominated, this time, by collectively created community stories. The shows included: the first forum theatre piece to turn up at a Canadian festival, presented by the Québecois Theatre Sans Detour and joked by Lib Spry, who has played a significant role in Canada's popular theatre training, advocacy, and theatre creation throughout these twenty years; Theatre Parminou's play, which used grotesque theatre form for political satire and commentary; *Sandanista!* by the Great Canadian Theatre Company which was the result of documentary research in Nicaragua and a good example of the theatre company and development agency partnerships which were starting to happen; Stephen Bush's *Life on the Line*, an alienated worker-focused solo piece whose form seemed Grotowski influenced, where the interior life and struggles are revealed in physical and metaphoric staging. And more. It rained non-stop. One performance venue leaked. An art show brought from Panama curled in the damp. No one knew in advance about a promise of per diems for international guests. It was great.

But some significant companies were not back, likely as a result of the perception of exclusion which the founding principles espoused. And some companies that were represented did not perform; they were doing work which could not be taken out of context and plunked into a festival setting. For example, Catalyst Theatre, the festival's host (this writer was its artistic director at the time) was doing highly participatory theatre work with specific communities, such as *Stand Up for Your Rights,* with mentally handicapped (as the term was then) adults and *It's About Time* with prison inmates.[5] We were not prepared to create a voyeur Festival audience for a community audience and we wondered how to represent and exchange about this work with others.

The Festival format had its drawbacks, and I think the problem of trying to really get down to healthy debate about the work was never solved over the years. Throughout the festivals, some work was misunderstood when seen out of context; other work was manufactured for the festival. In my view the work that (unfortunately) suffered most when brought to festivals was the work created and performed *by* communities. These shows tended to suffer most in translation. When out of context, their theatrical and performance weaknesses suddenly mattered much more than when the *who* was performing resonated with the *who* that was watching

and listening. And discussions at several festivals got bogged down in false 'quality' and 'excellence' critiques. Ultimately, the only work Festival audiences could actually *see* was that which was indeed created with a general audience in mind, when a bridging function between a specific community's experiences and a general public was intended.

Bread and Dreams, Winnipeg, 1985 again featured longish workshops, but they were more centred in an effort to exchange and offer skills within the Winnipeg inner city context; they were for community members at least as much as for the visiting theatre workers. This festival was the first to feature performances created and performed by Canadian community members, rather than by trained actors; for example, teens from Saskatoon's Native Survival School performed a collectively developed piece and plays by specific immigrant theatre groups were represented. Margo Charlton, festival organiser and director of Popular Theatre Alliance of Manitoba, encouraged a high level of participation by those involved in community education and community development as well as those whose background was theatre.

A performance of a forum theatre piece provoked heated debate. The piece was a story about domestic violence and it was performed for a group of women survivors as well as miscellaneous festival participants. In the name of working within context for which it was intended, it raised, for me, huge ethical questions: when women who had lived with family violence set out to intervene, in front of many 'voyeurs' (by that I mean, those who had no experience with domestic violence and/or no relationship with the survivor group), and when those survivors, because of the forum formula, are caused to 'fail' in their interventions in the name of 'deepening the analysis', the fallout is highly problematic. Unfortunately the debate about this ethical issue was squelched: at this stage, forum practitioners believed that all criticism was coming from a this-isn't-theatre perspective; the embattled are unlikely to hear other kinds of critique. Unfortunately, the notion of the recipe, it's done like this because that is the way it is done, was in the air.

Standin' the Gaff, 1987, Sydney, Cape Breton, Nova Scotia featured an intensive workshop with Augusto Boal. While full-participant responses were multi-faceted, unfortunately, Boal's public presentation presumed no previous exposure to process drama, improvisation or community based theatre; it was insulting. 7:84 was the first British group to exchange with the Canadian festivals. As with the programmer of the previous festival, organiser Ruth Schneider had come to an interest in theatre from a focus on development issues and development education and that engagement of the two forces was very evident throughout the festival. There were some impactful discussions about building stronger links between theatre and development organisations. The Jamaica women's theatre, Sistren, performed and led workshops and Aloke Roy's Jagran, from India, showed an example of its highly disciplined mime performance work. Both groups' performers, who in the binary of actor versus community member as performer, might be termed 'community member', demonstrated powerful performance values which challenged the rhetoric of the more 'professionalised' north.

Bread and Water, 1989, Guelph, Ontario. I suspect that the major advantage of this Festival, and to some extent this is likely true of all of them, was the value accrued by the local organisers and the way in which such an event impacted the local arts communities. In this case, a broad collection of groups and individuals were part of an organising team, and although this collaboration made life difficult in many ways, it also highlighted numerous issues which are central to the growth of popular theatre. Further, the work highlighted southern Ontario's need for collaboratively pursued work on educating cultural and social agencies about popular theatre, its standards and mandates; moreover, much of this it has achieved in the ensuing years. The Festival presented several interesting performance groups, quite notably the Inuit Tununiq Theatre and the Latina Puente Theatre, both of which presented remarkably theatrical collective creations based in those groups' own stories. Lina de Guevera, director of Puente, terms the work 'transformational theatre'; the piece represented a high level of theatrical attainment from a group of previously non-actor immigrants from Latin America. We also saw several forum pieces, including one created during the festival period by a local housing action group and another, by Second Look Theatre, which mixed forum intervention work with entertaining presentational scenes related to safe sex information. The forum 'format' was in the process of reconsideration and adjustment to Canadian contexts. The festival attracted a wide variety of community educators and introductory popular theatre skills workshops were most in demand.

It is significant to note the large proportion of 'non-professional' actors and other participants involved in this festival. Indeed, the huge majority of participants appeared to be students or community educators with an interest in theatre. Two reactions. The binary-based descriptors, 'professional' and 'non-professional', start to be less than useful in a field that asks for a complex set of knowledge and skills (theatre, facilitation, community education and development, to name several). Conversely, experienced theatre artists with a commitment to this use of theatre found themselves for the most part in teacher-ish roles; little was offered which extended their skills at this festival.

Edmonton, 1991. Perhaps in response to this focus on theatre basics and the non-professional (read: non-trained) actor, the next festival focused specifically on theatre and theatre artists. Ruth Smillie of Catalyst Theatre brought in a variety of highly polished international shows, very exciting theatrically speaking, very 'political' in content, including pieces from the American San Francisco Mime Troupe and Colombian Palo Q'se. In addition, several of the workshops were designed to create opportunities for a few very experienced popular theatre animators with very different working methods to collaborate and design workshops they had never before pursued. Social theme, plus a theatre style, focused each workshop. The aim was, with this festival, to provide opportunities for professional development of very experienced popular theatre artists. As I understand the impulse, this was a reply, in ways, to redress a balance, to alter a perceived loss of theatre to education-focused work in previous festivals. There was an implied challenge to the perceived over-use of naturalism and role play, and to the presumption that forum theatre was always the most appropriate kind of theatre in activist and educational work.

This ebb and flow of focus and definition regarding who the festivals served can be seen as a healthy tension between two significant but different parts of the popular theatre story: theatre making and community change. It can also be seen, to a degree, as a failure to discover a way to deeply exchange goals and methods, a failure to speak effectively across our differing but interconnected mandates, to acknowledge and embrace our varying relationships in a process of change. While that interpretation holds water, in the long-term, I see these festivals as the most impactful moments of professional development I have had the opportunity to be a part of, on theatrical and development grounds: it is the festivals that challenged us to find the points of intersection in our work, to make it count.

Of course the real work happened back home, where any learnings gleaned were applied, where one returned refreshed, challenged or all the more determined to follow one's own path. Frankly, I see the difficulty in deeply connecting theatre artists with community development organisations as the continuing blockade to Canadian popular theatre's fuller impact on the societies in which it operates. Funding patterns, but also the long-standing 'method' of producing theatre (show by show, theme by theme) works against engagement in long-term development work. At the same time, theatre is not always the most appropriate 'technology' within a given process of change, and the theatre 'specialist' is not always needed, whereas the community worker and community activist/educator is in for the long haul. Long-term association with specific organisations, unions, social agencies, NGO'S and the like help. However, the come-and-go nature of projects remains an obstacle for both groups; issue-based theme-of-the-year funding styles blocks much potential growth. At the same time, to underestimate the long-term skill development needed to be a truly flexible, responsive popular theatre artist, rather than a one-note applier-of-a-technique is to miss the deep potentials for theatre and the creative act in a process of community change.

Some interesting responses to such dilemmas exist, and their stories rest in the stories of specific companies and individual popular theatre workers, and their interactions with both their art form and the community actions of which they are a part.

I think of this period as the completion of the childhood of popular theatre – despite significant forefathers and mothers, mature and accomplished, the child must 'start again', learn to walk and talk, develop their intellectual, moral and ethical stances. Yes with the benefit of guidance and wisdom of their elders, but nevertheless the journey must be rediscovered and accomplished by each generation. By the nineties this incarnation had reached its teenage stage.

The 1991 festival was the last of the big festivals. Perhaps they had run their course. Certainly funding sources had dried up. The nineties professional development work was characterised by smaller, more regional efforts, workshops which aimed for more intensive work with fewer people. Many of these focused upon a particular theatre genre (for example, forum theatre techniques or community plays). Few included public performance of any kind. At the same time, several universities and extension programmes followed the lead of the University of Alberta, and filled the training gap to some extent by offering various levels of courses in community based theatre;

increasing numbers of community educators were turning to theatre as a tool; and many communities of interest chose to develop their own 'theatre specialists'. And a new generation of theatre expertise emerged, this time, rather than nationalistically inclined, as in the seventies, now often defined by race, culture and gender. The work burgeoned, despite economic difficulties.

Meanwhile, from some there was a greater understanding of the importance of fostering and nurturing partnerships, and that these groupings of theatre and development education, activists and agents of change were perhaps not best accomplished through festival and workshop formats, but in longer-term, ongoing projects. Many looked to dig in more deeply within their home communities and 'make a difference' over the long-term.

From Theatre to Community:
Dilemmas of an Estonian theatre community in Vancouver
Kadi Purru[6]

1 Ring!!! (a telephone sounds)

This is a call from Aino to Kadi both of whom are members of the Estonian community theatre group, in Vancouver.

Aino arrived in Canada as a young woman after the Second World War. Similarly to all post-war refugees, Aino has had to struggle, economically and culturally, in order to make Canada her home. The war interrupted her studies of medicine in Estonia. However, in Canada Aino has been able somehow to follow her vocation. Selling chemical and biological products to medical research laboratories, Aino has travelled a lot and met a great number of people. Aino also has a curious and explorative attitude towards life; it is hard to find a course she has not taken, especially in the areas of alternative medicine, philosophy, spirituality. Right now, although retired, Aino is learning new skills - her new vocation is quilting. Obviously enjoying the communications across multiple cultures in Canada, she, however, keeps close contact with the culture of her homeland. Aino has been acting with the Estonian community theatre for several years.

Kadi arrived in Vancouver about eight years ago. She grew up in Estonia when it formed part of the Soviet Union. Due to the Cold War and separation between East and West, she knew very little about the Estonians living on the other side of the Atlantic Ocean. Kadi left Estonia because of her marriage to a Colombian and lived in Colombia before coming to Canada. She has a theatre-related background: she studied theatre history and criticism in Leningrad and taught theatre theory courses at the University of Valle in Cali, Colombia. After arriving in Canada Kadi struggled to survive, asked questions, reviewed and transformed her previous understandings and convictions. But there was something Kadi was not ready to give up - her devotion to theatre. She became connected with the Estonian theatre group. Currently she is a graduate student of the University of British Columbia, working on her thesis which explores Canadian theatre from the point of view of 'diaspora'.

Contexts

Kadi: *(answering the phone)*

Hello, Aino . . . yes, yes I can talk, I am not so busy anymore. Oh no, I am not finished yet, I still have to write a dissertation. About what?! Of course I know about what - it is going to be about Canadian theatre . . . 'THEATRE OF DIASPORA' . . . No, I will not abandon my work with our theatre group, quite the contrary. No, no, it's not only the question of time, it's more, I see the work of our theatre group directly related to my thesis . . . yes, you understood correctly, my dissertation deals with Canadian theatre. Hmm . . . Estonians? But, Aino, isn't the Estonian theatre group in Vancouver part of Canadian theatre?!

2. Who are We?

Vancouver. A Sunday in June 1998. Comfortable West side home. There are many Estonian national regalia around. The paintings with Estonian motifs - the girls in Estonian national costumes, the peaceful green valleys and the medieval views of Estonian capital Tallinn - hang on the walls. The bookshelves hold the books with Estonian language titles, the prominent place belonging undoubtedly to the beautifully edited Estonian national epic Kalevipoeg. There are also traditional juniper beer cups and candleholders here and there in the room. The Estonian blue-black-white flag is visible.

Seven Estonians are sitting cosily around the dining table, speaking in Estonian. They belong to an Estonian theatre group in Vancouver. By the way, the name of the group is Kalevala, and it was established in the late sixties. This name is a little odd because it recalls a title of the epic of the Finnish people. However, the founder of the group, Elsa Jaako, named the group after the place described in the Estonian epic Kalevipoeg. Estonians and Finns have common roots; both belonging to the group of Finno-Ugric people who have lived on the shores of Baltic Sea for more than three thousand years. Thus, their culture and language are similar.

The group is in the beginning of a new project that is somehow interrupting . . . changing their former aesthetics and ways of work. They also reflect on the past, present and future of their group. From the window opens a view to the beautiful North Vancouver mountains.

Aino: *(inquires with insistent curiosity)*

Tell us, Kadi, more about our new project. I have not understood yet what you exactly have in mind?

Dagmar: *(Dagmar is always optimistic, full of energy, temperamental and straightforward. She recently celebrated her 35th birthday. In Estonia Dagmar was a volleyball player. She came to Canada eight years ago marrying a Canadian volleyball coach. Dagmar is not only a hardworking hostess in the Bayshore Westin Hotel but also the Estonian theatre group's 'leading lady'. She acts, sings, dances with an Estonian folk dancing group, and frequently skis on Cypress Mountain.)*

Don't worry, Aino, just wait until you get a script with your part!!!

Aino:

This is precisely what bothers me - the script! How do we get to the script?! What kind of script would it be?

Karl Aun, *The Political Refugees*: *A History of the Estonians in Canada*, Toronto, Ontario: McClelland and Stewart Limited, 1985, pp. 1-51

The Estonians are one of the smallest ethnic groups in the Canadian multicultural mosaic. According to the Census of 1961, there were 18,500 Canadians of Estonian origin. Very insignificant numbers of the Estonians have come to Canada later. The Estonian ethnic group in Canada is essentially a community of recent immigrants, the majority of whom arrived shortly after the Second World War.

It should be remembered that these Estonian immigrants fled their homes due to the occupation of their country by foreign forces (Soviet Russia) of which they became victims, losing all they had: material possessions, social and professional standing, close friends and relatives. The majority of Estonians hoped sooner or later, after settlement of the Big-Power struggle and the freeing of Estonia, to return to their country. Hence, they refused to call themselves immigrants, but rather refugees or exiles.

The hope that Estonia would be freed of Soviet domination was solemnly reaffirmed at most Estonian gatherings. The emphasis among Estonians was on remaining distinguishably Estonian, which meant primarily the preservation of the Estonian language and Estonian culture. Remaining Estonian also meant socialising the next generation to national cultural matters. This was the root from which the 'explosion' of organizations and activities in Canada emerged during the 1950s.

The driving force behind the vigorous cultural organizations and activities of Estonian refugee communities after the war was basically political. Its aim was not only to preserve Estonian culture but to keep the Estonian patriotic spirit and morale intact for a return to a homeland. There was a strong feeling that while the Soviet-occupied Estonia and suppressed Estonian cultural activities, only the Estonians abroad had the freedom, and therefore the obligation, to carry on fostering the development of Estonian culture.

The way of life, value systems, and standards specifically of pre-war Estonians were idealised and became a measurement of the way of life everywhere. Such ethnocentrism sharpened the cultural shock, provoking rejection and criticism of Canadian society. For many Estonians the image of 'primitiveness' of Canada continued to linger for a long time. Of Canadian cities, only Montreal was found to be 'pretty European'. The cultural differences, whether real or imaginary, reinforced Estonian ethnocentrism, especially among those to whom the workplace could not afford full satisfaction. As a result, in many cases Estonian immigrants developed a pattern whereby they lived one life at the workplace in English, conforming to Canadian social customs and another in their leisure time in their own Estonian society and organizations. Such dualism was dependent on a number of factors: the older the immigrant and the less proficient in English he was, the more he separated his 'Canadian' economic life at work from his social, cultural, 'Estonian' life after work and on weekends.

However, 'relapses' in 'Estonianess' were soon noticed and deplored . . . The young people who grew up in the Canadian environment could not be expected to devote their energies solely to the Estonian cause like their elders, or master the Estonian language perfectly, or marry only Estonians. Moreover, in the 1960s a new element entered the controversy, namely meeting in person with people from Estonia under the Soviet rule.

Contexts

Kadi: *(Kadi considers herself lucky to have spent a few years in the epicentre of Latin American New Theatre, in Teatro Experimental de Cali. She participated in and closely observed how a Colombian playwright, Enrique Buenaventura and his group used the methods of 'collective creation' in their work. Now she is eager to try out this approach with the Estonian community theatre group. Kadi is passionate about the Columbian method because she thinks that it could help the group to address the problems of Estonian community in Vancouver. At the same time, Kadi worries, she does not know how to communicate the Colombian methods to Estonians. Until now the group has mainly staged plays written in Estonia, dealing with the life in Estonia.)*

I agree that until now the things have been quite confusing. I know, it is much easier to have a dramatic text and work with it. This is what we have always done. But can't we create the play OURSELVES addressing OUR ISSUES!?

Dagmar: *(laughing in a carefree tone)*

What kind of theatre would it be? Are we going to take our coffee-table to the stage?!

Aino: (with worry and suspicion)

Who would care about our coffee-table talks?!

Kadi: *(trying to look confident and show that everything is under control)*

Weeelll, all the stories we have been telling to each other have a great dramatic potential! They are so compelling and different! It will be soooo easy to transform them into play!

Marje: *(Marje arrived in Canada after the Second World War with her family on a boat that the Estonian Second World War refugees had obtained in Sweden. Her family had to flee from Sweden because of closeness to and threats from their former homeland, Estonia. By profession Marje is a French language and literature teacher, however, it is not an exaggeration to entitle her also with the honour of being one of the principal hubs of cultural activities of Vancouver's Estonian community. This honour extends also to Marje's family: to her husband, children, parents, and sister. She is leader of and participant in different Estonian organisations in Vancouver, such as the Estonian Society, Filia Patria (academic women's organisation) and of course the Estonian theatre group, where she has been active since the 1970s. Marje is also an important intergenerational link; she is not only supporting but also intermediating between both her children's folk dancing group and the gatherings of her parent's generation.)*

Yes, I agree. The stories are different. There are stories about Estonians who, although in Canada, live like in Estonia; for example, my mother lives as if still in her native village Raeküla. Another example is my great-aunt, now dead. My aunt's home was here, in beautiful British Columbia, but she seemed to live in Estonia: her house was full of Estonian souvenirs, books, newspapers; she could barely speak English; I had always to accompany her to the doctor, to the lawyer . . . She did not have any Canadian friends. Isn't it sad?!

Aino:

I know many Estonians in Toronto, who have lived the same way.

Karl Aun, *The Political Refugees: A History of The Estonians in Canada,* **pp 94-97**

The theatre has formed the second most important sector of Estonian ethnic culture in Canada. (The most popular activity for Estonians is group and choral singing.) Estonian theatre in Canada is rooted in the traditions of the home country where amateur theatre was as popular as the professional theatre and was pursued actively on a wide scale, not only in the cities but also in small rural communities.

The Estonian immigrant post-war population contained a number of professional actors, actresses, and producers who laid the basis for the Estonian theatre in Canada. During the 1950s almost every Estonian Association in different Canadian cities had its theatre group and plays were produced several times of the year. The most stable theatre groups were operating in Montreal and Toronto. In Toronto, for example, three to six plays were produced annually during the twenty-year period from 1952 to 1972. Unfortunately, the Estonian theatre has largely been limited in its activities to the Estonian communities; it has had scant impact beyond Estonians.

P. Kangur, K. Muru, Ü. Tonts, *Väliseesti kirjandus,* **Tallinn: Eesti Raamat, 1991, pp70** (translated into English by K. Purru)

The main objectives of Estonian language theatre in Canada have been to maintain the identity of the homeland's culture, to preserve Estonian language and to assure the continuity of national legacy throughout generations. The repertory of the Estonian exile theatre has been principally composed of the plays by the authors popular in pre-war Estonia.

Due to the amateur nature of this theatre, the groups have been making compromises to audiences' preferences for light entertainment over high quality theatre. Very often the groups have been motivated by particular political inclinations.

P. Kruuspere, 'Eesti Pagulaskirjandus: Näitekirjandus' in. *Collegium Litterarum 5,* **Tallinn: Eesti Teaduste Akadeemia, 1993, pp 13-16** (translated into English by K. Purru)

By its quantity and aesthetic standards the Estonian drama in exile, in comparison to other literary genres such as prose and poetry, is significantly less developed. Throughout its earlier period of existence, due to the presence of theatre professionals, the groups were able to preserve and follow the theatrical traditions of their homecountry. Later, because of lack of 'replacement', the artistic and professional possibilities of the groups became more and more amateurish. In sum, in exile the Art of theatre became an amateurish pastime activity.

Contexts

Kadi:

Why did the people choose to live like that?

Aino:

I would say that for many Estonian Second World War refugees, after being forced to leave their homes behind, time stopped . . . they refused to accept that they were in Canada and continued living as if still in Estonia.

Marje:

My great-aunt laboured selflessly in order to save some money; she never wanted to spend it, she never bought herself anything 'fancy'. After her death we found out that she had saved quite a bit of money, which we sent to her older relatives in Estonia. They must be millionaires now!

Kadi:

Do you think that money made her happy, helped her to 'feel at home'?

Aino:

Of course not, but she was comfortable, safe!

Kadi:

I can imagine that war caused the people innumerable deep wounds, including psychological and economic ones. Perhaps for refugees who arrived to the new country with their hands in empty pockets, the construction of the economically safe place was one of the ways to overcome the feelings of loss?

Marje:

Yes, for my aunt the economic stability was very important . . . and she celebrated her accomplishments in her own way - sending the photos from Canada to her relatives in Soviet Estonia; the photos which pictured her standing in front of wide-open refrigerator 'full of food', in front of her TV set, in front of her car . . .

Helle: *(Helle is among those very few Estonians who immigrated to Canada in the 1970s, right at the peak of the Cold War. Although married to a Canadian Estonian she had to confront the hostility and distrust of the majority of Estonians in Canada. The Cold War situation seriously affected the relationships between the Estonians in Estonia ('home' Estonians) and the Estonians abroad ('foreign' Estonians). These relationships were almost non-existent, fractured and suppressed. Helle had to swallow many bitter moments of loneliness before the suspicion of her being 'a communist spy' was overcome and she was accepted into the Estonian organisations in Canada. Presently Helle does not easily miss attending any of the activities of Estonian community in Vancouver. Having a background in economics Helle is an accountant for West Coast Shipping Company. Helle's contributions to the theatre group are invaluable not only as an actor but also because of her expertise in 'money matters' of the group.)*

And we did look at these photos depicting the details of the 'economic wonderland' of the New World in Soviet Estonia with jealousy and admiration . . . Very soon people started sending letters to their relatives in abroad asking them to share . . .

Marje:

My own life has been definitely more complicated than my mother's because I have not been able to live solely according the Estonian traditions, I have been involved in the life of Canadian society. I feel like living in between two countries, one leg in Estonia, another in Canada . . . I do not know how could we bring these things into the play?! I really do not know . . .

Aino:

What Marje says is very important. This should be included into our play. All the Estonian children who grew up here, in Canada, share the experience of living in between two countries.

Helle:

Living in between cultures is very confusing; I am living at the same time in both places in Estonia and in Canada, but I do not feel like belonging to either of them. I haven't learned to speak English with absolute fluency, and now my Estonian has become pretty rusty.

Marje:

I am constantly inserting Estonian words into my English!

Aino:

I have lost a lot in terms of literary richness of my Estonian, of my mother tongue. In Canada my language has become so limited, I express myself in what we call - 'kitchen Estonian'.

Helle:

I had such good Estonian . . . now, writing the letters to Estonia I get embarrassed, I can see how clumsy my writing is. This has influenced my self-esteem, I perceive myself as imperfect, incomplete, a 'half-person'; my life seems to be divided: half of me lives in Canada, half in Estonia.

Kadi:

But what about the third generation? Marje, what about your daughter, Liisa?

Marje:

Liisa is ready to step into my shoes, participate in the organisation of Estonian community events. She has an interest in Estonian cultural legacy, but there are not many people like her around. Right now, Liisa is leaving to Argentina, for a month . . . What happens if she gets married there?! If our children forget Estonian traditions who would carry on? Or has the story of the Estonian ethnic community in Canada come to its conclusion? Should we stop fighting for its survival? Is it time to let our children to define themselves as Canadians . . . or Estonians . .

. because now they have the option to live permanently in Estonia? I don't really know what will happen but something is certain-we are passing by very critical times. We should bring these concerns into our play!

3. Professional – Amateur

Kadi:

Let me ask something. There are more than two hundred Estonian organisations all over Canada. Each one of us participates in the activities of different community groups such as Lutheran congregation, the Estonian Society, the Estonian Cultural Association, the Estonian Supplementary School, men's and women's choirs and folk dance groups. What has been the role of theatre among these many activities?

Marje:

It's fairly important! The Estonian theatre in Vancouver has more than thirty years' history! I had my first role when I was seventeen years old.

Helle:

As far as I know, in its earlier times the theatre was more professional, the professional theatre people used to lead the groups, Asta Willmann, Ain Söödor . . .

Marje:

Yes, and it was really interesting to work with them! In the beginning the Estonian theatre in Vancouver was very popular, now the tradition seems to perish gradually. Our community has become older and many leading people have died.

Dagmar:

But it hasn't stopped. Since the day I arrived, eight years ago, I have been on the stage.

Marje:

Dagmar, before you had your first role in August Kitzberg's *The Werewolf*, there was a fairly long pause in the activities of our group . . .

(The Werewolf is one of the most popular and cherished Estonian plays. It was written by playwright August Kitzberg in the beginning of the century. Since then it has been endlessly staged. The story is: an Estonian peasant family takes under their roof an orphan whose mother had been killed at the village square because she was believed to be a witch-werewolf. A tragic love triangle is formed when the orphan becomes a young woman and falls in love with the son of the family, Margus, who is supposed to marry another woman. The peasant family/community does not accept this love because Tiina, the orphan girl, is an outsider who has a different temperament and darker skin colour. As a result, Tiina leaves the village. During the stormy night Margus, fighting against hungry wolves, accidentally shoots his beloved Tiina. Because of its romantical and tragic plot the play seems to demand 'great dramatic' acting.)

Helle:

> *The Werewolf* was meant initially for the Estonian West Coast Festival in 1987. We were in the midst of the rehearsal process when the organising committee sent us the notice that *The Werewolf* is not a suitable play for the Festival. Some of the members of the committee argued that amateur actors should not touch the Estonian classics! We all had worked so intensely, with such an enthusiasm!

Marje:

> Unfortunately these kinds of conflicts do happen in our small community. These things make me sad and I often ask myself - why I am doing this? Is it all worth it?

Kadi:

> Hmm . . . and yet you have been continuing doing theatre . . . despite of all these internal misunderstandings. Why do you participate in the theatre projects of the Estonian community? What motivates you to come to the rehearsals after a long and busy working day?

Marje:

> Theatre plays an important role in the Estonian cultural traditions. We have an audience in the Estonian community that is interested in theatre and enjoys it. Theatre, since it is such a collective event, also keeps us together!

Helle:

> I also like the idea of Estonians getting together and doing something. We should keep working on the texts of Estonian authors. It would help to introduce the younger generation to Estonian culture.

Marje:

> *The Werewolf* is my favourite Estonian play and I have always wanted my children to know it. However, it was somewhat utopic to think that they are going to read it. Theatre facilitated them to appreciate this play. When we finally succeeded in staging *The Werewolf* in 1991 my children did not only enjoy watching it but they participated in *The Werewolf*!

Dagmar:

> And the older generation? Aino, why are you doing theatre?

Aino: (laughing)

> I am participating because there are not many 'actors' any more around. Every time I promise to myself that it would be the last time to help them out . . . but very soon I receive the next phone call and I'll find myself in a similar situation . . . helping out . . .

4. Low-High

Helle:

> After many nerve-racking experiences in my 'acting career' in the Vancouver's Estonian community I have been very cautious with my theatre commitments. When Kadi initiated the project *The Wedding in Abruka's Style* and invited me to participate in it, I asked for the smallest part . . .

Marje:

> I loved very much the beginning of *The Wedding in Abruka's Style*! It was really impressive to watch how you all gathered with your backpacks, bags, milk cans, beer barrels and with the COW! in the harbour of the small Estonian island Abruka; how you pushed and argued in order to get into the small boat taking you to the city.

Helle:

> It all looked and felt so hilarious and funny because we had an unusual staging strategy. Instead of being compressed in the tiny stage of the Estonian community centre, we had plenty of space: the two harbours, Abruka and Roomassaare, were in the different ends of the hall. This changed many things; the audience was not only seated in a 'weird' triangular way but they had to participate very actively - turning their heads towards the locations where the different episodes took place. As actors we had a feeling of real distance and we could, we had to shout - how else can the people in the boat communicate with the people waiting for them in the harbour when there are more than ten meters of ice between them!

Kadi:

> Because our audience consisted basically of elderly people who frequently have hearing problems and because not all of our actors can effectively use their voice, our 'shouting' helped to resolve these problems.

Marje:

> The play was also physically very challenging. Sometimes I wondered while sitting there behind the curtain ready to remind to the actors of their lines - how can they endure sitting, all crammed, in this little boat throughout these long conversations and episodes?!

Kadi:

> And the text of this play was so complex, hard to follow and memorise. It did not have traditional narrative logic or 'normal' dramatic development, it was all so fragmented: people constantly mixing their voices, conversational themes . . . sentences getting interrupted . . . or overlapped . . . just like the conversations in the real life!

Leida: *[Leida comes from a tiny Estonian island Muhu where people are used to harsh climate, hard work and speak in a slightly singing Estonian dialect. One day in 1944, with her little son and elderly mother, Leida left home. She was forced to cross the sea to a foreign country on a fragile boat due to*

My reflections on the work of the Estonian community theatre group:

It was not easy for me to join the Estonian theatre groups in Vancouver (there are two), although I was warmly invited. Although I tried to be respectful towards local theatrical traditions and artistic trajectories of the groups, I could not compromise myself because I felt that my background and ideas of theatre were so different. The experience with methods of 'collective creation' practised in Colombian theatre had definitely influenced and shaped my ways of thinking and approaching theatre. It seemed to me that such factors as the tight rehearsal period 'directorial' interpretation of a play, inflexible rules of 'professional' theatre, lack of space for joy, sometimes caused unnecessary tensions in the process of work. These concerns triggered a rethinking of the questions: What inspires people get together after a long working day? What is the purpose of theatrical activities of the Estonian community in Vancouver? What kind of repertory, rehearsal format, and production goals 'suit' the people who do not have particular professional training and who make theatre because they love it? What are the differences between so called 'professional' and 'amateur' models of theatre?

Among all these questions my main concern, of course, was with the refugee community itself. There were so many misunderstandings, frustrations, conflicts and tensions around, due to the unhealed wounds caused by interrupted careers, broken dreams, left behind mothers, brothers, husbands, friends . . . in sum, unlived lives. How to find a common language, build the connections with/between people, create a positive and collaborative spirit within the community which in a way seemed to be like a minefield: wherever one stepped there was a possibility of explosion?

Needless to say, it was not easy to find a play that would possibly inspire and unite the participants in a common project. I knew that it would have been wrong to enforce people right away to work according to methods they were not familiar with, so such an option as to create our own play was out of the question. It was necessary, I felt, to introduce different philosophies and ways of doing theatre gradually, invite people along in the process of work and also to make sure whether there is a need and desire to inquire into the new avenues.

Finally we agreed upon *The Wedding in Abruka's Style*. Our choice was quite intrepid and unusual because this play, written by Jüri Tuulik in the 1970s, pictures the life of Estonians during 'Soviet times'. A few years ago, in the conditions of Cold War, the intent to stage such a play would have probably caused very strong, politically motivated counteraction in the Estonian Canadian community. Yet, it was the year 1993 and *perestroika* had already produced the radical changes in the political map of the world. In addition, since the play's context is very closely related, satirising/criticising the socialist way of life, it became also a possibility for me, Dagmar and Helle (we all grew up in Estonia when it was under Soviet rule) to explain and communicate our experiences to the other members of the project. It worked as a healing process. Getting to know about each other's lives under different social systems helped to lessen the abyss of distrust dividing Estonians during the Cold War.

We opted for this play because we found it charming and very human, we all seemed to be receptive to the warm humour of the play. We considered the play funny but not

the dangerous situation her husband was caught in as a young man (similar to the majority of young Estonians), willing to join neither Russian nor German sides in the war. Having never been 'afraid of any work', as the Estonian saying goes, Leida is now able to enjoy her retirement years. However, it is hard to imagine Leida not being busy: she is one of those who makes you feel at home. Although preferring to work backstage, she definitely stole the show in Abruka with her energetic and spontaneous acting as a commanding and scolding countrywoman.)

Since it was hard to understand where it all went wrong, when it happened I just yelled to my partner 'Shut up!' and started the episode all over again!

Aino:

Remember, in the boat scene I had to be very comforting and caring with my cow, who was supposedly very sad because of being sold and forced to leave her native island Abruka. So in the scene where I console and reach to stroke her body, it resonates with hollow and booming sound-BUM! I had forgotten that my dear cow-Leesike-was made of a plastic beer barrel!

Marje:

Visiting the real Abruka in Estonia I found that the play has depicted it very realistically; I saw the people carrying their packs and barrels and travelling in the tiny boat from Abruka to the city. Our play was an accomplishment - we showed to the Estonians in Vancouver how the people live on this tiny Estonian island. The critique and satire regarding the differences between the rural and city people were also among the achievements of the play. I am only sorry that this critique caused misunderstandings . . .

Helle:

The play ridiculed the city snobs who think of themselves as 'cultured,' 'educated' and look down to the country people. But it depicts these characters of fishermen and countrywomen with such ingenuity and warmth that I think it is impossible to get offended by these coarse words we used. This is exactly how the people in the country talk! I myself come from the Estonian capital Tallinn and as a city woman I learned a lot about the Estonian rural ways and traditions through this play.

Aino: *(laughing)*

Oh, I know many Estonians who pretend to be 'highly' educated, for them the reality and speech of the characters of *Abruka* can easily be 'obscene or dirty' . . . these are the people who claim 'of having left their concert piano in Estonia' . . .

Armas: *(Like Marje, Armas arrived to Canada in his childhood. He grew up in Canada learning English at school and speaking Estonian at home. Earning his everyday bread in a government related job, Armas spends the majority of his evenings, holidays and weekends with the Estonian community in Vancouver. It is impossible to imagine any Estonian event without Armas' presence. Furthermore, Armas is not only present but he is the cornerstone of many events: Santa Claus in the Children Christmas party, member of the Estonian Church Committee, dancer in the Estonian Folkgroup and singer in the Estonian Choir. Besides, one can hardly find a play where Armas does not have a major role! By the*

banal in its depiction of the differences and misunderstandings, between 'down to earth' country people and snobbish city people. The play also has a very hilarious plot: the people from the tiny island Abruka undertake the journey across the half-frozen sea to the city. These trips are, for the islanders, an everyday reality, thus, every person in the boat travels to the city for a different reason: to get married, to sell the cow, to buy a refrigerator, to visit a daughter and so on. The comic nerve of the play is inscribed into the interactions of different socio-cultural discourses expressed through a variety of characters and speech styles, including: the juicy language of the country folk, pseudo scientific talks of the university professor, self-celebrating thoughts of the petty city lady, etc.

In many ways the play *was* a 'neckbreaking' undertaking for our group. We had such trouble with finding participants since *Abruka* involves so many characters. We also faced serious staging problems due to the small performance area and the fact that *Abruka* required quite a sophisticated set. In addition, we were also confronted with other 'traditional' problems of 'amateur' theatre, like physically and vocally untrained actors and the shortage of time. However, falling quickly under the spell of the play, which made us laugh, laugh and laugh in every rehearsal . . . little by little we got drawn into this challenging project. Rehearsal periods grew longer and longer until we realised that, without noticing, a whole year had passed by. Of course this year did not exclude moments of frustrations, tensions, fatigue and loss of hope. Nevertheless, the year also included joy, artistic explorations, the celebrations of birthdays, discussions and discoveries. It was wonderful to become aware of a collaborative spirit gradually emerging in the process of work. Since we had opted for 'naturalistic' staging involving a 'real' boat, 'real' cow and the other 'real stuff' found in the 'real' harbour, many people ended up participating in our project in very different ways: building a boat, constructing a cow, painting sheets for a 'blue sky', finding old beer barrels in dark and dusty basements, searching for music, creating sound effects, transporting the props, manufacturing the stage set, designing the programme, taking care of finances and so on. Inadvertently a large section of Estonian community - family members, neighbours, friends - had become part of our project.

There were also changes in terms of presenting the work to the audience. I just could not bear the thought that all this work on *Abruka* would 'end' with one or two performances as was a 'tradition', so we performed it at least five times. Furthermore, after accepting the invitation to the Estonian West Coast Festival in Portland, we kept preparing/rehearsing *Abruka* still another year. And although our presentation in Portland in a way 'failed' - in addition to many technical difficulties it was very hard to break the chilly official atmosphere of the large hotel conference room designed for business meetings and to reach the audience - it is not the night of the performance we remember the most about Portland. Looking back to this trip we cherish the moments of communality which happened when sharing the rooms in the hotel or having a meal together; when searching for the 'cow' who got lost in the huge hotel in downtown Portland; when having fun carrying dirty beer barrels, pieces of our 'boat' and other props - so terribly out of place - around in this five or four star hotel; when travelling together in a little minivan listening to each others' stories about 'tragic' and funny

way, Armas in Estonian means 'beloved'. Indeed, regardless of difficulties Armas is always smiling and joking, emanating joy and support for others.)
 Yeah, the piano and the maid!

Aino:

 Some people always talk with nostalgia about the great culture they left behind in Estonia - in Canada everything for them is so tasteless and 'culturally undeveloped'.

Kadi:

 Wouldn't you say then that *The Wedding in Abruka's Style* became kind of test of taste?!

(Everybody is laughing.)

Dagmar:

 Armas, I have been wondering where did you get so much energy to put into this play? First Jaan got sick and we had such a problem to find who could replace him; when Urmas refused to play his role in Portland in the Festival and I thought that we'll be never able to find anybody who could play his role. And in order to save the trip to Portland you decided to play Urmas' part!

Armas:

 Well, I never quite succeed in Urmas' role. His Professor was so wonderfully realistic - a city academic living in the ivory tower of science, alien to life around him. Remember, his research topic was dealing with artificial insemination but he could not differentiate between the cow and the bull! *(laughing from his heart)* Urmas played the Professor's part so truthfully because similarly to Professor, he also did not have any idea about 'artificial insemination'!

Kadi:

 How come!?

Marje:

 Urmas feels that his Estonian is not so good and he is a city boy!

Helle:

 Urmas is a very disciplined actor, he learns his lines very early because he has to work with his Estonian very hard. I am always happy to work with Urmas, he is so committed and experienced.

Kadi:

 With *The Wedding in Abruka's Style* we had so many struggles, complications and FUN! But how do you feel about this project being so long-two years? It took us a year to stage it in Vancouver and then another year to rework it for the Festival in Portland.

incidents during the performance, or singing Estonian popular songs with 'indecent' words, when feeling the sense of belonging to the theatre community in the midst of big crowds of Estonians from all over the world; when realising that in spite of differences in our ages, political ideas, professional backgrounds, cultural aspirations *we enjoy being together*.

The Cold War is over. Many Canadian Estonians have returned to Estonia, their home country; some have stayed, some have come back. The Estonians in Canada are still actively organising/participating in cultural events. However, the mission and purpose of events has changed, there is no need anymore to worry about the continuity of Estonian language and preservation of Estonian culture . . . so what is the purpose of Estonian gatherings in Vancouver? What kind of mission is the Estonian Canadian community currently involved in?!

Working two years on the *Abruka* project we had become a group and there was an eagerness to continue. But we were not sure how. We kept coming together, talking about past events and *Abruka* related endeavours, searching for new texts to stage. However, we have not been able to get started with the new project, we have not found a play that would address our issues or inspire us in some other ways. How to find a script that could speak to the Estonians who have made the preservation of the Estonian identity the central mission of their lives; to the Estonians who have desired to become Canadians; to the Estonians who have felt like living in between cultures; to the Estonians who have arrived in Canada in their adulthood; to the Estonians who were born in Canada; to the Estonians who have married non – Estonians; to the Estonians who have arrived in Canada just recently; to the Estonians who have always dreamed about returning to their home country; to the Estonians who have felt at home in Canada . . . ? In the process of telling each other our stories we came to understand that there is not a universal model but endless stories of 'Canadian Estonianess' each of which is an intriguing journey worthy of theatrical exploration...

Contexts

Aino:

I feel very positive about our rehearsals, these were great gatherings with coffee and snacks always around . . .

Helle:

It was never boring during the rehearsals, the play was full of jokes and we always laughed so much!

Marje:

Did you always believe that our trip to Portland would take place? During its preparations there was a time when I completely lost my hope! I took the whole process so much into my heart living through it very intensely. In Portland I got disappointed with the Estonians who were going to MISS our play. Think how much energy and time we all put into this play during these two years!

Helle:

The presentation of the play in Portland was a disaster! There was not enough space, the lights were blinding to the eyes, we were tired of preparing the stage and the fact that we could not have any rehearsal in the new stage just made it all impossible. The best part of it was the trip back to Vancouver . . . remember how we were singing, remembering funny incidences related to the play, making jokes and laughing all the time!

Kadi:

For me theatre is not just the premiere, I value very much different aspects of it, the whole process, rehearsals . . . Recently I read the comments made by the critics in Estonia about the theatre of the Estonians abroad. Both critics coincided in the opinion that theatre is the aesthetically weakest and the most unprofessional artistic expression among the cultural activities of the expatriate Estonians. I thought - how can one approach the activities of community theatre solely from the aesthetic perspective! The work we have done here with our group has another purpose, function and meaning. We come together in order to communicate, to share our experiences, stories, to explore the 'Estonianess' of our culture in abroad. And theatre is a great tool that has helped us to communicate, investigate and express those experiences. I do not think that perfectionism should be our ultimate goal. In addition, even the so-called professional theatre has multiple models and visions . . .

Marje:

The next Estonian West Coast Festival will be in Los Angeles and then there will be the Estonian World Festival in Toronto. What do you think, would we have courage and energy to participate?!

Aino:

I am getting anxious! Have we decided . . .

Helle:

>Really, let's decide, I need to run, we have been discussing more than five hours!

Dagmar:

>Wait, wait a little, Leida, there are the rumours going around that you always take your burial clothes along to the folk dance rehearsal. Is it true? Leida, tell us about this story!

5. Ring!!! (a telephone sounds)

This is a call from Kadi to Aino. It is Sunday evening, April 18, 1999. Earlier this day Kalevala has had a presentation of their 'work in progress' in Estonian Church. The meeting was titled: The Journeys . . . from Home to Foreign Land. The idea of the meeting was to share the stories of the group members with the wider public in order to explore the audience's response and to impulse people to tell about their experiences of immigration (to gather more 'material' for the future play). After the year-long storytelling sessions, there was a feeling among the Kalevala's members of a need for communication, so we decided to accept the Estonian Cultural Association's invitation to give a presentation in one of their meetings. We organised the event in discussion format since the theatrical shape of these stories has not yet emerged. However, we tried to get rid of intimidating and distancing conference staging by placing the audience seats in semicircle and using several smaller tables i.e. multiple 'sites of enunciation'. We used music, slides, quotations from history books not only to explore the expressive scope of diverse media, but also to inquire into how personal memory and subjective account of the events interacts with the generalised objectivity of history books. In addition, our purpose was to try to tell stories . . . as spontaneously as possible without referring to the help of written remarks, in order to gain self-confidence and to observe what happens when the personal story becomes a public presentation. The audience response was vivid. Lots of comments were made regarding the content of our stories and suggestions were given for possible perspectives. Many people approached us afterwards, interested in collaborating and sharing with us their stories.

Aino:

>No, I don't know . . . I am still confused, not sure about how it all worked. But that's good that you found the answers to your questions . . . The audience was large? . . . It is good that many people are interested in coming forward with their stories. What are we going to do next? You know, I am not interested in repeating my story, people already got to know it. The next step would be giving our stories theatrical form?! Oh, I see . . . that would be interesting . . . today telling my story of escape on a little boat from Estonia to Finland during the war I felt that something really important was completely missing . . . I COULD NOT COMMUNICATE MY FEELINGS TO THE AUDIENCE! But I would like to convey to people the fear, desperation, asphyxiating loneliness I felt when I was left with the group of other Estonian refugees behind the closed doors in the Finnish prison during the heavy bombing. We heard bombs exploding everywhere around us and yet we were unable to run . . . to run away in order to save our lives. The prison executives were all gone . . . the only thing we could do was to close ears and eyes and just hope . . . hope . . . hope . . . to stay alive . . . I think that these feelings could be explored and expressed through theatre . . .

4 Forms of Theatre

What Theatre Can Do (and What it Can't)

Theatre can say the unsayable.

This capacity is perhaps its most central asset. Whether at the individual, group, or public level, theatre gives us ways to express: our dilemmas; our political views, whether conservative or radical; our insights, however tentative; our problems, shortcomings, fears, intentions, complaints, angers, commitments. Theatre allows us to enter difficult and dangerous territory, whether emotionally, socially or politically, by virtue of its capacity for narrative, embodiment, symbol and metaphor.

Some of the ways that theatre can be used in community organising, community education and development are: as a bridge from one community to another; as a celebration of a community's achievements, or indeed of its very existence; as social critic, namer of issues, revealer of contradictions. Theatre performance can give recognition to a group and its issues, it can present situations which are difficult to talk about, it can concretise issues by putting flesh and bones and heart and soul on statistics and intellectual and theoretic concepts and analysis, and it can offer on-the-spot opportunities to practice new skills, to test and evaluate strategies or try out possible solutions.

Just as there are related but significantly contrasting community development and community education ideologies and methodologies, popular theatre overlaps and shares territory with a variety of other strategies, as well as a variety of kinds of socially interested theatrical activity. These include some kinds of educational theatre, process drama, political theatre, community plays, people's theatre and even, in some ways, drama therapy. One can see all of this theatre and drama work as connected by the general notion of development, and different from one another in the degrees of emphasis placed upon: individual, group, social, communal, economic and political change, as well as upon the varying kinds of analysis in which they are grounded. Such an argument holds water if one subscribes to the 'personal is political' viewpoint.

It is helpful to define our terms, to declare what kind of project a theatre facilitator, director, or educator is pursuing. In defining our work precisely, which some may see as an exercise in 'unnecessary labelling', we start to reveal our priorities, the social and political biases that we carry. With this declaration comes potential for greater clarity in the selection of most appropriate processes, content, theatrical form, community partnerships and kinds of analysis. Without such clarity and definition, in our experience, projects lose their way. And certainly projects are found wanting by theatre and development workers alike when these differences are not clarified.

Theatre, whatever *theatrical form* is used, does not become popular theatre unless certain criteria are met: intention, process, context/ownership all are part of what defines theatre. However, theatrical forms themselves do hold certain social and developmental biases. An appreciation of the differences between various forms can lead a practitioner to a greater freedom to select the form most appropriate to the social and cultural context as well as to a community's development intentions.

The Psyche Project
Don Bouzek

In May of 1998 Lorna Thomas approached me to direct a staged version of the Psyche myth. When I became involved Jan Henderson had already agreed to participate. The performance formed the initial event at a weekend retreat for women dealing with breast cancer on September 18, 1998. The show was repeated at Edmonton's Cross Cancer Clinic in October

15.10.98 Edmonton
Tonight we gave our performance at the Cross Cancer Clinic. A local performer (who has done a number of popular theatre projects) told me afterwards that she was really surprised by the piece. It didn't look like any popular theatre she'd seen. I realised she was looking at the work as a theatrical style. I don't see it that way.

For me, the form - be it Boal's Forum or street agitprop - is the least important aspect of the work. Rather popular theatre is a way of working. It uses various stylistic vocabularies as tools.

19.12.98 Winnipeg
I look at each project as a set of questions to be answered theatrically. So I've decided to arrange these diary entries as a series of responses to some of the basic questions I pose as I work:

1 Why am I Doing This?
I have a new first question before I start any project - why am I going to do this? Theatre takes a lot of time, energy and resources - all for virtually no economic return. Long ago, I realised that the adrenaline rush of opening night wasn't enough reason to keep making plays. So I turned to popular theatre, which gives the work a broader social sense of purpose. However, in this neo-conservative era, there are an infinite number of critical issues. Which projects to choose?

28.07.98 Davis Creek, B.C
To act with integrity, we must see ourselves in context, as individuals and as members of a larger community. . . No one can live out the fullness of self when she or he is hungry or condemned to a life of poverty and discrimination. . .To live with integrity in an unjust society we must work for justice. (Starhawk, *Dreaming the Dark* 40 - 41)

What I like about Starhawk is that she sees the connection between personal work and political action. Lives in balance. I remember at meetings of the Peterborough Coalition for Social Justice that the older people were all 'church people'. When I looked at Floyd Howlett, still co-chairing the local Day of Action against Mike Harris when he was in his sixties, I realised I had to learn something from him if I was going to still be doing the work in another twenty years. His lesson was understanding a spiritual context for the work. If there is a way of connecting the daily struggle to a deeper purpose, it becomes something that can be sustained. For Floyd, that answer was the Christian faith. That's not a structure I identify with. But it started me on the road to look for my own spiritual centres.

I've found the image of the Celtic shaman useful. Traditionally, there were three roles the shaman played. One was the history keeper for the community. That is why I keep working on the labour history. We need to remember our own stories.

Second, is the 'praise singing'. I look at that as the revenue generation projects that are under the direct control of another agency, in my case, usually a union. Creating a video that tells new members why unions are important plays a role in building the coalitions which fight for social justice - and it pays the bills

Third, is the role of seer - what Sean Kane calls 'the mythteller'. For me, it is a vital part of the work that energises all the others. But it is hard to fund the spiritual side in these literally mundane times. Unions are no better than corporations at seeing beyond the world of economics.

This project allows that spiritual side to find expression, while still working within the frame of popular theatre methodology. There is the cross connection with a social agency, and the collaboration with people directly affected by the issue. At the same time the door is wide open for an exploration of myth and how to stage it. It's a lucky opportunity

2 What are We Trying to Achieve Here, Anyway?

23.12.98 Brandon

Once I've decided to work on a project, my first step is to define the pragmatic objectives. Years ago at a Canadian Popular Theatre Alliance Festival, Jan Selman explained a formula she used to get social groups to focus their projects. She asked them to fill in the blanks in the sentence 'We want - to —.' The first blank was the intended audience, the second the project objective, stated in terms of an action. I stole the formula and have been using it ever since.

28.05.98 Edmonton

The first day on a new project.

Lorna has brought over a copy of the Cupid and Psyche story. When I read the text, I can't see the connection to breast cancer.

In the late afternoon I fight the traffic across the High Level Bridge over to the Cross Cancer Clinic. On the surface it's a very modern hospital, very tasteful in shades of rose and burgundy. But there is no way to disguise two things. First, this is a medical institution, just behind the pastels there are white corridors and people in clinical garb. Second, this a place where people have to confront their fear of death. There is a carefulness in the air, as if any misstep might expose the raw heart of the disease.

The group that gets together is wonderfully diverse. Marilyn Hundleby, a staff psychologist from the Clinic is the focal point. Among the others is Marion Simmons, who works in the school system, and who will be adapting the text. I am on the outside here, both by gender and by lack of experience in dealing with cancer

My first rule of popular theatre is that I must be working with people who have direct experience of an issue. Again in this room I learn why I have these rules. Lorna asks us for our reactions to the story

Each woman has made a strong connection with the myth. So it's clear who this project is for. The myth speaks to women on a cancer journey. Now, what action are we trying to take?

> . . . the economic needs of pre-industrial capitalism . . . shifted the 'normative image' of that world from that of a living organism to that of a dead machine. . . we imagine ourselves . . . as flawed computers with faulty childhood programming . . . I call this consciousness estrangement because its essence is that . . . We see the world as made up of separate, isolated, nonliving parts that have no inherent value . . . Among things . . . separate and lifeless, the only power relationships possible are those of manipulation and domination. (Starhawk 5, 7-8)

14.06.98 Edmonton
Our first working day.

I began by getting Lorna to actually outline the context for the performance. She explains that the work Marilyn Hundleby is doing at the Cross Cancer Institute involves broadening the base of treatment out from the traditional narrow definition of invasive medical intervention. Marilyn sees the psychological and spiritual dimensions as all being integral to the healing. I think of the antiseptic corridors of the Cross. It's clear now that what we want to do with the play is to open up the possibility of these other dimensions for the participating women.

I mention that the traditional medical view of healing is like Starhawk's image of the world as a machine to be fixed. The comment is like opening a door for Jan and Lorna. I had no idea they were both well into Starhawk.

We begin to look at ways of staging the myth. Lorna and Jan have brought masks they created in an earlier unrelated workshop. They see these as Psyche and Venus. They are wrestling with the need for another mask for Eros, and who will play him. I ask them if they have ever seen any of Felix Mirbt's work. This is the second door opening

It turns out that they were both part of a workshop Felix gave out here. Jan also goes on about seeing *Woyzeck* years ago at the National Arts Centre. That show, and *Dream Play*, were equally magical experiences for me. Since that time I've worked with him on a number of projects

So we begin to explore the way we might use Jan and Lorna's masks as puppets. It's completely liberating.

3. How are we Doing This?
a) On Style & Puppet Magic
28.12.98 Brandon

Only when I know the objectives do I begin to discuss with the participating group what form a project is going to take. It may turn out to be a professional touring show for long-term education, or a piece of street theatre for immediate media impact on an issue. It might be presentational or it might be Boal. Form follows function

Even in this case, where I came into the project with a lot of variables in place - the sponsor, the myth and the performers - up until that first night together I had no real idea that we'd be doing a 'puppet show'.

12.06.98 Edmonton

Nothing does change, unless its form, its structure, its language also changes . . . The magic that works is . . . a language of action, images, of things rather than abstracts. . . Learning to work magic is mostly a process of learning to think-in-things. (Starhawk 26-28)

This has so much to say about puppetry - about the kind of stylised theatre I love. I have always described the work that most attracts me as 'magic with nothing up our sleeves'. When the theatre works for me, it is when we conjure, with the simplest of means, a complete illusion. When I can see the puppet manipulator, but still accept the life of the puppet.

Starhawk's 'learning to think-in-things' is a lovely description of what is required by image theatre. It is that ability to grasp the power of an object and make that power visible.

Going into the *Psyche Project*, I see the chance to explore the Mirbt world of text and music as the soundtrack for a visual performance. There is something about this kind of theatre which feels like the comfort of being a child and having a parent read to me. Lying warm in bed, closing my eyes, and letting the spoken words create pictures in my mind.

13.07.98 Edmonton

We meet again in a new configuration. Lorna has invited Eva Colmers to join us. Eva immediately fits in. She has worked with Shadow Puppets and she was in the workshop that Felix gave. There is an immediate sharing of vocabulary among us. I suggest that the session needs to focus on a couple of things:
1) What are the key scenes in the text that we want to develop?
2) What is the physicality of the three principal characters - Psyche, Venus and Eros?

The discussion of key scenes leads us to an hour of very productive discussion. I always feel guilty about spending too much time talking in rehearsal. It harks back to the old days at University of Alberta when, as an MFA directing student, I was told never to explain too much to 'the actors'. However, the whole point of much popular theatre work is that it is collaborative - each person contributing to the shape of the work. I don't believe that can happen unless each person participating is crystal clear on the intent of the piece. I find that time carefully invested in this work at the beginning pays off many times once we get on our feet. So it is tonight.

After a break, we come back to do some physical work. I suggest we go character by character to find a physical definition of the piece. We begin by wearing the masks. I ask for a traditional acting approach, finding the weight centre, the walk, etc. Then we try different emotions. It always amazes me how powerful this basic mask work can be. When people have a skill for this, the mask is such an emotional magnifier.

Once we have found a basic character for Venus, Jan takes the mask off and we re-work it into a puppet using the same wrap of fabric we had created on her body.

Lorna's Psyche latches on to a teenager's energy, which she explains she gets from her daughter. If Psyche starts with that sense of self-importance, then she has a psychological journey that she can travel during the piece. Perhaps the perfection ascribed to her is a reflection of our own youthful sense of having health and power. This is what is confronted with the reality of a disease like cancer.

Then we begin to shape Eros. Lorna and Jan give his face some character with a turban Lorna has brought. I get a couple of sticks to use as arm extensions into wing fabric. With two people on the puppet it does become a wonderful romantic figure. Then we find an image for the fabric wings as bed sheets for their wedding night that is quite beautiful, even in this rough form.

17.07.98 Edmonton

Tonight's question: 'can a feather be an eagle?' I'm interested in whether manipulating a single eagle feather can evoke the bird who helps Psyche at one point.

We start by looking at the actions in the writing, then visualising them, then adding the text as soundtrack. Eventually we set the cues. The old Felix trick of ensuring that nothing is exactly in sync, so it doesn't become 'show and tell'. It is a wonderful thing when images just begin to flow in a group.

We also look at the possibility of using shadow puppets. I turn on the overhead projector, and we try a few images for the sorting of the seeds. By the time the session is done, we've decided to try a take on the underworld using shadows.

b) Some Words on Words

28.08.98 Crane Lake, Alberta

The Celts, like many oral cultures, believed that the moment of performance shaped the story being told. There was a story 'out there' which the teller plucked out of the air with their voice and their strings. The way it came out was unique to the moment, to the place on the earth it was being told, and the people listening.

That is the magic of the theatre - the way it shapes itself to that moment. The way it brings people together in a moment. It is why theatre can be such a force in building a community.

28.12.98 Brandon

One of the central issues in my sense of popular theatre is the question of 'voice'. The work often involves starting from oral histories. We've all built shows from interview transcripts. The form of that material usually lends the show a sense of a story being told directly to the audience. In that way, it's closer to what we think of as a narrative rather than a dramatic form.

I have always been interested in storytelling. Most of my work has involved direct address to the audience. I actually find the image of theatre as an overheard conversation among characters quite artificial. Even in traditional plays, I used to be attracted to pieces with monologues addressed directly to the audience.

The other aspect of 'voice' is embedded in the question of authenticity. Normally in my work this has touched on issues of cross-cultural characterisation. In response, I developed a working process that includes people from groups being depicted in the work, usually directly as participating artists.

On the *Psyche Project*, the connection of the material to the women concerned with the issue was made by having the myth adapted by Marion Simmons a woman who had experienced breast cancer, and was currently involved in support groups at the Cross.

5.08.98 Edmonton

Marion comes to rehearsal with a completed text. Part of the challenge on this project is to bring together a professional creative team with a writer who has never written for the stage before.

I find my attitude to dramaturgy/workshopping a script has changed a lot since the time I worked at Factory Theatre in the 1980s. There I would often lead the charge to pull apart a text line by line, with little feeling for the playwright's sensibilities. Now, I find my role to be more about trying to clarify the writer's intent, so we know what we are interpreting.

In this case, it's particularly important because we are dealing with a woman who has been through the breast cancer experience herself who is writing for other women going through that process. What counts is the honesty of the feeling.

Of course, this kind of a theatrical structure involves a different kind of writing in the first place. The piece is essentially illustrated mythtelling. This is not about constructing a scene with character objectives, dramatic action, etc. It is about finding a way to share a story and give it meaning in a particular community.

Marion has done a wonderful job of re-casting the myth so that it is shorter and more focused. She has also lost the worst of the paternalistic overtones, and created a story that speaks to women.

Marion works at the St. Albert School Board, and much of her work is writing. But this is different, principally in the respect we accord to her words. Every time I do this work I have to re-learn that that respect is so central to what we do. Most people are not given any sense of self-worth in their daily work. In theory, 'the arts' are a place for human expression, for giving people dignity. Yet all too often we treat each other with a shocking lack of mutual respect. Or rather we force each other to 'earn' respect by a show of intelligence, or technique. Rehearsals can feel like we are continually having to prove things to each other.

One of the most important things I have to do in a rehearsal is to create an atmosphere in which none of us self-censors. All the people involved here are creative artists in their own right, so we don't lock ourselves into rigid roles of performer or 'director'. A lot of the time I simply facilitate the exchange of ideas. The best shows are often the easiest, they seem to stage themselves.

18.08.98 Edmonton

We are now into editing the text. Marion has given us *carte blanche* - she does not have the time to be at more rehearsals. She has deliberately written in a heightened language. That works in so far as it feels wrong to be dealing with gods and goddesses in completely contemporary idiom. However, at times the language obscures the basic action of the story. This is the other problem with doing myths for a modern age. None of us knew this story going in, so how do we expect that any of the women in the retreat will have the plot? So a lot of our work involves going for clarity.

Despite the fact that this is illustrated mythtelling rather than 'a play', there is still a difference between words spoken from a stage and narrative writing. When something is spoken out loud and connected with a set of visuals, there is not only less need for the description - it actively works against the connection to the deeper truth.

The second area of revision is in the places where the sentiments feel a little too New Age. How do I mean that? Probably that the spiritual dimension is made too nice and less mysterious somehow. One of the things we discovered is that the less said about the motivations of Venus or the other gods, the better. When they simply act and we are left to deduce the meaning of their actions, it feels more right.

We constantly reference our choices to the context of the intended audience. This is a difference from the traditional theatre approach. I acknowledge the fact that I know who this work is intended to reach, and what it needs to do. It's not some vague artistic quest to make a statement in the abstract.

Mainstream practitioners often say that this somehow corrupts the purity of the work. I don't actually believe that their theatre is less influenced - the audience clearly shapes the differing stage images at the Citadel, Catalyst or the Fringe. Each has evolved a particular kind of show. However, I do think there is a denial of this reality. I find working directly for a known audience gives the work strength. It puts the focus on the truths you believe you have to tell and the craft you need to tell them to a particular group.

This is connected to the sense that the mythteller must be a part of a community. The ancients knew very clearly who they were speaking to as they sat around the fire eating the meat the hunters had brought for them.

c) Synthesis

28.08.98 Crane Lake, Alberta

We live in the interplay of the two modes of knowing, the one chattering like a monkey yet powerless to mean, the other meaningful as a sunset yet powerless to name. (Kane 144)

This is the path I'm walking, the territory I'm exploring. How and where do these modes meet? My theatre work at the moment is moving toward the 'sunset' where images conjure a story. Yet the path resists any explicit content. The moment we state things too baldly, the web of energy feels dragged down. Yet there must be the connection to the real world, or the web will float away.

3.09.98 Edmonton

The thing about this kind of visual work is that you don't really know what the image is until you have it in your hands. When you workshop a script, you can read the text, then try

changes to the words and read it again. It's a relatively fast process. With puppets, they aren't really present until they are finished.

We've evolved a pattern. First we decide the objects to be manipulated in the segment. Say, the third task - we use the river cloth for the water Psyche must collect, an urn, an antler as a dragon and an eagle feather for the bird. We figure out the basic action pattern. Then we have to solve it with three manipulators. But the pragmatic solution is also part of the meaning - we need Lorna as the eagle, so we have Venus summon her spirit - her manipulator - to do the task. Jan suggests a wonderful image where Lorna uses Psyche's hair/body as a gateway to step through. It suggests Psyche is getting new perspective from the vantagepoint of the eagle while her body remains locked in the dragon claws of emotion. The staging is the meaning.

Next we block the action through with the text. Then we put the segment on videotape, Like dance, there is no faster way to remember the physical images. Writing it is useless. It's not about noting the actor is holding the eagle feather prop. It's about how Lorna holds it, in which hand, and the sound she makes with it to suggest flight.

Then we sit and note it in our scripts. Of course, all this takes forever. Like dance, in this work, each visual minute takes hours of rehearsal. Marilyn Hundleby, the staff psychologist from the Cross, has begun to join us. She will be reading the text during the performance. Her time is severely limited, so we feel the best way to proceed is for us to completely work out the cues in the text based on the actions with the puppets. That way the more experienced performers actually control the rhythm of the show. Again the balancing act of including community participation.

4. The Retreat

We spin our circles. Some of them hold and many unravel; yet we begin again, knowing that this work of making community is weaving the mantle of the Goddess. May it be a cloak to shield each one of us from the cold; a net to catch us when we fall. (Starhawk 134)

17.09.98 Edmonton

We finally get a complete run through of the show - the day before the retreat.

I often think that the hardest thing in popular theatre is to get all the people in the same room at the same time. Today, we have a narrow window from 8.30 – 10.45 am with Marilyn. Tracy, the harpist, can stay a little longer.

The first priority is to get a walk through to clean up everything. There's lots of places where Marilyn is waiting for the manipulators and they are waiting for her. We also have to work through the bits of re-staging we did last Tuesday without Marilyn and Tracy. All this, of course, eats time like crazy. Suddenly we only have a few minutes to get reset and do a run.

By this time, we've collected a mini-audience of friends. It's a bit scary to be watched on the first run. On the other hand it gives everything a lot of focus and energy. Overall, it's remarkably good for the state we're in.

I do some notes afterwards. I have to remind the manipulators that they can take time, the reading is timed to their actions - they are in control. This is crucial because in this kind of work the meaning is in the action. Everything has to be endowed with importance. Otherwise it really is just people playing with bits of fabric.

We've just begun to hit the point where the shift happens between knowing what you are doing physically and acting. With this kind of theatre sometimes there will be two people on one puppet/character doing an action - for example Psyche sorting the seeds. There has to be a sense of what Psyche is feeling as the ants help her, and then a shared expression of that. It's only when all these factors - the clear gesture with a clear intent - happens that the puppet truly lives.

18.09.98 Blue Lake Lodge
Quite the day!

It's a grey day - cold and not quite raining. I start in the studio at 8.00 am to load out the sound equipment, then pick up Jan at 10.00 am. The fall colours get more intense the further we get from town. The aspen are like gold coins in the breeze, a shard of captured sunlight even today.

Of course, once we get to the Lodge we discover that the room for the performance is in use until 4.00 pm - we were supposed to have the afternoon to set up. Pretty typical. Slowly all the various pieces of gear begin to arrive. Some with one of the organisers, then with Eva and finally with Lorna. We push our way into the room shortly after 4:00 to begin the set up. This is pretty obviously a 'one off', not a full tour where everything is obsessively organised in the van.

Set up is always structured chaos, particularly the first time. We get the basic stuff in place - overhead projector, backdrop, speakers. It immediately becomes apparent that what looked like a large room is actually pretty small. So we shift it into a corner, to play the diagonal. It's always great to work with people who have experience playing in different types of space. This kind of flexibility drives traditional theatre people crazy. Personally, I just love the act of transforming a conference room into a theatre - a magic box of possibilities.

Miraculously by 6.00 pm we are ready to start. Of course, supper goes over and so everything is pushed back by half an hour. The run is fine - losing the low ceiling and pillars of the rehearsal hall totally opens up the show. The puppets suddenly begin to stir and the manipulators disappear.

By just after 7.00 pm the participating women begin to drift in. The organisers have created a lovely 'alter' with flowers. Lorna lights a candle from the site of St. Brigid's flame in Ireland. The other participants light their own candles and state their wishes for the weekend. It's all very holy, very peaceful and moving.

Then we move on to the performance. The show is the right thing for the right people at the right time. It's one of those magic nights when you feel the audience breathing with the performance.

We move immediately into the discussion I've structured. The women are divided into units of five or six, which they will keep as affinity groups through the weekend. In each group, with a facilitator, I ask them to each tell a personal story that the myth evoked. The results are immediate and powerful. There are tears as the process of opening up begins.

5. How Did it Work?

Audiotape with the performers:

Eva

I was surprised how calm I was at the performance. Because I didn't doubt the purpose of being there. . . When I perform something else, there are all these questions. Not only 'do I know my lines?', but 'why am I doing this?'. I didn't have that. I knew exactly why I'm doing the show. . . It was a very important revelation for me to do theatre in those terms . . . It's just like, if you hand out bread to the hungry, you don't apologise if it is only white bread or brown bread or with poppy seeds or whatever. You just are so happy to hand out something meaningful. Usually my focus is on, 'should I have maybe put poppy seeds on it'. Because I usually fed it to people who were not hungry.

Jan

When you act out of inner commitment, the universe opens doors and throws things at your feet against all logic. I've learned that over and over again in theatre.

Lorna

I've done years and years of popular theatre, . . . but this was new for me - a very stylised, very classical form. . . Whereas any of the other pieces I've done, they've always been very contemporary, the stories have been very literal. . . Being freed from language was hugely gratifying. . . It was just the character who held me in its grip, and sharing that character through a mask was such a treat.

Eva

I was so pleased when two women came to me and said that those masks really looked as if they moved. As a puppeteer and mask operator, that's the biggest compliment, that they could have sworn that they were alive.

Lorna

So if that can happen, anything can happen. They can get well.

Videotape of the participants:

Woman in Yellow

When you have a life threatening illness, it's like a journey into hell, like the play that we had.

Phyllis Sevignay

Psyche had to accept help from all other sources, . . . and that's what I found with my battle with breast cancer. I always was Super Mom. I did it all. I did everything for everybody, all the time. And people depended on me, and then when I got breast cancer I had to accept the help just like Psyche did. And it was really hard for me to accept it. I had lots of volunteers helping to do housework, bake, all kinds of childcare, to taking care of me when I was in bed.

111

And it was really hard to let go of my independence. And to be able to love myself enough to be able to accept it guilt free.

Heather Morrison

A haunting image for me was the hands raised as Psyche was going through the Underworld, and what courage it really took to continue honouring herself and carrying on her journey.

Peggy

I view cancer as a blessing. It opened so many phenomenal doors that it's almost the gift of life, It's like Psyche's story with the connection of her mind, her body and her soul. And, in the process, she eventually became free.

Audiotape with the performers:

Lorna

I was just stunned that all our hoped-for connections - and more – were made . . . It was just too good and too easy that it really did work.

Eva

I mainly felt as a facilitator, just like a connector. . . I didn't want them to focus on me, because then they wouldn't get the story. In acting, you want them to really relate to you and see the emotions reflected in you. This wasn't about me. . . So my biggest compliment was that they got the story.

Jan

It resonated through the whole weekend. Whenever I had anything to do with anybody after, whether I was facilitating a group or just having lunch, they felt compelled to talk about the story, and they always talked about it relative to their own experience.

Eva

The play was a very powerful gift, but it became even more powerful because of how it was followed up. If it just stays with the play and people leave, yes they might have thought about it, but I think the full impact comes by people building on it. . . If it's just a performance. You have a beer and go home.

Lorna

So it's how it's processed?

Eva

Yeah. What comes afterwards.

Presentational Theatre

This category of theatre can portray a world hitherto unknown to an audience; create a picture of a community; elicit emotional response; argue a point of view; inform; entertain; and engage audiences in a person or group's dilemmas. However, on its own, it cannot provide a forum for ongoing discussion of an idea or issue; draw a group together; elicit specific action; nor reinforce the meaning of the experience. Other aspects of community work (such as workshops, discussions, strategic planning, long-term contact, etc.) must provide for these and other development needs.

A variety of labels have been given to presentational forms of theatre which seek, in various ways, to critique the *status quo* and/or to reach out to people not served by the theatrical mainstream. People's Theatre is a term which is widely used in parts of the world. For example, in the United States it refers to performance-based theatre which reaches audiences which are little, if at all, served by the commercial and regional theatre systems. In that sense, the term came into wide usage during the late 60s and early 70s, as part of the collective and communal movements of that era. It tends to imply theatre which uses a local vernacular, which tours to communities not served by commercial theatre, which tells stories which are recognisable and local or which reach people by playing in non theatrical spaces, including parks, community centres, etc. It ranges from the celebration of a community's stories and identity to pieces which are critical of the *status quo*. Many would include this activity under the 'popular theatre' rubric, while others would see such inclusion as a softening of popular theatre principles, largely because people's theatre may or may not include involvement with ongoing development work.

Political Theatre is performance-based theatre which espouses a particular political viewpoint. The content is often a protest or a critique of current government, economic, or social policies and the venues include everything from traditional theatre spaces to bars, comedy clubs and picket lines. Again, political theatre may well also be popular theatre, but only if the process has deeply included the people most impacted by the issue at hand, and only if the theatrical presentation which results is part of some larger community process. For instance, one of the best known pieces of political theatre in post-war Britain, John McGrath's *The Cheviot, the Stag and the Black, Black Oil*, could not properly be described as popular theatre since its mode of production was confined to 7.84 Theatre Company, rather than any of the communities in which it played with such success.

Many of the performances which fall into the category of popular theatre today grow out of a process which leads to a devised play. 'Devising' means a process of collective creation, usually leading to some sort of performance. There are several different models, depending both on production relations within the theatre group and on relations between that group and the community with which, or for which, they are working. For example, the theatre group might engage in a phase of research in a community out of which comes the material for the devising process so that the product of the research is returned to the community in the form of a theatrical

performance. In another instance the researchers might be made up of another, distinct group of persons, with the process emphasising the exchange between these groups. A more participatory model would cast the theatre group as facilitators of a community's own research process, from which the community would stage its own performance either to other members of that community or to an external audience with which the community was trying to establish a communication (a community of homeless people might seek to perform to an audience of local government housing officers in order to effect a change in policy). As with other categories of popular theatre, the key issue in any devising process is that of co-intentionality between performers and community as well as within the group of performers and in the community itself. Clarity of intention allows for clarity of communication and effective dialogue.

In Canada, Collective Creation is more commonly used than 'devised'. In the popular theatre realm, this approach has provided a means for practitioners to 'give over' the creation process to community people. In the nineties the groups to use this process of creation and performance most commonly have been youth and seniors, although there are certainly significant examples among women's groups, prison groups, ethnically defined groups, and others.

The term Collective Documentary has grown up in Canada to describe plays created collectively out of first hand community research. It is a form and a process, used primarily to tell and celebrate community stories and experiences. The theatrical form that is implied in this process is eclectic: a collage format of a number of 'snapshots' of community life, historical and contemporary. The implication is that the content is tied to actual events and people; these are 'documented' on stage. In practice, a variety of theatrical forms and styles are used to express this 'documentation'; groups tend to search out popular, recognisable and entertaining 'forms' (the game show, dances, familiar songs, the vaudeville sketch, stand-up comedy, etc.) within which to present certain facts, events, ideas, etc. At best the forms are used to create juxtaposition in order to deepen the commentary on the social conditions which are in play.

The other form that is often seen within this approach is the monologue/scene. Actors overtly 'take on' characters, *presenting* them to the audience rather than pretending to *become* them. Often the actor presents the character, telling a story as it was told to the actor during the research process. Imbedded in this dramaturgical structure are a number of useful implications: as actors overtly take on a variety of community-based characters, an element of performer choice comes into play. The performer, the person there in the room, in front of the audience, is responsible for choosing who to play, and how. There is a direct accountability to be found within the theatrical space.

The mobilising of a community around the activity of making a Community Play is about as old as records of European cultural history. The phenomenon which had been in decline since the advent of the purpose-built playhouses of the Renaissance, has been revived in recent years in a movement that in Britain has focused on the work of Ann Jellicoe and the Colway Theatre Trust. Coming to prominence in the Thatcher decade of the 1980s, Jellicoe's version of community drama presented no challenge to right-wing ideology but rather an alternative to the cultural hegemony of the

metropolitan centre. Operating mainly in small towns in South-West England, she mobilised anything up to 500 people in an act of one-off creativity, usually directed towards recuperating and celebrating a moment in the history of the town. Criticism of this approach to communities has tended to focus on the extent to which the massive effort of participation was kept firmly in the grip of a small core of professionals under the direction of Jellicoe herself and on the limited sustainable gains derived from this one-hit style of operation. Jellicoe has claimed that the act of co-opting the creativity of a whole community on this scale results in the releasing of untapped potential which is subsequently available, not only in the particular area of play-making, but also in many other areas of community interaction and mutual support. Context is a key consideration in this project and it may well be that the kind of radical, popular intervention demanded by her critics would have been both inappropriate and impossible among the essentially conservative and petit-bourgeois communities in which she chose to work. Nevertheless there are serious issues of ownership in this work, highlighted in the case of the 1985 Dorchester Community Play, *Entertaining Strangers*, written by David Edgar and subsequently given a professional production by the Royal Shakespeare Company. Does this play belong to Edgar or to the people of Dorchester? It came to be treated like any other play text, available for production in contexts far removed from its original conditions of creation.

However the story of the contemporary community play offers a lovely example of where artistic impulse met with academic/development critique; in some cases this interaction led to a reformation which incorporated the strengths of the mass engagement and highly visible theatre forms and processes with impactful levels of participation; both theatre and the development agendas have grown as a result.

In Canada, these versions of the community play started in 1990, led by members of the British Colway Trust project. The process and principles were directly imported. Many projects have developed since. This work could be seen as an aspect of popular theatre work; the overlap includes the high level of community involvement and, in some cases, their development and resistance agendas. However, popular theatre purists would part ways with much of such work because of the lack of community ownership of the messages and analysis, and the lack of engagement in analysis of many of the people who participate. The impact of these ideas has been important in Canada. Along with parade, pageant, clowning, street theatre and other initiatives, it represents an important continued exploration of theatrical forms other than role play and realism-based work. When the form is chosen because of context and intention, rather than formula, whim or 'good marketing', popular theatre thrives. As with the arrival of forum theatre, the initial community play work closely followed the blueprint provided from 'away'. However, since then a number of theatrically inclined community animators, such as Don Bouzek, Ted Little, Ruth Howard and Julie Salverson have allowed the format and process to change, in light of context and in the name of community development principles. The results have been new explorations of what large-scale theatrical forms can do, as well as the growth of new partnerships and understandings within communities. This connection between intention and form, where the selection of form grows out of an analysis of context (cultural, social,

economic, political), community needs, intention and development process, as well as a full understanding of the strengths and uses of a specific form, revitalises the work, and keeps it creative as well as responsive. Part of popular theatre's contribution to community growth is the very offer of creation and invention, of new ways of seeing familiar and apparently rigid circumstances. Form, as well as content, can provide surprise – a new way of looking.

Open-air manifestations of popular theatre frequently focus community and media attention upon the politics of space and the rights of ordinary people to lay claim to the use of public or common space. In 'developed' countries like Canada and Britain, it is increasingly rare for cultural life to be played out in public. Ever since the Renaissance in England theatre has been increasingly confined to designated, usually indoor, spaces more readily subject to control by state and local government than the amorphous, fluid and frequently spontaneous irruptions of performance onto the streets. Whilst the notion of the travelling player is long since dead, it is still possible to find theatrical performances attaching themselves to outside events such as demonstrations, Parades and Carnivals. Their purposes may be celebratory or oppositional but either way take advantage of a crowd gathered for another purpose. In many instances, the aims of the popular theatre company run in direct opposition to those of the representatives of established order. At its more radical end, Street Theatre issues a challenge to those who, in our name, seek to control or deny access to 'our' spaces: streets, shopping malls, common ground.

Video and Popular Theatre. With the rapid increase in the use of lightweight, easy to operate camcorders it has become commonplace to use video as a means of recording the ephemeral theatre performance. The recording may serve a variety of purposes, from teaching tool to promotional material in the pursuit of funding or work. More interestingly, video has begun to be used in the context of community self-development in similar ways to the theatre process: as a means of enabling communities to articulate issues pertinent to their lives in an artistic medium. Such representations can then be edited into the conveniently transportable form of the videocassette with the potential to reach many more people than a live theatre performance. Most people's experience of dramatic form comes today through television. Community video works to demystify the televisual process and move the means of production from the broadcast centre to the community periphery. There remains the issue of the control of the distribution. Today this issue is no longer one of technical limitation and cost but of power and control. As in theatre, the distinction between the mainstream and the popular is one of passive consumption of leisure opposed to active participation in the mode of representation. The popular is made by the people in order to express their realities.

Video has begun to appear as a developmental tool in the work of NGOs such as Oxfam and Save the Children and its potential has yet to be tapped as an alternative to the written field report. Video can provide the means by which some of the most marginalised people on earth can project representations of themselves into the offices of those who may hold the power of life and death over them.

Participatory Theatre

Various forms of participatory theatre can, in addition to the capacities inherent in presentational forms, involve audiences in decision-making experiences; pose problems within a complex cultural context which audiences try to solve on-the-spot; provide opportunities for audiences to practice skills needed to solve real-life problems or to confront others; provide immediate feedback to audience's perceived solutions; reveal audience opinions and attitudes in light of the effect on others; challenge audiences to examine their own issues in ever-increasing depth; and encourage and emphasise the value of peer problem solving and communal solidarity.

However in most development situations, theatre, whether participatory or not, is unable to work successfully when independent of ongoing organising and action. It can have huge short-term impact, and it is most powerful when used strategically within a larger development plan. When popular theatre facilitators and their community partners can identify the immediate goals, and view them in light of the working context; when they remain flexible and allow the choice of when to use theatre and what form of theatre to choose to vary with the varying context and varying goals; and when they work in concert with other aspects of development work, they use theatre's powers to the best effect. Precise use of terminology can help us in this matter.

Interactive or Participatory Theatre refers to a wide variety of approaches for involving the audience actively in the theatrical events. Practitioners of theatre in education and popular and politically motivated theatre, as well as theatre practitioners who aim solely to entertain, have all found value in engaging the audience directly. In the area of popular theatre, the most common theatrical approaches to this direct involvement are: forum theatre, animation in role, 'total participation', and various improvisatory games, often used to warm up an audience or community group and prepare them for deeper or riskier levels of interaction.

Forum Theatre, a term coined by Augusto Boal, refers to a very specific approach to involving audiences in investigating responses to oppressive social and political circumstances. Normally, a story or situation is dramatised with a view to presenting a complex yet specific issue or problem to an audience. The piece is performed once straight through, then it is played again with an invitation for audience members to stop the action at any time they see that someone is 'oppressing' another. The facilitator, who is called the 'Joker' by Boal and followers, directs the audience member to replace the character they believe is being oppressed, in order that they can try to change the outcome or stop the oppression. The scene is wound back a few lines, and played with the audience member in the role; Boal describes this as a 'rehearsal for life'; the intention is that audience members test out possible actions that could stop specific oppressions. Once the idea has been tried the audience member returns to their place and the original scene is picked up where it was stopped and the process starts again.

Animation in Role refers to a theatrical form where *characters* (neither actors nor a joker) play out a situation to a point of crisis or dilemma, then turn to the audience for

advice, assistance and analysis. Issues are discussed and analysis deepened via the *characters'* response. Depending upon the intention, scenes are structured to create opportunities to explore anything from behaviour options (for example 'how can I handle this job interview' or 'how can I explain this to my boyfriend') to revelation of complex contradictions. This work has been vastly informed and deepened by the insights into narrative and Brecht's analysis of the dramatic structures useful in revealing contradiction, offered by practitioners such as Michael Etherton, David Barnet, Jane Heather and Tony Hall. (For more about this work, see Alan Filewod's book, *Collective Encounters* and also CBC Television's *Catalyst Television* series.)

Theatre in Education (TIE), discussed in more depth in other parts of this book, usually refers to theatre developed for children which includes an element of participation. The level of participation varies widely, from children providing environmental sounds or indications of agreement, to discussions after the presentations, to audiences making moral and social decisions for characters who are in dilemmas. Some branches of this movement have quite radical agendas and a fuller examination of TIE requires a close look at the potentials and constraints created by its performance sites, most usually educational institutions. The term Theatre *for* Education tends to refer to theatre which is created by adults and performed for children and young people and tends to focus on aspects of the curriculum, social or academic.

In a Fix – Theatre in Health Education in Schools
Iain Smith & Gillian Twaite (*Catalyst Theatre Company*)

The following extract tracks the devising process and touring of *In a Fix*, a participatory theatre in health education programme for nine to eleven- year-olds by Catalyst Theatre Company, based in Birmingham. This programme which examined the use and misuse of legal drugs was devised and toured in the Spring of 1998. The devising of this programme followed several successful tours of Sorted (a drug education programme for eleven to thirteen-year-olds) which had revealed the level of interest in these issues within primary schools and was co-funded by a number of trusts, charities and a local Health Authority.

Rationale for the Programme
Drug education programmes for young people invariably touch on sensitive issues and need to be clearly thought through. It was important that the members of the company, the funders and as many of the teachers as possible were all aware of the programme's aims and content. Given the young age of the participants and the areas of interest highlighted in the Curriculum Guidance documents, it was felt necessary to concentrate solely on legal drugs: medicines, alcohol and tobacco.

December 1997 - Research
After a three month concentrated effort to secure funding for this new project, we cast the three person programme (which was to undertake two tours) and the team set about

researching and updating our knowledge of drugs education and information. This included finding newspaper/magazine articles on recent 'drugs' stories to use as stimuli for follow-up work and visiting local schools with drugs education workshops, in order to gain a better insight into the needs and levels of awareness of our target audience.

We centred our research on three contrasting schools, two inner city and one from the outskirts of the city. The company has built up a relationship with these schools over the years and this mutual trust proved invaluable when we sought permission to run workshops and ask sensitive questions. The sessions were a challenge. Left alone with a mix of ten and eleven-year-olds the word 'Drugs' sends a ripple of energy around the space and a breeze of whispering. We asked them to name all the drugs they could think of - this was enlightening! It is often said that times have changed since we were at school - but when the street names such as 'Buda', 'Black' and words such as 'Bong' appeared we realised that linguistically at least many of today's ten-year-olds were very 'aware' of the street culture of illegal drugs. It became clear however that there was a great deal of misinformation taken as knowledge and many areas of confusion. Was Coke (Cola) a drug? What about chocolate? As a whole group we focused on what the word 'drug' meant and asked them to think of reasons why people were likely to take drugs at different ages. A large percentage agreed that stress was a reason why ten-year-olds might take drugs (they cited homework, bullying and parental unhappiness.) We finished the session by asking the group to put down anonymously on a piece of paper any question they wanted to know about drugs (one side) and any experience they had had with drugs (on the other). These were illuminating:

How come drugs give you fleas?

Do you get drunk in any pub?

How do people take acid if it burns?

Is weed harmful?

When I had asthma I had to take a good drug.

Many people came, and my dad told me to go upstairs and play Nintendo. I played Mario and then went downstairs and saw my dad taking drugs and said why are you taking drugs?

My dad was very stressed when my mum and him split up, so he took an overdose of his medicine which was paracetamol and he got rushed to hospital. He was supposed to take only two at a time and he took nine. He also started smoking heavily but now he has cut down to seven a day. I felt quite sad for him, but I feel a bit better now that he is better.

Two of the teachers sat in on the sessions and moved in and out of the activities as they thought appropriate, the third chose to leave us alone with the pupils ('they will be more honest without me around') but asked for feedback afterwards.

119

As a result of our research the team put together the programme's aims and set to work on devising the structure and the narrative.

Programme Aims

In a Fix aimed to enable young people to make healthy and informed choices about drug use and misuse and to improve the status, confidence and skills of young people by:

a) providing accurate information about the use, misuse, and consequences of legal drugs.
b) actively involving young people in exploring attitudes and values towards the use and misuse of legal drugs.
c) developing skills in communication, risk assessment, decision making, and seeking help.

January 1998 Devising

We brainstormed our initial ideas onto a piece of sugar paper. How to make the story/characters interesting and durable; how to give information, challenge attitudes and values and create a forum for discussion and development; how to make it appropriate to the target age range; how to fit it all into ninety minutes!

Of course we couldn't fit all the subjects into that time and so we made the decision to focus on the drugs that most children were likely to come across at that age (cigarettes, alcohol and medicines) and look at the personal and social issues that surround 'healthy living'.

A framework was created which we felt had an attractive central theme, winning the Lottery and going to Disney World. A time of excitement and broken promises.

The Programme

Clench

> Drugs are substances which change the way the body and the mind work.

Chubb

> All medicines are drugs but not all drugs are medicines.

Glover

> All drugs are dangerous unless used properly.

After introducing themselves to the pupils, the teacher/actors re-enter the classroom in role as customs officers, Clench, Glover and Chubb. Adopting an officious tone, they tell the pupils they are here to talk to them about drugs - 'It's not big, it's not clever, so don't do it!' They brief the class about one of their recent cases, inviting the pupils to see if they can discover the truth. They are shown three suitcases which burst open on a flight from Orlando to Birmingham and a bin liner full of their recovered contents. The pupils' first task is to decide which items go in to which case and, as the plot thickens, which of the following 'suspicious items' belong in which case:

Exhibit A: 800 cigarettes; 200 concealed in video cassette cases
Exhibit B: 4 bottles of Coca Cola mixed with vodka
Exhibit C: a cuddly toy filled with tablets

After speculating on who the owners of the cases might be and why their luggage contained these suspicious items, the action moves to the school hall. Here they meet the owners of the suitcases, the Applebys: Robert the father, his nine-year-old son Jay, and his thirteen-year-old daughter Nikki.

The pieces of the puzzle quickly fall into place. During the course of the first scenes the pupils discover that the father is a smoker, Jay is an epileptic on medication which he does his utmost to avoid taking and his sister Nikki and her teenage friends are experimenting with alcohol. The final piece of the puzzle slots in to place when, by a miraculous twist of fate, the Applebys win a share of a big lottery payout and the children persuade their father to take them on holiday to Florida. However, Robert sees this as an opportunity to coerce his children: he gets Jay to vow that he will always take his tablets and Nikki to promise that she will not touch alcohol with her friends. In return, his children force him to make a hollow promise to give up smoking.

Returning to the present, the pupils were asked to imagine they were in the interview room at HM Customs at Birmingham Airport. Using hot-seating techniques the students were then able to interrogate each of the Applebys in turn and decide which of the available sanctions they would impose on a character: a verbal caution, a written caution or a fine.

After this the pupils witnessed a brief but tense scene as the Appleby family returned home from their ordeal at the airport. Robert, humiliated by his children's antics, refuses to be questioned about his continued smoking and apparent broken promise. In a fit of pique he sends them both to bed early with a warning that he will get to the bottom of this tomorrow.

The class then discusses in three groups what each member of the family promised and why they broke it. They then create still images of these reasons. The pupils then prepare the three characters for their impending family meeting. Each group speaks to one of the characters and offers advice on how to explain their worries and suggest ways forward for all three of them.

The teacher/actors then de-role and ask the final question. 'Why do people find it difficult to do things that are good for them and yet do things that they know are bad for them?'

February 1998 The Preview

As with all our programmes we held a teachers' preview. This gave all the schools participating an opportunity to see the programme, ask questions and discuss any aspects of the performance. Each teacher was given a resource pack with relevant information and follow-up activities for use in conjunction with the visit. The preview also gave the Health Authority an opportunity to see and comment on the work and to liase with schools to ensure a programme of preparation and follow-up activities were going to be carried out at the schools involved. The turn out was good and after an initially quiet start, teachers reacted loudly to 'dad's' hypocritical 'adult' attitude towards his own smoking addiction and proposed that a substantial fine be administered on discovery of the hidden duty free!

Evaluation

Both teachers and pupils contributed to the evaluation process by completing evaluation forms and through informal discussion with company members.

Response of Pupils

Sixty pupils completed evaluation sheets which asked participants to select words from a list which best described the experience for them. It is possible to see from their selection that the programme was extremely well received by pupils, 90% of whom said that *In a Fix* was well-acted. A similar percentage also found it to be interesting and enjoyable. Importantly for an educational programme, 92% of participants said they had learned something new and 70% said it had made them think. These high percentages support the statements made on teacher evaluation sheets, many of which emphasise the high levels of concentration and participation generated by the programme.

The statistics also show a very positive response to the participatory style of the programme. The performance element of the programme lasted only twenty minutes of the ninety minute running time; the remainder of the session was given over to participatory activities including hot-seating, still image, group discussion and forum theatre. These activities were carefully structured to incorporate pupils of all abilities and did not require prior knowledge of either drama skills or drugs issues. Encouragingly, as many as 70% of pupils stated that they would have liked to have joined in more. The following gives a flavour of the responses:

> I learned not to drink till I 'm eighteen even then I know not to drink much. And when I need tablets I will take them even if they taste horrible. And not to smoke because I don't want cancer.

> You should not drink and smoke when you are young because they have drugs in them and if you are ill and have some tablets you should take them.

> I learnt a lot of things today about drugs. It made me think about things what my father, mother and my thirteen-year-old brother are doing.

Response of Teachers

18 teachers completed and returned evaluation sheets. The majority of teachers reported that they were impressed with the *In a Fix* programme and most felt it was highly appropriate for their pupils to be receiving this type of drug education at this stage in their lives. Staff were particularly influenced by the commitment their pupils had given to the participatory elements of the programme and many commented on positive feedback from all who had taken part. A very high percentage of respondents said that this programme had stimulated follow-up work and a percentage said that it linked with their regular health education curriculum or health week.

In Conclusion

In a Fix was not about offering teachers and young people easy answers to the complex issue of drug education. However, by balancing the provision of accurate information with opportunities for young people to practice skills and examine their own attitudes about drug use and misuse, we felt that the programme had a major impact in enabling young people to recognise the dangers inherent in drug use.

In a Fix completed its first two tours of primary schools with a positive and enthusiastic response from pupils and teachers alike. There is undoubtedly a tremendous demand for drug education on the part of teaching staff, many of whom recognise there are insufficient resources in this field at present. In addition, there is an acknowledgement that more imaginative approaches to drug education, such as *In a Fix*, appear more likely to engage pupils, challenge attitudes and positively affect behaviour.

The term **Total Participation** attempts to describe dramatic events where audience members are asked to take on roles, perform tasks and make decisions within a dramatic context and over an extended period of time. Indeed there is usually no 'audience' in the traditional sense of audience-as-observer, or even in the sense of Boal's 'spectator' audience. Without the audience playing out these roles and actions there is no theatrical event. Often the drama puts audience members in the position of decision-makers; after the drama the choices, decisions and behaviours are discussed in terms of the social, cultural, and political values and power relationships that were experienced and exposed. One example of this form is Catalyst Theatre's Project Immigration; participants took on the roles of immigration officer teams and, via a series of activities determined which two of five immigrants (played by actors), would be accepted into Canada and which three would not. After the events, the 'audience' examined the biases, racial, economic, gender, etc. at work in their decision-making process and reflected on Canada's immigration policies.

Participatory Process

In considering what theatre can and cannot do, however, we need to consider deeply the value of *process*. Just as participatory forms of theatrical performance can achieve a wider variety of goals than presentational work, active participation and indeed control of the drama making process can also increase the meaning and impact of popular theatre. When the strengths of theatre performance are combined with deep community involvement and ownership of the research, issue identification, story making, analysis, selection, and experiential processes of drama making, the impact of popular theatre is more fully felt.

Drama in Education (DIE) involves students, usually children, in a dramatic process. Sometimes there are issues of social concern at the centre of the content. Sometimes it is used to personalise a topic and to educate 'experientially'. Often the focus is on individual and group development and there is emphasis upon the benefits of drama in and of itself as a process of personal development. In Britain this work was pioneered by Dorothy Heathcote and Gavin Bolton and their writings still exert a major influence on this field. **Process Drama** is a term used mainly in educational settings. It is drama process (theatre games, improvisations etc.) used for personal and group explorations of themes and curricula, social and individual. The focus is on the growth of participants: growth of understanding, co-operative skills, personal development. A related term is **Transformational Drama**; as the term implies, the focus

is on change and development through the use of drama. Sometimes these terms are used to indicate drama events which are led by teachers 'in role' (playing characters) in order to take participants through a dramatised series of events; the intent varies, but often involves children deeply experiencing a situation and context which relates to a curricular goal. With popular theatre, education and development fields' increased appreciation for participation, two-way communication, and community ownership of research and actions, has come increased valuation of process drama and related experiential opportunities from within and without the classroom.

Drama Games and Theatre Games refer to a wide variety of drama exercises which are designed to encourage various kinds of personal and group development. Typically they are used in drama classes and in early stages of community development processes. They are particularly useful in encouraging energised, fun, safe, focused and co-operative dynamics. Facilitators carefully choose from a wide variety of exercises in order to develop a specific tone and skill which will address the needs of a specific group or session. Many popular theatre practitioners both invent and adapt exercises for the specific circumstances.

Beyond skill and group building, **drama exercises** are used extensively in participatory processes of issue identification, story finding and storytelling, and political and social analysis. A variety of approaches to storytelling (verbal and non verbal narrative), sculpturing (embodiment and symbol-making) and role play are staples of this work.

Neither drama games nor 'drama exercises' are value free; the structure and methodology of the exercise embed biases about how humans work, how they change, about which values are most significant to the moment, and what kinds of information and understandings are sought. Similarly, the approaches to the 'unpacking' of these drama activities highlight facilitators' agendas and intentions, whether stated or not. While participation is very high, levels of commitment to risk and change vary hugely.

Drama Therapy is drama used in a therapeutic process of personal and group growth. It is usually led by a psychologist or therapist who employs drama skills as part of a healing programme. Its intent tends to be to 'normalise' individuals. Some emphasise intervention in self-perception and behaviour. This territory of drama/theatre work comes up and touches one border of popular theatre in the area of skills development and building group cohesiveness and solidarity. As with popular theatre and social theatre, the intentions, methods and results of drama therapy are hugely impacted by the philosophy, analytic basis and intentions of the practitioners. Lisa Sokil, a practitioner of both popular theatre and, more recently, drama therapy reflects on their relationship, their processes and values.

The Practice of Justice
Lisa Sokil

I worked for eight years with Concrete Theatre, a popular theatre company in Edmonton. As a group, we were committed to the ideal of popular theatre as the practice of justice, in

process as well as in product. Much of our work involved youth at risk, and I saw how this population enhanced self-esteem and built confidence through dramatic work. Through popular theatre projects, we also created a supportive space in which participants could actively analyse their situations, explore their options, and come to a sense of power and decision-making. Action towards a more just world was also a goal of many projects.

Following my work with Concrete Theatre, I was accepted into the inaugural year of the M.A. programme in drama therapy at Concordia University. Popular theatre and drama therapy both use dramatic images, such as body sculpture and movement, stories, and characters, to concretely portray internal images - perceptions, ideas, and world views. In this concrete form, the images are explored and analysed, patterns can be shifted, and new options experimented with.

It has always seemed clear to me, that popular theatre can critique and work against injustice in the world beyond the drama group. This is done by educating, raising awareness of alternative viewpoints, agitating and suggesting community action. Popular theatre can also work towards positive social change by modelling and rehearsing desired ways of being within the group, for example: mutual respect, tolerance of diversity, and consensual decision-making. When a project does not consist of justice at this level, it is hypocritical and self-defeating. How can justice be achieved through injustice?

Years ago, I watched a show that was billed as popular theatre. A cast of professional and semi-professional actors had interviewed people who had experienced family violence. The actors then selected, adapted, and combined these stories to create a show. The performance was accompanied by a discussion led by police, social workers, and counsellors. From my perspective in the audience, this was all fine. Afterwards, I discussed it with people who had been interviewed, some of whom I knew quite well. At least one woman was fuming. She felt that her story had been stolen and distorted, used to present a message she had no control over. In the scenes onstage, she recognised herself and her story, but she did not own the message the scenes illustrated. The company had wanted clear, realistic illustrations of elements of domestic violence. It didn't matter what the contributors had wanted, since there was no room in the project to accommodate those goals.

A slightly different dynamic happened at the time Concrete Theatre incorporated. For two years, university students and graduates had been creating and performing plays with street-experienced youth. We had done many projects over those two years, with some members coming and going. Each project was participant-directed, ethical, and supportive. Then we the students formed an official society, and gave our colleagues notice that we would be working with other groups. They were shocked. They understood the nature of 'our group' quite differently than we did. I don't believe they realised the hours we had spent planning and preparing for each session with them. Still, I feel remorse about the way we told them of our plans, and the lack of choice they had in the matter. I'm sure they felt betrayed. They had not signed on to help us develop skills which we would then use to found a society and sell to others. Although previous group decisions had been consensual with them, this shift in the nature of our contract was not. Like the contributors in the first example, they felt that their stories had been used to achieve goals they did not control.

Clearly, injustice can happen at the levels of group structure, goal setting and decision-making. At its extreme, the trauma of telling one's story without ongoing support, control, and

safety can be enough to drive one to suicide (Olujic). This danger can be avoided, first by valuing the project's effects on participants and their internal images, over the effects on the outer world. Throughout the process, the participants' goals must continue to be the driving force. Justice is the ultimate goal, within the group as well as in the wider social domain.

The one exception is cases when participants' stated goals or ground rules perpetuate their own victimisation. Salverson describes a group in which a participant, apparently willingly, stepped forward to offer his story, but felt traumatised 'used and discarded' (187) afterward. In cases like this, the facilitator must pay ongoing attention to the interactions of the group, and move victimisation from what is enacted among participants, or participants and facilitators, to stories. In doing so, we strive for justice at intra- and inter-personal levels.

One area in which my study of drama therapy has expanded my practice is work with the 'group as a social microcosm' (Yalom 29). The way that group members interact with each other during a session is a representation of how they interact with people in general. Opening up problematic behaviour and attitudes to conscious reflection, questioning, and possible change, is an integral element of all group therapies (Yalom). Drama therapists use dramatic projection to accomplish this (Jones; Emunah; Jennings). Schutzman wrote of Theatre of the Oppressed (TO):

> Maybe what I'm hoping for is rather ideal, which is that whoever was the joker at that moment (when sexism or other oppression is occurring within the context of a TO workshop) could actually use Cop-in-the-Head techniques, or any techniques, to take what was happening right then and there and, perhaps, create a forum. So it could be processed, not necessarily resolved. The idea here is to use our own fundamental knowledge of TO, and our own improvisational powers, to address whatever arises. (222)

Far from being an innovative ideal in drama therapy, the use of dramatic technique to address whatever arises is a keystone of the field (for a concrete example, see Wharam).

In my drama therapy internship, I learned how working with the group as a social microcosm can be useful in promoting justice at internal levels. I was placed at an urban alternative school for youth with mild to moderate behavioural difficulties and learning disabilities. I saw a group of four young men, aged fourteen to seventeen, once a week for sixty minutes, over four months. Axel and Chris had relatively severe learning disabilities, Chris was also coping with ADD (Attention Deficit Disorder), and each group member had occasional to daily difficulty in controlling the expression of his anger, with Axel and Jordan especially noted for violent acting out behaviour. Tony was one of the most highly functioning students at the school; his violence was almost always verbal.

The group members were assigned based on private interviews, during which each stated a preference for quiet, imaginative activities over high-energy improvisation. I was surprised that these apparently angry young men would have this preference. Based on their statements, I made one of my goals for the group the creation of a refuge of quiet, relaxation, and concentration in the chaos of school and adolescence. Additional goals were to raise self-esteem and self-awareness, and to build the abilities of the group members to respect and support each other. I wanted to let each young man know that he could be both himself and a member of a group; and that his contributions would be accepted and

respected. The exact issues through which these goals would take shape were only determined after the first meeting, during which we discussed the group contract.

I introduced 'no insulting' as an informal rule in the first session, but the group's reaction showed me that they needed a firmer limit. During the initial session, Axel and Tony attacked Chris and Jordan. The insults began in creative humour - 'Stinky Patagonian sheep cheese' - but moved into clearly hurtful exchanges involving race and family heritage. The words themselves seemed less important than the reactions they elicited. Chris withdrew, and Jordan threatened to retaliate. It was obvious to me that this behaviour was not emotionally safe; however, every one of the group members was willing to say they 'did not care' if others insulted them, and even that they wanted the 'right' to insult each other 'playfully'. I had the impression that, while they did not enjoy being insulted, it would be considered weak in their tough school culture to desire protection from such abuse. While none wanted to appear to the others to endorse the rule, within the next week three of the group members asked me privately to keep and enforce this rule. I found this an awkward situation: on the one hand, respect for others and self is so basic and important, and I wanted them to have that experience in our group if nowhere else; on the other, I need support from a group to enforce a rule. If I impose a rule from above, group members are absolved of responsibility and are neither empowered nor challenged to demand respect for themselves.

Therefore, although 'no insulting' was clearly established as a group rule by the third session, I continued to allow a small amount of it to occur. This allowed a space in which the group members could begin to take personal responsibility for rule enforcement. Only in the final session was this resolved, with Chris clearly saying 'NO insulting!' to Tony.

The youths' heated energy and discussion around the issue of their being allowed to insult each other, was channelled into the focus of exploration for the duration of the nine-week term. Insulting was explored in many ways in the sessions: by direct discussion, by co-creating the group contract and negotiating enforcement of rules, and by storytelling and enacting fictional situations of insulting and being insulted. During these scenes, emotional reactions to insulting and being insulted were explored, and work was done with individual characters, reflecting the scene or story in a way which emphasised their strengths and positive attributes rather than their aggression. We further balanced this content with experiences of power-within (in visualisations) and responsible, non-aggressive group interaction (in ball-toss games).

It is important to note that the group goals did not become an exploration of insults and power. The group goals were still to promote self-esteem, mutual acceptance, and safety. The exploration of power, aggression, and insults was a means to these ends.

The group members enthusiastically cast themselves as characters in the office of the 'Insult Consultants'. Axel loved this idea, laughed and said, 'Oh, that's my job, I *run* that place.' In character, he passed on his skill in insulting to Chris's character, who wanted to defend himself against bullies. The client was, of course, much insulted in the process. Jordan, the boss, took time off from his passion (writing TV sitcoms) to insult his employee. When they were all finished, Tony entered, playing a janitor. He cussed them all down, swept up, and went home. When the scene was over, and in a follow-up session, each group member was given positive feedback about their character, reflecting their objectives

and actions in a way that emphasised positive, responsible strengths. This scene work recognised and accepted the group members' tendency to verbal aggression, and allowed them to work together to safely express that aggression in a dramatic context. Achieving these goals was more important than the depth of the youths' understanding of power as manifested in insulting.

After this and other scenes, we de-roled, each individual saying how he was similar to, and different from, the character he had created. De-roling is a drama therapy technique allowing actors to consciously separate from roles at the end of a scene. The distance between self and character is one element of what Salverson has referred to as 'the gap' (184). Those aspects of the dramatic experience which point out the difference between actor and character, reality and dramatic world, allow an actor to do things they would not ordinarily do. Thus, new patterns can be initiated and rehearsed. De-roling makes explicit the fact that 'the character I played was not me'. And yet, of course, on another level it was me. By taking a step away from the character, an actor can decide what they want, or do not want, from this role - what they will carry over into life. This conscious shift in emotional distance is empowering because it offers the actor a means to control and define a potentially transformative process.

The path this issue took within the group concretely illustrates the process of drama therapy, as shown in the following diagram.[7] Perceptions of the world influence perceptions of the self, which are externalised in various ways. In traditional group therapy, social interactions are analysed, while in drama therapy we can examine things within the safer realm of the dramatic image. Because the group members are the masters or directors of the images, they can easily criticise them, question and shift them, resulting in changed internal images and self-perceptions as well. Finally, (in a step popular theatre may understand better than drama therapy) those changes in internal images can be harnessed to make change in the world.

It was vital to stand against this group's initial apparent willingness to abuse and be abused. This was one case in which taking the participants at their word would not have yielded change or even an emotionally safe working environment. Instead, I was able to suggest a dramatic context for the group members to appropriately explore the issue of insulting which so clearly fascinated them. By allowing this exploration on the one hand, and yet banning it from their direct interactions on the other, the clients' interest in injustice was accepted, while they themselves were protected from it. The final result was a shift in the internal images of the group members. Self-images became more positive and deserving of respect, and images of power shifted to include the possibility of responsibility as well as abusive dominance.

As facilitators and as therapists, we need to recognise that participants, like the members of this group, are expressing their needs even while they recreate their own victimisation within the group. They are drawn to explore this dynamic and find alternatives. The leader's task is to be aware of this potential acting out of trauma within the group's interactions, and to remove it to the dramatic context. The situation can be recreated within a dramatic image, over which the participant/client takes control. In the safety of the dramatic form, this person can explore and gain perspective over the situation. In Freire's terms (1970), they become subjects as opposed to objects in that situation.

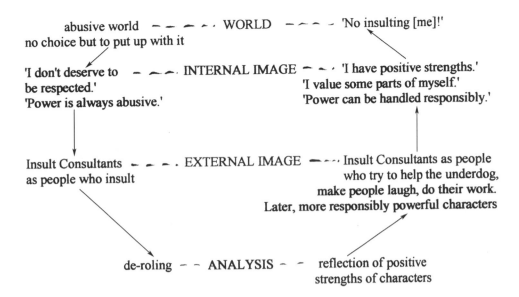

abusive world — WORLD — 'No insulting [me]!'
no choice but to put up with it

'I don't deserve to — INTERNAL IMAGE — 'I have positive strengths.'
be respected.' 'I value some parts of myself.'
'Power is always abusive.' 'Power can be handled responsibly.'

Insult Consultants — EXTERNAL IMAGE — Insult Consultants as people
as people who insult who try to help the underdog,
make people laugh, do their work.
Later, more responsibly powerful characters

de-roling — ANALYSIS — reflection of positive
strengths of characters

Thanks to Lib Spry for this flow chart of popular theatre process.

Thinking back to Concrete Theatre's founding, these questions come to mind: Could we have somehow explored the situation to define perspectives and options, and express opinions? How could we have used popular theatre, scene work, or dramatic ritual to explore feelings about the ending or transformation of a long-standing group? Could we have used similar means to disclose to our participants, our feelings of limitation - for example, our recognition of our own inability to train them as facilitators when we were only learning these skills ourselves? Would this have helped minimise the injustice of the situation? It is relatively easy to see the facilitator, administrator, or funder of a project as wielding power. A participant may also submit to the power of the group as a whole, or to the power of the dramatic form itself. And what about the power of their habitual patterns of interaction, or their own internal images? Awareness of the dynamics of all these relationships is relevant, whether we define our practice as drama therapy or popular theatre. If as theatre workers we intend to use our creative form as the practice of justice, we must be fastidiously conscious of justice and injustice in our projects – at any level. Working with the issues expressed in the group dynamics can be a powerful tool towards that goal.

When popular theatre facilitators and their community partners can identify the immediate goals, and view them in light of the working context; when they remain flexible and allow the choice of when to use theatre and what form of theatre to choose to vary with the varying contexts and varying goals; and when they work in concert with other aspects of development work, they use theatre's powers to best effect.

After the brief consideration of a number of the most common expressions of popular theatre we are still left with the abiding question: what is a popular form? Are there, indeed, a set of forms which belong solely and peculiarly to the arena of the

popular? Intention and function seem to count for more than genre and style when it comes to determining whether or not a particular process or performance falls within the category 'popular'. Levels of participation and the nature of the contact with the audience often set the popular apart from the mainstream. The popular theatre movement, in whatever form it casts itself, is set up in opposition to the notion of leisure consumption which underpins other kinds of theatrical activity.

Once the desire for social change is acknowledged, popular theatre is as much a matter of means as ends. The choice of means relates to the question of participation: should 'the people' determine the nature of the personal and collective change or should the popular theatre worker/company be in the vanguard, leading 'the people' to a better life according to their prescription? In cultural intervention where do the limits of the intervenor's responsibilities fall? Access to forms is an important issue here. Frequently participation is held at the level of role-play and simulation with more sophisticated forms of the theatre process being kept under the control of the professionals. This can lead to the perception that the theatrical art is sacrificed to the social function in popular theatre. But this creates a false opposition since the most disciplined and rigorous theatre is that which communicates most effectively as cultural intervention. Similarly, if the performance fails to entertain its intended audience as theatre, it has no hope of succeeding as an effective, sustained intervention into the consciousness of those who watch it or participate in it. Rather, because popular theatre is seeking results in the sphere of social action, it has to work harder than much of mainstream theatre to ensure that it gets itself onto the same wavelength as the audience, in order that performers and audience are inhabiting the same, recognisable world. The confidence which comes from shared ownership is a crucial prerequisite in encouraging ordinary citizens to take charge of the structures which maintain their oppression and marginalisation.

In formal terms there is a vital distinction between naturalism and realism to understand here. Naturalism is the form which, in the theatre, situates the audience passively as a 'fourth wall' with only an observational role to play in the process. However critical the piece being performed, naturalism presents the on-stage reality as normal, as 'natural'. It reproduces the surface appearance of social relations that is responsible for the inequalities and injustices of the contemporary world. Realism, by contrast, has the possibility of probing beneath the surface to reveal underlying, structural systems which require change if oppressions are to be effectively addressed. In other words, form plays a key role in moving responsibility from the moral value of the corrupt but reformable individual in naturalism to the systemically exploitative structures of the *status quo* which can be exposed in realism. We are back with intention: depending on the declared intention of the theatre process, one form will assist that process where another will thwart it.

5 Popular Theatre Process

Process: the way of doing something. The *how*. When thinking about popular theatre, the notion of process must be looked at as two entwined, but different strands. It is here that popular education most fully informs popular theatre. It is here that progressive community development approaches should entwine and inform the theatre process. Popular theatre encompasses both community education/organising and theatre making. It is chosen by people involved with education and development because of its participatory processes which recognise cultural forms, which engage body and mind, which use specific stories to illuminate communal situations. It is chosen by people who make theatre because it works within communities rather than off in writers' garrets and isolated black boxes; it is useful theatre; it is theatre that matters; it is a way for theatre artists to marry their social and political values with their personal and professional interests.

However, in selecting popular theatre, both groups encounter new territories that they need to learn about. Popular theatre intentions are best realised when the theatre process is embedded in longer-term development work, and when development workers both make fullest use of the theatre and embrace the kinds of time lines implied by theatre processes.

Popular theatre process is, as with all of these elements, highly impacted by other factors, most obviously by intention and context. Processes should and do differ in

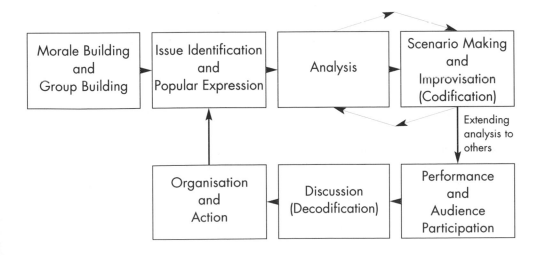

Figure 1

response to community conditions, cultural milieu, community and facilitator goals, and more. However, Ross Kidd proposes a useful overview of effective popular theatre process in Figure 1

However, issue, context and intention largely influence and alter the balance of these activities, their order, and their organisation. Basic to popular theatre process is the high level of involvement of the community which is most engaged in the issues. In many cases, the artistic process is never separated from the community process - artists never 'go away' and create, whereas other contexts lead to a period of high engagement with relevant communities followed by a period of creation which is separate from the full group. This stage of creation, in turn, is followed by another period of consultancy, negotiation and response.

Producing the Process: Processing the Product

Discussion of *process* has, in the past, been hampered by an almost automatic reflex to place the term in a binary opposition to *product*. According to this ancient tendency, drama is concerned with process and theatre with product. In any consideration of popular theatre such a distinction is severely misleading. This notion of theatre as product derives from the consumer culture where theatre takes its place among a galaxy of leisure activities which are purchased by those who can afford its products. Its function is not in essence any different from the benefits to be derived from a visit to the health club, the golf club or the night-club. The interactive component is confined to the purchase of the ticket and the ritualistic applause at the conclusion. There may also be the club-like pleasure of a conversation with like-minded individuals in the bar at the interval, typically focussing on some aspect of theatrical aesthetics such as the degree to which a particular performer was 'convincing'.

In popular theatre the audience, even in those instances where it is not called upon to intervene actively in the performance, is engaged on a different level if the piece is to be in any way effective. In non-participatory forms of popular theatre the performers are making an act of engagement with the audience as a consequence of the ways in which the performance has been created. For example, a writer may have researched the community, or a similar one, in the process of developing the script or the performers may share a common history, common politics, or common oppression with the audience. By such means the audience and the performance inhabits a shared discourse out of which must emerge the need and desire for action in the 'real' world. More than consumption is called for: a social action or at least the possibility of taking action because social relations are alterable must have entered the minds and imaginations of the audience. This is the fundamental requirement of Brecht's theatre which recent popular theatre practitioners such as Ross Kidd and Augusto Boal moved onto the plane of physical action to accompany the intellectual engagement at the heart of the Brechtian practice.

Another limitation of the binary opposition of product and process is that it fails to take account of the processes that go into the creation of the product and does not

allow for the possibility that a product may occupy a position within a larger process. It is common, for instance, for a theatre for development project to commence with a performance from the facilitators which may operate simply as an opening ceremony, a gift from outsiders to the community, or may be intended as an agitprop piece of consciousness-raising conceived as a prerequisite to the participatory phases of the longer process of the whole project.

Whether dealing with active or mental participation, the particular attraction of theatre over other forms of development is that it engages the whole being of the individual and the collective spirit of the community. Many development initiatives have failed because they deal only with the level of reason and information and do not address the structures of feeling which bind communities. The causes of human action and inaction have as much, or more, to do with people's emotional conditions and the myths by which they live as they do with a reasoned analysis of what addresses their best interests most effectively.

The Creators

Who does the work?

The question is central in examining or planning any theatre or development project. This question includes some others: Who owns the work? Who determines the content? Who shapes the content (and thereby likely shifts its meanings)?

Within popular theatre work, the 'who' is one of the more volatile factors. Freire's influence has moved many popular theatre workers from a position of the 'artist' creating plays of social criticism which tell stories of the dispossessed and critique the *status quo*, to increasingly greater involvement with both the community which is most impacted by a certain issue, and the most oppressed in our society.

Theatre which once was created *for* the people, came to be much more fully created *with* the people and in some cases, moved to theatre created *by* the people.

In Canadian and British popular theatre practice, this element, the *who*, often quietly leads the way in the process of decision making. Animators and artists find 'a place to do their work' and a way to fund it, and determine not only that they will be part of the project, but also how and in what way they will interact with community.

Other factors can and often do impact who are the creators (who do, after all, largely control the content). At a basic level, a theatrical project is not popular theatre if community members, those most impacted by the conditions under examination, are not in control of what is performed. However, how this happens, and to what degree, is dependent upon all sorts of matters of context: community members' availability, level and source of funding, the intention of the performance element in a project, to name but a few.

Well-meaning artists, however skilled, are not necessarily the best people to be in a performance of a well-meaning project. One may have made that choice for all sorts of good reasons, and it still may be 'wrong', or not as effective as if the people who are actually involved in the situation take on the roles. Sometimes there is great cost in

choosing to have the community members perform. After all, acting is a skill and talent that can be nurtured, that some people become expert in. And this is not to be dismissed. To place it in the extreme, do you want to be able to see, hear, and understand the performers? Does this matter as much, or less, than other aspects? For example, does it matter as much as the audience believing, indeed knowing, that the actors have lived the stories they are telling? Does it matter as much as the audience recognising and knowing the people on stage? Is the 'artistic accomplishment' as important or less important in a given circumstance than the sheer pleasure of watching an accomplished artist do what they do best?

The above is a false dichotomy of course, made extreme to raise the questions.

If performers who have lived the story/issue present it, they model a courage to take action on their own behalf right there, in the performance.

If the piece is interactive, can a non community member go into the unscripted parts of the event with enough knowledge of the world and the life they are presenting to offer 'true' responses when challenged or questioned?

What reads off the stage above and beyond the acted moments? Does the courage required to perform a difficult story, or a fire behind the need to tell/enact that story, mean more ultimately to an audience? Does it provide more meaningful theatre experience than a 'well crafted' and committed performance from someone who has not lived such a life?

Which is the audience, this particular audience, inclined to put more stock in?

And here we can also cross into questions of popular forms of performance. Community members may well not be 'actors' as the theatre mainstream has defined it. However, what if they are performing within popular cultural forms? Part of development action can be to reclaim and to highlight local cultural expression, and who better but the local practitioners. At this juncture in our history, when 'globalisation' is tending to include the erasure of cultural identity, the vitality of local cultural forms is central to communities' ongoing health. Some of the question of performance ability is tied entirely to forms which may not be those which are natural to the community.

And the forms may not seem to be theatre. What are the indigenous games, music, dances, forms of humour? How might those be a part of the *popular* theatre work?

Many debates within the arts community and within the development community, circle around the question of *who*. Some believe that the process is about putting the cultural tools, in this case theatre, back in the hands of the community; their work, in Canada at any rate, is often expressed in forum theatre work, where community members perform the forum piece as well as develop it, or in collective documentary work, where community members express their stories or their perspectives on an issue through theatre performance. Others, concerned with accomplishing a level of performance only possible with trained actors, or interested in the use of various other theatrical styles, may engage deeply with a community throughout the play making process, in order that professional actors perform the result. Many projects move between these two poles, with various blends of 'community members' and 'visiting artists' and with 'trained artists from the community' playing roles.

Becoming One With the Mud –
'Running Through The Devil's Club': A Theatrical Exploration in Healing
Deborah Hurford

April 15, 1995, Prince Rupert, British Columbia
> Seven Sisters and Me
> Sucking the Poison from our open Wounds
> Scream and Spit
> Snarling Crazy Wild Eyes
> Glaring Back through the Windshield
> Ghosts among Us
> The Smell of our Blood is Scaring Us . . . [8]

(The scent of sandalwood incense lingers as you enter the theatre. The stage is dimly lit. A drum set, including bongos, two floor toms and a cymbal, is placed up stage right; a semi-acoustic electric guitar, rain stick, microphone and stand are placed up centre; and two keyboards are placed up left. Forty, six-inch white candles, in small and medium sized earthen flower pots, are placed on the floor in front of the musical equipment and on the sides of the stage, to create a semi-circle which outlines the playing area. Five satin saris/shawls/skirts, each a different shade of purple (dark pink to cobalt blue on one side, and mall black on the other), are neatly placed in front of the candles. Three women enter and take their places behind the instruments. They are wearing different styles of black dance skins and purple saris/shawls/skirts which are draped over their bodies in different configurations. Their faces are smeared with mud.)

March 7, 1995, Saskatoon, Saskatchewan
> My eyes are powerful . . . I look scary. My hair is wild. I look like a wild woman . . . I am ugly and beautiful at the same time.

(The lights dim to black and a haunting soundscape begins. Five women, in different styles of black dance skins, enter in the darkness and crouch down in a small circle, down stage centre. As the vocalist speaks in the darkness, one of the women lights a fire stick and slowly raises the flame above the heads of the women. In unison, they light their fire sticks from the original flame.)

May 12, 1995, Edmonton, Alberta
> Bertha says something happens when she lights that match. Something she can't explain. It's like there are Spirits in the flames.

(The women ceremoniously light each of the candles in the semi-circle which surrounds the back and sides of the stage. Their silhouettes become illuminated by candle light, and are slowly enhanced by stage lighting.)

Vocalist:(Speaking)
 Someone once told me
 That my guiding spirit is the Coyote
 The Howler
 The Trickster
 The Hungry One
 Starved for Chaos
 Grinding in the jaws of the blackest night
 Always running ahead of the pack
 Circling back to watch the others from a distance
 Hiding behind the branches
 Staring
 Watching
 Until a twig snaps
 And everything changes
 The moon exposes you
 Melting in its heat
 You can't help but bare your teeth
 The hunt begins . . .

(All text is taken from the performance script *Running Through the Devil's Club*, by Deborah Hurford *et. al.*, a collaboration in association with Azimuth Theatre, 1994.)

(When the Vocalist has finished speaking, all of the candles have been lit. As the Vocalist sings, one of the women dances wildly around the stage with her sari while the other women, each holding a candle, slowly circle around the audience in the form of a procession. When the song subsides, the women have returned to the stage and are in position for scene one.)

'Hi'. I smiled as I opened my office door. 'My name's Deborah Hurford and I'll be facilitating and directing the show. Come on in and have a seat right over there. Before we get to the actual audition, I'll just explain a bit about Azimuth Theatre and the project so you'll understand why I'm interviewing you as part of the audition. Azimuth is a non-profit, charitable organisation committed to the development research-based performance art which examines critical issues and empowers individuals, institutions and communities to initiate positive change.

Devil's Club: A strongly aromatic shrub which is densely covered in spines and prickles;
'I'm looking for four women to research, write and perform a play on the issue of sexual abuse and assault. I just finished touring a play about violent men to maximum security penitentiaries throughout western Canada (*Maelstrom* by Paul Austin and Lorne Cardinal *et. al.*). In the post-performance panel discussions, it became apparent that a play about sexual abuse and assault would be useful for women in prisons since, according to the Correctional Service of Canada, the majority of incarcerated women are survivors of sex crimes. I would

like to develop the play over the next two months, and test it at the Edmonton Fringe Festival. Then, sometime next year, I would like to tour it to women's prisons in western Canada'.

Three months before the onset of the project, a Metis artist friend of mine had told me that my Guiding Spirit was the Coyote. We discussed native spirituality a great deal and he introduced me to the concept of nature as a healing force.

'I'm looking for four women of different ages, ethnic origins, and body types, who are from varied backgrounds, to represent a cross section of 'women' in the world of the play. Of course, I'm aware that males are also effected by sexual abuse, but this project will focus specifically on the female experience - it will be women centred. I want the artists to come to the project as artists, but also as women. I want them to approach the issue from an intellectual, emotional, physical, sexual and spiritual point of view.'

The prickles of the Devil's Club produce a festering wound;

'I've been thinking about doing this piece for a long time. When I worked as a Crime Prevention/Community Relations Officer with the Sherwood Park Royal Canadian Mounted Police, I facilitated a play on suicide with a group of teenagers. During the process, one of the girls in the cast was triggered into remembering her sexual abuse and I tried to help her get into counselling. It turned out that there was a two month waiting list at the Sexual Assault Centre because her abuse was not immediate. It was an extremely frustrating time for me and I told myself that one day I would produce a play about sexual abuse. Since that time, I have come to realise that numerous women in my life have been victims of sex crimes. As a result, my conviction to develop a play on the issue has just grown stronger over the years, and the overall structure of the piece has been percolating in my head.'

Two months before the beginning of the rehearsal process, I had a dream about a Wolf. It was trying to attack me, and I was karate kicking it and screaming at it. When the Wolf retreated, I stared it down. Dreams of the Wolf continued throughout the process, and I started believing that perhaps it was trying to teach me lessons about myself.

'I see two 'worlds' in the play: a realistic world in which the characters tell their stories, and a spiritual world which represents the collective consciousness of all survivors. I would like to integrate dance, movement, and vocal intoning, as well as 'the elements' - fire, water, air and earth, into the spiritual reality, so I see us using candles, incense, mud, and veils. I would like the artists to be grounded in their own spirituality, and I would like this to be evident both in the process and in the final production.'

Devil's Club is used heavily by West Coast Indians for both medicinal and 'strong magical powers'.

'We will attempt to uncover the stories of survivors and sit with the pain, the despair, the guilt, and the struggle to heal. I want the artists to interpret the stories and transform them into a theatrical experience. The stories will name the truth, but they will be told with dignity and respect. I see the play as an offering. A way of giving the stories back to survivors as a gift, as a means of validating their experience.'

February 28, 1995, Vancouver, B.C.
. . . It's been so crazy, painful, tense. I'm trying to connect with the reasons I am doing this tour - and the reasons I do this work. Sometimes I can't remember . . . I am shedding layers and layers of skin . . . trying to discover who I am, what I need and want. I'm not sure what will result at this moment. I guess I'm sitting with a lot of confusion right now.

'I have been working in the fields of family violence and popular theatre for the past eleven years, and have come to realise that violence is on a continuum. We are all situated on that continuum both as victims and as perpetrators. Clearly it's more complicated than that, but I can see that men are hurting as well - obviously, for very different reasons than women. Our society, as a whole, needs to do some serious healing. I don't want this to be a man bashing play. And I don't think it's really useful to present a lot of depressing stories that say 'ain't it awful', and just leave it at that. Survivors are strong and resilient people. They have managed to endure these horrific experiences and they still get out of bed most days. Survivors need to 'see' that. The play must celebrate their strength and their ability to heal. The play must give us all a sense of hope.'

Image/ A Pair of Broken High Heels Lying in the Middle of a Dirt Road

'This project will be very difficult. I'm sure there will be times when you'll feel sad or depressed or angry or overwhelmed. So I need to know that you have a support system in place. People to talk to, healthy ways of dealing with stress. I don't need to know if you have experienced sexual abuse or assault but, if the process works as it should, you will probably be triggered into remembering issues of loss in your life, and you will have to deal with them during the process. If you are a survivor, I need to know that you have dealt with your issues enough that you can focus on the task of creating and performing the play. Of course, the cast will be a source of support, and I can certainly refer you to appropriate resources if the need arises. A number of sexual abuse and assault specialists will be consulting with us on the project. So, do you have any questions before I ask you to present your monologue?'

April 2, 1995, Chilliwack, British Columbia
A guy in Cranbrook looked me in the eyes after the show and said, 'You have Coyote. You can be strong.'

During the auditions, I attempted to ensure that the artists understood that I was more interested in their willingness to explore the issues in an honest and collaborative manner, than I was about their previous theatre experience. Once I started talking about the project, the women immediately opened up and shared their personal thoughts about sexual abuse and assault. I got an immediate 'gut feeling' about each of the women within a few minutes. Clearly some of the candidates were not truly engaged with the issue. Some were frightened of exploring the issue, or quick to tell me that they were opposed to presenting 'graphic' material. Others immediately started telling stories about women in their lives who had been raped or abused. Some of the women shared their own experiences with me. I remember feeling somewhat surprised by their openness since

I had not asked any of them to share. In retrospect, I realise that I had simply given these women permission to talk.

I have never cried so much in my life. Sometimes I thought I would literally crumble to the floor, sobbing, if I heard one more person tell me a heart wrenching story about how they had been violated, or how they had raped and murdered someone. Funny, but this sense of calm and strength would just wash over me every time someone started disclosing. There's some powerful force that supersedes your own pain when you know that someone else's pain is greater. I learned how to breathe very deeply. I accepted the fact that sometimes tears were going to roll out of my eyes when I didn't want them to. And people were okay with that. I didn't feel disempowered in those moments. I felt human.

Throughout the first round of auditions, I made a personal connection with nearly all of the women. Their monologues and songs were the most grounded I had seen in any series of auditions over the past eleven years of my involvement in theatre. It was a moving experience for me, and I found myself hugging most of the women before they left my office. We had shared our mutual concerns about an issue which had ultimately affected us all.

The main criticism of the piece, in the post-performance discussions, was that it did not include male victims of sexual abuse and assault. We explained the intention of creating a women centred piece, and pointed out that, according to statistics, females are victimised more often than males. This issue was raised a number of times by both men and women. On some occasions, it seemed as though it was a genuine concern and, since touring this play, I have no doubt that there are a great number of Canadian men who were sexually abused and assaulted as children, but have not reported it to anyone. However, on occasion, it felt like some audience members were attempting to deflect from the issues of male dominance and traditional gender role socialisation. When we felt that audiences were avoiding these issues, we assertively encouraged men to get together to write a play about the male experience in this regard. This suggestion seemed to surprise audiences and it ultimately allowed us to refocus the discussion.

Casting this project was extremely difficult. Each time I selected a possible combination of women, I eliminated a critical representation of age, ethnic origin, body type or theatrical skill. After several sleepless nights, I modified the project budget and selected five women of different cultures, experiences and ages to collaborate on the piece. As originally planned, a female percussionist and a female composer/pianist were also selected to collaborate with me on the development of the music/sound.

Image/ A Woman Examining Her Naked Body in the Mirror

I wrote the theme song for the show one night after we went running in a field by Mill Creek Pool. We went down to the river with a bucket of water and some towels, and we just started smearing mud all over ourselves and each other. When we were all covered in mud, we started running through the field in our bare feet. Faster and faster. Swishing our skirts in the air. Laughing and jumping. Feeling the dirt in between our toes. Without us knowing, a group of teenage boys had gathered to watch us from the top of the bank. They started yelling 'Run you bitches! Run!' When we stopped and looked up at them, they took off on their bikes.

The script-writing process began with a two-week in-service on sexual abuse and assault. A number of family violence specialists and survivors came to speak to the cast, and we watched videos, took notes, and waded through stacks of reading material. Several themes evolved, and were placed on a white board. Eventually, each woman claimed these themes and character traits through a slow process of elimination. With the assistance of the group, each woman built a character around her selected themes, while mixing and matching stories which had been shared with us by numerous survivors.

It was difficult to ground the process in spirituality when most of us were still trying to define our own spirituality. After several discussions, we discovered that only one of the cast members appeared to be anchored in an organised religion, and the rest of us seemed to be disconnected or searching for something else. Nature as a healing force seemed to unite us spiritually as a group of women. We simply collected, modified or imagined rituals which we thought might assist us in our process.

Image/ A Naked Woman Squatting Erect in an Open Field to Urinate

All of the actors smeared mud on their faces during the play. 'Becoming one with the mud' represented something very different to each woman. For some, it symbolised how 'dirty', 'marked' or 'stained' survivors often feel; for others it represented the mask of denial worn by survivors who choose to deny their abuse and its impact on their lives; others saw playing in the mud as a means of reclaiming the lost childhood which was stolen from them, or a way of cleansing oneself with mother earth. Playing in the mud was a wonderful, freeing experience. It had a profound impact on us, as well as anyone who viewed us.

We brainstormed possible journey skeletons for each character, and then the women would go away and write scenes individually. Often women would pair up and audio tape improvisations of scenes if they were having difficulty writing. Eventually, the scenes would be shared with the whole group for feedback and dramaturgical support. It was an excruciatingly slow and difficult writing process, but it ultimately captured the honesty and cohesiveness necessary to ensure the integrity of the piece.

Image/ A Man Holding a Woman Face Down on a Car Seat While Another Man Rapes Her

Some of the women in the cast were survivors. Slowly during the rehearsal process, the women began disclosing experiences, as they were triggered by the research and discussions with other survivors. We discussed personal boundaries at great length because, as a facilitator, I did not want the women to present their own stories on stage. I felt like it would be asking them to prostitute their stories, and I didn't want to be a pimp. Despite my references to this metaphor, some of the women were still in favour of presenting their own stories. Conversely, other cast members, some of which were also survivors, were adamant that they wanted to be perceived by audience members as artists, not survivors. I wanted to ensure that we all made clear distinctions between our own experiences and those of the characters we were creating. I felt that this was important for our mental health and personal

140

'safety'. I wanted the artists to channel their passion and empathy for the issues into a fictional character which was based on a compilation of true stories. In the end we compromised, and segments of some cast members' real stories were integrated into the play, largely because these women were so connected to them. I think this added to the authenticity and sacredness of the play, and it created a profound sense of respect amongst the women, and for other survivors. In many respects, I think it was an empowering experience for the survivors because thousands of audience members unknowingly validated their stories and celebrated their resilience. On bad days, however, when we were emotionally and physically exhausted, I think some of the survivors felt revictimized by presenting parts of their own stories on stage.

Image/ A Wolf Ripping a Woman's Throat Open With Its Teeth

The most painful thing for me on this tour was watching this group of women withdrawing from the larger group in order to cope with the demands of the tour. We were a diverse group of women. We came from different backgrounds, and had different interests, values and beliefs. We were always bleeding at the same time, and that proved to be volatile when we were under stress. Looking back, I can see that there weren't many times when we weren't under the gun in some way or other. There were times I loved each of these women in such a profound way that I cannot accurately express it in words. There were also times that I was angry at, disappointed in, and ashamed of each one of us. I guess we all had normal responses to abnormal situations.

Image/ A Man With Tears in His Eyes

I know from my family violence training with the Royal Canadian Mounted Police that sexual abuse and assault is about power and control. The perpetrator is not seeking sexual satisfaction, although that may result during the act. The perpetrator is overpowering, controlling, manipulating, humiliating and degrading the victim. Sex is equated with power. It is commonly agreed, among therapists who work with sex offenders, that empathy training is a vital step in the rehabilitation of sex offenders. If they cannot recognise that their victims are thinking, breathing human beings, rather than objects, sex offenders can easily deny the impact of their crimes and rationalise justifications for them. A sense of empathy assists sex offenders to understand the impact of their crimes on others, as well as identify the relationship between sex and power.

Image/ A Prisoner Lifting Up His Muscle Shirt to Exhibit His Nipple Ring and Tattoos

We were bombarded with performance requests from prisons throughout western Canada - many of them housed males, and many of these men were known sex offenders. After much discussion amongst the cast members and representatives of the prisons, we decided to perform the play in male institutions, as a form of empathy training. Our biggest concern was the possibility of being (re)victimised by the men. As it turned out, many of these men had been victims of childhood sexual abuse, and could relate to the stories in the play. In the

post-performance discussions, we attempted to validate the stories of the male survivors and encouraged them to seek assistance from the institution psychologists.

Often male inmates were angry after the play, and openly stated that sex offenders should be killed. This attitude seems to be based on the fact that many inmates, or their loved ones, have been victims of sexual abuse and assault and, as a result, their anguish and anger are triggered. We attempted to challenge these men to recognise the irony of using violence as a means of stopping violence. The post-performance discussions were very heated around this issue, but inmates would often hang around afterward to continue the dialogue, disclose, discuss the play, or thank us for our performance. The piece obviously acted as a catalyst for critical thought and discussion in prison environments, despite the fact that on some occasions, both inmates and guards attempted to flirt with us or impress us. The relationship of power, particularly between these two groups of men, was quite evident and, I suspect, affected by our presence in the institutions. Sometimes it felt like these men just didn't get what the piece was about and, other times, it seemed like light bulbs were going off all over the place. Ultimately, the cast members were very conscious of personal boundaries in male prisons, and essentially assessed and responded to each interaction on an individual basis. Some of these performances were extremely inspiring, and others were completely frustrating.

Image/ A Woman Mutilating Her Arm With a Disposable Razor Blade

Once each character's individual journey was complete, we cut and spliced the scenes together in the form of five one-woman shows unfolding side by side. The script was structured in such a way that the stories were always going back and forth between the women in a seemingly unstructured manner. When one woman was speaking, the others would freeze while remaining 'in character'. As a result, the stories managed to comment on each other despite the fact that the characters were operating in separate realities. In each series of scenes, the journeys had a common thread, such as the character's typical day at work, or the event which triggered memories of her abuse/assault.

It was extremely difficult to perform the play to incarcerated women. They were by far our most volatile audiences since, clearly, most of them were survivors. They often sobbed throughout the entire performance while we choked back our own tears. Sometimes, particularly after the flashback scene which described the characters' abuse, women had to leave because they couldn't bear to watch their own stories unfolding again before their eyes. Fortunately, they would usually return, with a friend or caregiver by their side, to see where the characters had ended up on their healing journeys, or to participate in the post-performance discussion. Despite the excruciating pain, for both the women in the audience and the women on the stage, these performances were the most meaningful for me. It was so moving to see these wrist-slash scarred, massively tattooed, seemingly unbreakable, broken women actually 'see' their experiences validated, and their survival celebrated. They would literally cling to the performers after the discussion, hugging them, touching them and exchanging stories. Often the survivors in the cast would disclose their own stories of abuse and assault with these women, and they would offer encouragement and support to each other. It was a profound, communal healing experience.

After each series of scenes, the characters would come together as a community of survivors in the play's transitions, or spiritual world. While the songs were sung or voiced by the vocalist, the women would share a collective reality; dancing with the candles, vocally intoning, as well as interacting and supporting each other.

Various drafts of the play were read to the consultants who had participated in the original in-services with us, as well as a number of local artists. The first draft of the script was quite dark and hopeless, since it largely focused on specific instances of abuse and assault. After obtaining feedback from the consultants, we realised we had to create three-dimensional characters, with current 'lives', who happen to all be on separate healing journeys.

One night, while we were touring, I had a dream that the Wolf approached me in a dark forest. It was night. I was naked and all alone, but I wasn't afraid. It wasn't going to hurt me. I started stroking its coat - caressing it with my hands. I climbed on top of it, wrapped my arms and legs around it, and hugged it with all my might. Its fur was so soft against my naked body. I felt safe.

In the spring of 1995, seven women and I toured *Running Through the Devil's Club* to community halls, school gymnasiums, prison chapels and theatres throughout western Canada. We presented the play and post-performance discussion on seventy occasions to teenage and adult audiences from the Queen Charlotte Islands and Victoria to the federal Prison for Women in Kingston, Ontario. The three month tour was gruelling. Travelling by rental van, ferry and aircraft, we visited remote communities, large urban centres, reserves, conferences, university and high school campuses, as well as male and female federal correctional facilities which housed known sex offenders. We were uncovering and sharing the stories of survivors as a means of stimulating discussion, solidarity, action and hope.

A month after the tour ended, I had my last dream about the Wolf. I was in my house - searching for something. I opened a white closet door, and the carcass of a dead Wolf was lying on the floor. Its fur was matted with bright red blood. Its eyes were closed. I felt nothing. I closed the closet door, and kept searching.

Running Through The Devil's Club was an attempt to expose and eradicate sexual violence against women by way of a sacred theatrical process of purification and celebration. It was supposed to be a gift – to survivors, to the artists, and to our society. The play was a magnificent spray of colour, light, tears and hope spiralling off the stage into the hearts of audience members and survivors everywhere. It was a magical journey. But behind the scenes, in the wings, rental vans and hotel rooms of the performers, the process provoked a wrath of anguish, powerlessness and rage. Several of the artists began emanating the very behaviours they were trying to annihilate, and the group ultimately imploded. Perhaps it happened because we were women, because we were survivors of all types of personal and cultural violence, because we did not have the skills to resolve conflict or cope with the pain. Because abuse is imprinted in the cells of our bodies. Perhaps it was also because it is virtually impossible to create a healthy, non-hierarchical, non-destructive process to hold and nurture the artists, and the work, within the context of a violent society.

Naked, facing forward, standing here and now. On the edge of this body of water. I am alone. Coyote is behind me, in the trees. But my heartbeat is calm and steady. Heart beat Heart beat. Silence. I am inbetween.

We were all damaged by the process. I need to name that clearly, and honour it. Research-based theatre about sex, power and violence is dangerous. The artists have to recreate the terror in order to validate and release it. And in order to cope with the excruciating pain, as well as the emotional strain of absorbing horrific stories of abuse over long periods of time, the artists unknowingly begin to mirror the culture's dysfunctions back onto themselves and each other. And because that irony is often too painful to acknowledge in the moment, we retreat further into denial or isolation.

Heels in the Sand, toes in the lake. Dried Mud in my hair and up my nose. Cracking off my skin in chunks. Pulling.

Sometimes it feels pointless, but I am attempting to create unforgettable theatre. Theatre which challenges artists' and audience members' assumptions, perceptions and choices. A process which unites artist and community in a celebration of our humanness.

Pinching. My skin is Screaming. Blood is running down the inside of my legs. But I am calm and steady. Heart beat.

But I still struggle with the process. I struggle with the appropriateness of casting survivors to play the roles of survivors in a play which explores sex, power and violence; with women behaving like they are healed. My methodology requires artists to disassemble their personal experiences and resurrect them in a sacred theatrical form. Art, and this process, cannot merely exist within the realm of personal exploration – that is simply therapy. But the process, and the sharing of the work, must be therapeutic. It must alter the artists as well as the audience members. The personal experience is the spark, the impetus for the journey. But the personal experience only achieves its divine meaning, its greater purpose, when it has been abstracted into a shared theatrical ritual. Clearly, this task demands considerable training, skill and experience. And the process must provide immense support, compassion and time.

My toes squish the Sand. My heels rise, one leg at a time. I step forward. Ripples. Mirrors. No Sound.

Today I know that I would never facilitate this process in exactly the same way. I haven't lost faith in the potential of theatre as a healing force, or the potential for a project of this nature to work. *Particles of Sand slowly rise and make the water murky.* Did we expose and eradicate sexual violence in our culture? Was our sacred act objectified? Debased? Denied? Was the price that we paid as artists, and as women, too high? (She smiles). The questions are too loaded. It's a matter of degrees, and frozen moments in time.

Transformative Fictions

As we have noted earlier, popular theatre shares many common roots in radical pedagogy with community education. Any learner-centred praxis must take account of the social environment of the learner. Inevitably, therefore, society has to be viewed as an object of study, capable of being transformed by its members. Patterns of relationships at micro and macro levels reveal the oppressions that limit human potential and distort the free-play of development. Not only are members of communities the subjects for adult education but the community itself, as a sociological entity, becomes an object of study. This is the notion lurking behind Brecht's search for

a 'scientific theatre' - a theatre capable of mounting an analysis of society which takes account of the realities of all its members. In the broadest of senses Brecht took Marx's analysis of society and applied it to the theatre or, if you prefer, applied theatre to *it*, even as Boal was later to take Freire's notion of critical pedagogy and explore ways of constructing theatre in a spectator-centred way. Boal had the advantage of working with Freire in marginalised communities, sharing practice and together developing a praxis. The relationship of Brecht to Marx is not so close since Brecht came at Marx solely via the latter's theoretical writing in which there is very little written about culture as such. Often, though, the broad principles derived from Marx gave him the necessary ideological starting point for his theatre practice: 'I wanted to take the principle that it was not just a matter of interpreting the world but of changing it, and apply that to the theatre' (Willett 248). In both cases, however, that of Brecht and Boal, there is a search for theatrical form designed to allow not only the depiction of working-class and marginalised peoples in the theatre, but also the access to theatrical means of production for those sections of society to which this has traditionally been denied. Brecht's 'grand pedagogy' which 'abolishes the system of performer and spectator' (Weber & Heinen 35) was fatally interrupted by the coming to power of the Nazis in 1933 and thus prevented him from achieving the radical pedagogy which is outlined in the *Lehrstücke*. Predating popular theatre rhetoric, he asserted that in these works it is the participants who learn and the presence of an audience is an optional extra. Much of the essence of Boal's thinking on forum theatre derives from Brecht's experiments of the early 1930s in social conditions which were not to be repeated in his lifetime.

In both cases the dramatic process, whether or not it develops into theatre, is not an end in itself. It is rather the means towards an analysis of the social structures and hegemonies which maintain patterns of oppression. If the result of the analysis is action, this takes place beyond the theatrical space in the 'real' world: in which case the rehearsal has turned into revolution. Although the emphasis in the theatres of Brecht and Boal falls in different areas, both are closely related to the practice of a critical pedagogy. For Brecht, operating under conditions of bourgeois hegemony, the central project was to alert audiences, particularly those drawn from the sections of society most likely to be desirous of political change, as to the real workings or deep structures of capitalist organisations. This is why the notion of *verfremdung* (distancing) figures so prominently in his theatrical discourse: it is concerned essentially with the process of defamiliarising the audience with the bourgeois world in order that it may view it, not as an inevitable norm, but as a particular form of social and political structure; man-made and susceptible to the ever changing processes of history. Boal's theatre is also about confronting people with the challenge of changing what is usually presented as unchangeable. These changes may need to take place at the inner level of the psyche, 'the cop in the head', or at the outer level of social organisation on a micro scale such as the family or a macro scale such as the state.

Some notion of 'popular' can be applied to these instances whether it be the raising of popular consciousness in order that the conditions for action beyond the theatre can be created, as in the case of Brecht's epic theatre, or ordinary people taking control of

the theatre process itself in the form of Boal's forum theatre or any of the other strategies adopted for popular theatre.

The Nature of Popular Theatre Process

Programmes of community development initiated from centres of power outside the communities are usually driven by needs analyses which, whether arrived at through research methods that have included the community or not, rely on data arrived at by the application of reason, common sense, and informed opinion. These sources all too often neglect those other sources of local knowledge, intuitions, sense of well-being, identity, alienation and contradiction which a thorough involvement with a theatrical process can reveal. As an art form theatre is concerned with the totality of being human and participatory forms of theatre engage the participants in ways which enable them to articulate that humanity. The space, notwithstanding Peter Brook, never empty but ideologically constructed, is one where the consequences of being human can be rehearsed, developed and analysed without rendering the participants vulnerable to reprisal for daring to articulate what those consequences mean for them. This is not to say that at times and in places it may not be very dangerous to express this sense of being human, and the theatre and those who work in it have down the years proved regular targets for repressive regimes unable to tolerate versions of humanity which have conflicted with their own. However, for those actually engaged in the process, in the moment of improvisation or performance, there is a sense in which anything can be risked, in which the 'unsayable' can be said, the 'undoable' done and then, if necessary, undone.

This is why theatre is at the heart of the self-development process. It is a collective form of rehearsed action, available for repetition and analysis, capable of incorporating a wide range of expressive forms that can encompass the whole reality of the individual and the community. Because of this, the dangers of easy solutions and false harmonies can be more effectively resisted so that development action occurs which takes account of conflicts and contradictions. Such action is more likely to be of lasting value to the community than any magic solution which forces art and reality to part company.

> The integration of content and structure right at the beginning of a particular project is central to the process of popular theatre, for what is being presented is not just 'oppression' but a specific experience of oppression. Through the process of the drama there is a precise exploration of that experience (the concrete situation) as well as of 'oppression' (a theoretical abstraction). When the popular theatre activist says the work is by, for and about (community members) in his or her society, this is what he or she means. The work, therefore, is not a superficial protest drama. A great deal of rhetorical posturing about revolution is swept away. (Bappa and Etherton, 29)

Participation

The short history of theatre for development demonstrates a continuous movement towards fuller, genuine participation by ordinary people in its processes. The work of Augusto Boal's Theatre of the Oppressed has been heralded as a great advance in participatory theatre with the creation of the new category of 'spect-actor'; one who views the theatre spectacle presented by the 'expert' performers and then intervenes in the action to make it more real in terms of the intervenor's life experience. But with the formalising of this system and the installation of the Joker as the key figure in control of the process, there are already critiques being mounted on this work on the grounds that the modes of participation and the rules for participation are too much in the hands of agents external to the community; binary oppositions of 'oppressed' and 'oppressor' may not effectively represent the reality of every situation and may not provide an appropriate point of entry into the improvisation. Once again it is a question of ownership: for whom is the work being done? Who has the power to determine which is the right way to generate the process?

Theatre for Living
David Diamond (Headlines Theatre)[9]

My history doing *Theatre for Living* work with First Nations communities goes back to 1986 and the very first *Power Play* workshops. I had had my first contact with Paulo Freire and Augusto Boal in 1984, had experimented with Theatre of the Oppressed techniques with some friends and had decided to try to put together a workshop that took people in communities from 'zero to performance' in a week. The only way to see if it would work was to try. Word went out across British Columbia and eight week-long workshops were booked, three of them in First Nations communities. They were a tremendous success.

In 1987 a three year project on issues of ancestral land started with the Gitxsan and Wet'suwet'en Hereditary Chiefs in the area around Hazelton, BC. This was *No` Xya`* (*Our Footprints*), which toured BC, Canada and New Zealand. During this time I was very honoured to be given a Gitxsan name (*Aphleexw*, which means 'spider') by Gitxsan Chief Baasxya laxha (Bill Blackwater Sr.). This happened in a ceremony in Kispiox. Two subsequent First Nations projects that also became very large were: *Out Of The Silence* (1991-92) and *Reclaiming Our Spirits* (1996). The former was a touring forum theatre production, initiated by the United Native Nations and the Urban Representative Body of Aboriginal Nations on issues of family violence (also broadcast live by satellite on BC's Knowledge Network). The latter, initiated by Lisa Thomas and Mary Martin, Nuu-chah-nulth women and founders of Native Families in Crisis in Ucluelet, BC. *Reclaiming Our Spirits* was a workshop tour that went into ten First Nations communities throughout BC, creating forum plays on Residential School issues as part of a province-wide healing initiative. Over the years there have been at least fifty projects with various First Nations across Canada and the US. I am giving you this history to try to put the following writing about a specific project

inside a context. Word travels inside and among these oral cultures. I believe the invitations (my work is by invitation only) come from a building of trust - trust that my agenda is simply to create an environment where people can use the language of the theatre to express themselves - to tell their own stories. Not to 'teach', not to 'study', not to 'anthropologize'. The communities themselves own the work.

My practice in a workshop is to create a report after each day. It is mostly subjective, and gives me a record and insight into how the work unfolded. It is one of these reports that I am sharing with you. The report is reprinted with the permission of the community in which the workshop took place, and edited for clarity. My understanding with the community is that confidentiality will be respected and so all names have been either deleted or changed, and the community itself will be known only as 'a First Nations community in Northwestern BC'.

October 13, 1997
Here I am in a very little room in a small village in Northwestern BC. The journey here was extremely rough. I hope it isn't a metaphor. There is a welcoming tonight for me at the Hall. The workshop starts tomorrow morning. This is the third attempt in a few years to do a *Theatre for Living* workshop in this community - something has always happened to cause cancellation at the last minute. It seems that we are going to go ahead this time. Later - holy crow. There were 43 people there - mostly teenagers including 6 adult support workers. Big, big group in what becomes a small workshop space. Some old friends are here, including a man who was a participant in a theatre workshop a few years ago. He lives in the interior of BC now but was visiting his relatives and heard this workshop was happening and decided to stay. It turns out he is using the *Theatre For Living* tools in his community with youth, and figured he would learn more if he did another workshop. Good to see him and that he's putting the work to use.

I talked for a while and then did some games and an introductory exercise, to give them an idea of what was going to happen - talked with them about the journey of the workshop, about desire and having to want to do this, about it being theatre (we will make plays that go to performance) that investigates moments of oppression and what that means. I am hoping the numbers are going to decrease a little. It's a really big group and I have only four full days before rehearsals.

A strong indicator of what is happening in the community is that even out of a few introductory games came an extremely violent image - without any asking: an image of a boy putting his foot onto another boy's face while two other people watch.

October 14, 1997
Did a lot today and we travelled a pretty big distance. We still have forty-three, including the support people. The games went well, although there were attention and focus problems, sorting out the 'this isn't school and I am not a teacher' aspect of the workshop. At least half of the group are really present and wanting to work. About a quarter of them are in the room and frightened, and, I think, about another quarter are there because they just don't want to be in school. It is this last quarter that are worrisome - because they sap energy and drag the rest of the working group down. We had numerous talks about desire today.

We made eight groups for Images. Some of the images were extremely powerful. Lots of alcohol and drugs, lots of battering, lots of people standing by and letting it happen, lots of small kids having to parent their parents. From the discussions after activations I believe that there were surprises for some of the support people - the depth and pervasiveness of the issues. The way some of the images 'hit home' for the adults who commented on how the youth were experiencing what they themselves had experienced when they were youths themselves. A solidarity - a commonalty building. A young girl came to me on a break and mentioned that she had seen *Out of the Silence* when it toured BC. I said, you must have been just a little kid, that was five years ago; she replied that, yes, she had been really young but it had had a very strong impact on her and that she was very excited to be doing this workshop now. This made me think of all those children, brought by their parents, who would run around during the forums. The cast and I would think about how disruptive they were and have to reach through them to the audience - but that in their own ways they had been paying attention - and who knows what power they took from the stories being told.

October 15, 1997

We started off slowly today, unfocused and sleepy. Everyone returned to the workshop, but attitudes hadn't changed. We kind of 'dragged' through the first two games in the morning and then in the middle of a blind game I just stopped. There we were doing trust work and some of the participants were hitting, tripping, pinching etc. There is a very fine line here. I do not want to become the participants' oppressor - -forcing them to do things they don't want to do. We are here, though, to make theatre about the lives of the people in the room. They have to want to do this. It can't be my role to convince them. Yet, intrinsic to this situation is working with people who have been deeply abused and who, are going to express themselves through violent language (both verbal and physical). How does the space remain safe? There has to be some kind of secure structure. I said I knew that about 80% of them were trying to do the game in good faith and that they were being sabotaged by the other 20%, and that those people knew who they were and that they had to take responsibility for the fact that they were ruining things for the rest of the room. I said I did not want to be put in a position of asking people to leave but that I would if things didn't improve. I hate doing this, I said, and talked about knowing that it's the ones who are causing the most problems who are struggling the most, but also feeling strongly that I have an overall responsibility to the majority of the room to ensure safe space, and if a few of the participants are shattering that safety then they will have to leave. I asked if they understood what I was talking about and many nodded yes, although none spoke. I was careful not to speak to anyone in particular at this point. I suggested we take a break. In the break the support people went to talk to individuals.

When everyone came back we embarked on Glass Bottle (six or seven people stand in a tight circle, one in the centre. The person in the centre goes stiff and falls into the arms of the circle. The people in the circle place the person back upright, centred, and then she falls in a different direction). We 'went around a corner'. The energy of the room changed dramatically. I know that Glass Bottle, the first in a series of trust games, will often do this, but deciding to do it with this group, considering what had just occurred was risky. It paid off.

We looked at the rest of the images and the strength of these was equal to yesterday's: Parents passed out, fathers beating mothers while the kids tried to stop them. One image was extremely powerful - just two people - a man hitting a woman who was cowering on the floor. They were alone. Behind closed doors. Many of the women (both adults and youth) came and sat in solidarity with the abused woman. It became an extremely powerful image that didn't have words - because the beating happened in silence from both sides.

After lunch we did Magnetic Image[10] and the focus in the room was tremendous. Some of the groups went through very heavy discussions - one in particular about not being able to connect with parents at all - not being able to say 'I love you' to your parents because they are always absent- passed out, drugged up, emotionally damaged. We looked at two images out of this exercise and one was particularly strong: a two person image of a young boy being forced to accept an apology from someone - the apologies always happen and then the abuse happens again and then the apology happens and then the abuse happens . . . a never ending cycle full of failure and lies.

Support people did not participate in this exercise, but were asked to join the circles as support. Some 'took over' the circles and ended up talking for long periods of time, unloading their own stuff, apologising for their behaviour to their own kids and the more they talked the more silent the group became. I talked with them about this afterward and explained that while I understood how hard it was for some of them, it was really important that they not allow themselves to become participants in the workshop. If they took over the exercise, they robbed the participants of being able to engage deeply in the work themselves, if they directed the discussion they shut down the youth who would themselves become the leaders in that moment. I said that while I knew it felt like they were helping, actually their actions were disempowering the youth - the workshop had to belong to the youth.

We agreed that tomorrow, when we do the next exercise, the support people will not join the discussions at all - the plays need to be owned by the youth and that in order for this to happen they are going to have to struggle through the process on their own.

Some of the young participants are emerging as leaders in the group and I really want to create an environment where this can continue to happen. They are starting to focus each other, to help each other through difficult moments. This is really new, from what I understand, not just in the workshop, but also in their lives. It's great. More tomorrow.

October 16, 1997
OK - we have four plays. Two of them even have elegant structures. But I am getting ahead of myself. The morning started slowly. They were dragging themselves around the room during the first few games. We talked about commitment again. There are a lot of them, as you know, so doing the Intestine (a trust game that needs a relatively large group) was going to take a long time but I felt it was important to do if we were going to proceed. It was a good instinct. Only about 50% of them would do it, but they all participated - sometimes working really hard to put large members of the group through. As the exercise progressed they gained more and more power, until they were focused and applauding after finishing with a person. Then we settled into seeing the rest of the Magnetic Images. More strong images of violence . . . *all* the images of violence also contained alcohol and/or drugs.

People started questioning this - is the alcohol the source of the violence? Can there be violence without alcohol? Alcohol without violence? A deep conversation about how the two do not always necessarily go together, although in the participants' lives they often do. Then, at a break, one young woman came to me. (Someone who has been shining these last few days, really articulate, really searching, and always talking about how incredible the workshop is because it is full of 'mystery'.) She came to me and expressed concern that there were no images of sexual abuse. Why? she asked. I explained that it had to come from the group and that it was not my place to impose this - perhaps the group wasn't ready to offer this. She went away and then one of the support people came to me and said there was a group of participants who wanted to know if they could present a 'special' image before the exercise ended. Of course.

It was a *very* strong image of rape. Very courageous. Two men are holding the young woman's legs. Another has his hands ready to undo her pants. Another is ripping off her shirt. Another is holding her girlfriend, his hand over her mouth. The room was stunned. The counsellors were stunned. The group wanted to activate the Image. This led to a long discussion about safety and responsibility in the community. I asked the young women if they felt safe in the community. No one said yes. Who is unsafe? They all raised their hands. Can you talk about it?

Here are some snippets:

You never know what's going to happen - who is going to turn on you. It might be a family member, it might be a friend, it might be a stranger.

You can't walk alone. It's asking for trouble - especially at night.

At parties the boys offer alcohol and more and more and more and if you don't drink you are pushed out of the group - a number of the girls (fourteen-year-olds) spoke of passing out and then waking up naked with no memories.

Then I asked the boys about this - about how they feel hearing this. They were more guarded but expressed that when they witness these things they are afraid - that they can't say anything because they, too, will get targeted for violence or blamed for something they didn't do. There were lots and lots of tears from both young men and women.

We embarked on an exercise called Song of the Mermaid. Here's how it works: everyone thinks of a moment of oppression from their own lives. They think of the strongest emotion attached to this oppression. Each person thinks of a sound (not language) that is evocative of that emotion. When they have that sound they put up their hand. Pick one person, stand them up and take them to one corner of the room. Ask that person to make their sound three times. Ask the group to stop offering their sound if it is anything like the sound that has just been offered. Do this three or four times so that there are three or four different sounds being offered from different corners of the room. Then ask the people chosen to start making their sounds together. Ask the people left on the floor, keeping their eyes closed, to slowly make their way to the sound that is the most like their sound or that resonates with them the most. In this way groups are formed based on very emotional core

151

sounds. The most important thing about the exercise today was that one of the sounds was silence and at least 50% of the participants went to that sound. It was heartbreaking. Some of the support people were crying. This big group broke into two smaller groups so that they could work. I asked the support people not to help the groups at all - so that the participants had to make the plays on their own - sort things out on their own - so that they would truly own their plays. They made it through and showed the plays.

October 17, 1997

I went into today somewhat fearful, because in my heart I didn't believe that we could accomplish what we needed to get done in the time we had. I put together a very tight schedule for the day. This group is crazy about Fox in the Hole. A tag game. They are kids, after all, and in the midst of all this very serious work they want chances to just play. More of them did the Fall (falling off a table backwards into each others' arms) than did the Intestine yesterday. More important, the room was really focused. We moved into the Gym - our performance space. Big and boomy. I explained that we would work in rotation. While I worked with group one for thirty minutes, the others would work on their plays. 'Work' would include: cleaning up blocking; making actions definite; choreographing any violence; letting moments finish before something else starts; focusing the action; and developing histories and clear motivations for characters. Group one was the group in the best shape from yesterday - group four the worst shape - that gave the groups time to come into rehearsal with the best possible plays. Then, after rehearsal, Group one would go and run what we did at least ten times before they could have a break. I would work with Group two and so on for two hours. Then lunch. This was exhausting but they were very focused and took it seriously. After lunch they wanted Fox in the Hole again to get started and then, with my stopwatch, I had twenty minutes with each group in order again, same routine. Then we showed the plays. Here they are in the order we will perform them tomorrow. Although the plays are not any one person's story, they are honest representations of the participants' lives:

Group One

This was supposed to be a series of images but at the last minute the group changed its mind and created a very loose play. Dad is drunk and caring for the baby. Mom tries to take it away from him but he refuses, saying she treats the baby badly. Mom's friends come over and want to party. Dad passes out and she puts the baby in another room on his own. She parties with her friends and they pass out in the kitchen. She goes to where the baby is and lies down. Dad wakes up and finds Mom and beats her while she holds the baby. One of the friends wakes up and pulls Dad away, complaining he is making too much noise. They go back into the living room and fall asleep. We will perform this play but not do forum on it.

Group Two

A young girl sits alone. Around her, frozen in images are her drunk father, her drunk mother, her sister and her abusive boyfriend. She lifts a cloth in front of her on the floor to reveal a knife. She brings the knife to her wrist. She says to the audience, 'I bet you are wondering why I want to do this.' Her father activates and comes to her door, very drunk, pounding,

calling her name. She hides the knife. He enters the room and asks her why is she closing the door. To keep him out? Why isn't his dinner ready? She tells him to make it himself and he hits her hard, telling her not to talk to him like that and leaves. She gets up and goes to her mother (who activates) and asks for help. Her mother is almost passed out. She pleads with her mom to stop drinking, she needs her help. Her mother tells her to fuck off and leave her alone. The sister has heard this and meets the girl as she comes out of the mother's room. She wants to help. The girl, echoing the mother, tells her sister to fuck off and leave her alone - she is just like everyone else. The sister protests but the girl refuses her help until finally the sister says, 'fine then' and walks away. The girl goes to her boyfriend who immediately starts accusing her of sleeping around. She says she hasn't and he calls her a liar. He hits her. His friend, who is present, pulls him off her and the two boys get into a fight. She leaves. Back in her room she sits in front of the cloth. The other characters are around her, frozen in image again. She removes the cloth, revealing the knife. She picks up the knife and brings it to her wrist, looks at the audience and says, 'See?' We will perform this play but not do forum on it.

Group Three

A young woman is cleaning her home. There is a knock on the door - two girlfriends from the community and a guy who is visiting from somewhere else. They want to party. The woman doesn't want to party. They offer her a drink - she says, 'No, I can't' – 'Why not?' they ask – 'you know why, because I am pregnant,' she tells them. 'Well,' they say, 'it's not the baby who's going to have a drink, it's you - come on!' And so she has a drink with them. Her husband enters. He is drunk. He sees her and yells, 'what are you doin' you know you're not supposed to be drinking!' He grabs the bottle and hits her hard. The friends pull him off her and he gets angry and leaves. They want her to come to the party with them. She agrees to clean herself up and go. They wait outside. The husband comes back and wants to apologise. He has brought her a present - a very expensive bracelet. She says he always apologises and never means it. He insists this time is different - he doesn't want to fight anymore - they are going to have a kid. She throws the bracelet on the ground, saying she doesn't want his gifts. He starts to hit her again - calling her an ungrateful bitch and leaves. She goes and gets a bottle of pills and starts to take them. Her friend comes back and finds her and starts yelling at her, saying, 'what do you want to go and kill yourself for? Are you stupid? Just let your husband kill you - you keep letting him beat you up anyway!' The friend leaves. The woman picks herself up. She walks to a bridge and climbs onto the rail. She prepares to jump. We will do forum on this play.

Group Four

There is a group of guys (played by girls) and a group of girls. The girls are on their way to the mall (this play takes place in a larger town nearby). One of them expresses concern about running into a certain guy - the leader of the guys and the others tell her to stop worrying. Freeze. The leader of the guys is talking to his friends about how he's really hot for a certain girl, even though she has a boyfriend. He figures taking her away from the boyfriend will be a really good challenge. He asks his friends to help him get her. One of the friends doesn't think this is a good idea but is shamed into participating. The two groups

meet. The leader of the guys comes onto the girl, asking her to come have a smoke with him. She doesn't want to. The friend who was concerned before gets between them and tells him to back off. She is talked down, though, by the other girls - one in particular who says it will all be OK and the two should go off together. The leader of the guys takes the girl aside, while his pals hold off the other girls. The leader of the guys comes on really strong, pawing at the girl. She tells him to back off - she doesn't like him and she has a boyfriend. She starts to leave. He grabs her and twists her arm, telling her she is just making it harder on herself - that he loves her and he needs to have her. Telling her he loves her again and again, he throws her to the ground and rips away her pants and rapes her, while his buddies hold off the other girls. While this is happening the boyfriend and the girl's brother enter, see what is happening, pull him off her and start to beat the crap out of him. Freeze. The girl who said it would all be OK and that they should go off together moves to the raped girl, who is in a little ball on the floor. She says, 'I'm sorry, I'm so sorry and cries over the body of her friend. We will do forum on this play.

The final circle took two hours. For the first time everyone spoke. So many cried and talked about how they fit into these plays, told excruciating stories of being raped when they were six-year-olds, ten-year-olds, by relatives, by friends, and no one ever doing anything - of abandoning friends who were in trouble and the friends being raped, of having friends who killed themselves, of drunk parents, of beatings - on and on and on. And in the midst of this laughing and saying how great it is to work together this way, how much fun they are having, how they have become a family even though they knew each other before. The counsellors are amazed at how these young people have opened up - at how supportive of each other they are - of how they are working together - and everyone is anticipating blowing the community's mind tomorrow night. We had a group dinner after the circle and something affected me strongly. A number of the young women in the workshop - who, really, I see as girls - they are fifteen or so, have babies. I didn't know this. The babies have not been around. So many of them. Children with babies.

October 18, 1997

Today started at noon and ended at 12.30 am. The day was pretty normal, really - we ran the plays and rehearsed Forum. Some of them already knew about Forum from seeing previous Headlines' productions. The rest took to it really well. The thing to worry about became the room. A really difficult space to be heard in. Lots of voice level work - eventually I just told them they would have to scream. We broke at 4.00 pm and met again at 6.30 pm. At 6.30 the participants started arriving, really stressed and out of focus. We couldn't do anything with any of the plays because with each of the groups people were missing. Late. Then very late. But there was no panic. I gathered them around and talked with them about all the hard work they had done, that they knew the plays really well and now it was time to give these gifts to the community. The hall started to fill. People came and came and came. The rest of the cast arrived. We had to pull out all the bleachers (bench seats) and sit people on the floor. People were sitting on countertops. People were in the doorways. At 7.30 we started. Although we had a microphone on a long cord, there was no way to boost the dialogue in the plays. Like any community performance there were lots and lots of kids - little kids running back and forth through the

playing area - people on bleachers, every movement making noise - the room picks up everything. It really was necessary to scream to be heard. After the introductions I chose to forego the microphone because the casts were not going to be able to use it and I wanted the room to get used to listening. It was scary.

The first play was performed better than it had ever been performed. It had been my big worry. One of the cast has Fetal Alcohol Syndrome and this was a real challenge for her. They really pulled it together, though, and set the tone for the evening. When the second play was over you could have heard a pin drop in the hall. The community has had a lot of suicides and this play hit hard. This was the youth of the community articulating really clearly that they were killing themselves because their parents were alcoholics and drug addicts and were beating the crap out of them and they had nowhere to turn. Before we started the third play I did a warm up with the audience. Drawing imaginary X's and O's in the air, that kind of thing, to break the tension. The forum began with the third play, which was also performed very well. The interventions started immediately by people from the community. A testament to the relevance of the plays, to the honesty and also to the performance levels of the casts.

The connection came through the emotional integrity of the performances. Almost all the interventions in the evening shared one aspect. They were mostly about breaking the silence in one way or another. Appropriate, as the strongest sound in the creation of the plays had been silence. Interventions ranged from various ways to be assertive with friends regarding not wanting alcohol to protesting loudly and publicly when someone made unwelcome advances. Writing this now, the notion of doing this seems pretty basic but in the context of the forum these were revolutionary acts. There was lots of laughter, lots of silence, lots and lots of applause. We also discussed consequences of various actions. It became easy to embarrass the oppressor, for instance, but the people playing the characters were very honest about how angry this made them and that they were real and this meant that eventually they would have revenge. Is hostility the best response, then? Does it solve the problem in the end? This, of course, led to other interventions. The event ran for two-and-a-half hours with no break. I asked the audience if they wanted one at one point (I needed one) and got a resounding 'no!'

There were presentations at the end. The support staff gave all the participants certificates and there were gifts to me - amazing gifts. The final circle took two-and-a-half hours. Each and every one of them spoke, many at length. This has to be understood in context - six days ago many of them were hiding in corners in silence. There were lots of tears - also stories of triumph. I felt it was important to try to prepare them for re-entry into the real world. I explained that on Monday they would be going back to school and that it would be the same school, and that that would probably be difficult. I asked them not to expect the community to be miraculously different in the morning. There had been changes (little miracles) and those changes were inside them. I asked them to nurture those changes, stay connected to each other, and left them with a challenge: to continue what they had done this week and be the leaders of their peer group. My heart was pounding as I said this in the silence and focus of the final circle of the workshop, because it was obvious that to many of them this made sense.

155

July 28 1998 nine months later
I asked one of the organisers of this workshop to give me an update of what has happened in the community since we did the community project. It follows:

'Many things have happened as a result of the (Theatre for Living) workshop on family violence that we did in our community:

Youth established a 'Teenagers Accomplishing Goals' group. They meet as often as they can; a support worker and one youth takes on the leadership role to ensure the meetings and events will occur. It's slow and commitment is always an issue to many of the youth who would like to see changes made spontaneously. The group is presently at a standstill and is hoping to continue in the summer or fall.

A women's support group has been established and meets every Thursday to discuss very personal issues relating to violence, abuse and mostly about the relationship between spouses and fathers. We plan on expanding on this group and providing activities, exercises and resources to come in and facilitate topics of interest.

Two men's conferences have occurred to address the issue of violence and the response has been tremendous, from hearing victim impact statements to commitments to help curb violence amongst our First Nations members. The traditional method of healing was utilised during the second conference: Sweat lodge, traditional prayer chants and cleansing ceremony. This conference allowed female participants - at first this was not acceptable, but the men welcomed the women's perspective to help them through their healing.

Several youth workshops have occurred: harassment, grief and loss, suicide prevention/intervention and talking circles. A Youth Conference occurred for two days, with great youth participation and community support. This was sponsored by the Holistic Centre and hosted by the school staff. Another one is planned for the fall. The Youth Centre Council have initiated a lot of youth activities, field trips, night hoots on weekends. Community members volunteered to establish a 'Citizen's on Patrol' Program and it is well attended by the community and leadership. The group consists of parents, youth, young adults and a few elders who meet with the local R.C.M.P. and have the opportunity to take some training to make the program more effective. Our leadership have stated and supported that the Holistic Centre provide as many preventative activities, workshops, conferences for our youth to help curb violence, address alcohol and drug issues, grief & loss - activities that provide a healthier life-style and continuity. Building self-awareness and self-esteem. We have two youth workers at the Holistic Centre now and have more people offering their services voluntarily.

One of our elder volunteers provides and prepares Sweats - Sweatlodge on a need be basis.

More community members are involved and wanting to begin healing. More reports are being made to the R.C.M.P. They believe the community members are no longer afraid to take action on violence, especially spousal abuse. A victims' assistance training program will occur very soon, two members have volunteered to participate - I'm one of them. More community members are taking the initiative to begin on their healing journey, going into Treatment Centres for A&D Programs, Survivors of Trauma and Residential School Programs. The results are awesome.

As you can see, a lot has happened since the Theatre for Living workshop. Although, we did get some criticism we also received a lot of positive feedback that this should have happened a long time ago. It is a beginning and it feels good to know that we now have community and leadership support. We will continue to provide our services with the hope and prayer that our community will recognise the changes they are making. Again, David I thank you and Headlines for your input and contribution to our community. Take care and keep in touch with us. You may summarise the information I have provided.

Until your next visit to our community.

Tightropes of Facilitation

The popular theatre worker treads a tightrope between the rock of the over determined intervention and the hard place of the unstructured facilitation which prevents a critical engagement with social reality. Popular theatre processes, like people-centred pedagogies, have to start from where people are in their individual and collective realities. However, these processes also have to move people from where they are in the direction of where they want to be; in the direction of their self-fulfilment as creative, autonomous human beings. Such a process inevitably engages a popular theatre practitioner in a potentially contradictory position. Many people all over the world are in situations of such extreme alienation and cultural deprivation that they are unable to have any sense of the ways in which change might become an agent at their own disposal. For such people the facilitator has to intervene in this condition for any sort of process to begin. However, if the process is sustained beyond the moment of its initiation by the facilitator, it must start to move out of the control of that person to become a tool at the disposal of all in the community who wish to use it for individual and collective change.

The alienation being conceived of in this instance does not only refer to the material conditions commonly afflicting the majority of people in the so-called Third World, but also the psychological alienation suffered by people throughout the world who are unable to take control of the forces which determine their lives. These forms of alienation manifest themselves in the states of apathy and passivity encouraged by the monological communications of broadcast television and the loss of all collective activity within communities as well as in more direct, tangible states such as homelessness, unemployment and family breakdown. There is a connection between the passivity of alienation and its antidote in the active interventions of popular theatre. Broadcast television, films and mainstream theatre alike produce representations of human relations based on the assumptions that a few people hold about many. Thus the producers control the means of representation and the spectators consume the representations, internalising them via the dictates of false consciousness. As consumers, having purchased the representation, we may accept or reject it but we cannot replace it. Popular theatre, by accessing its processes to all who wish to make representations, enables the audience to be transformed from the mass to the particularised, active and local.

In consequence, hitherto unknown patterns of behaviour and knowledge which are the product of a specific context, a unique set of circumstances, may enter the public domain. Only when the disempowered are felt to have something worth saying can the necessary conditions for dialogue obtain. Otherwise participation is token, a phase in which all have their say in order to feel better before the expert tells them what they need. Like the doctor whose bedside manner puts the patient at ease prior to intervening as an external agent to solve the problem but who would never suppose that by actually listening to what the patient is saying, the diagnosis might be more accurate; still less that the doctor might even learn something new about the nature of the disease. The grassroots will only flourish if watered by tears of humility, not exhausted by the extractive demands of the fertilising facilitator.

The movement of contemporary popular theatre is towards greater and greater degrees of participation; an increasingly blurred distinction between performer and audience as well as an increasingly uncertain demarcation between what constitutes a theatrical space, a space of fiction and public spaces of daily reality. Site-specific projects, street theatre and work in closed institutions all contribute to the aim of enabling ordinary people to have access to the processes of popular theatre. However, in process as with the other aspects of popular theatre, there is no 'correct' model; no workshop manual on how to do process. Again context is all. Specific circumstances give rise to specific strategies for realising the purpose of using theatre as a means for marginalised groups to represent and/or change their social reality.

The example which follows describes how a community theatre company evolved a particular relationship between a community of people suffering from mental illness and the actors given the task of representing them through a theatre performance.

Shrinkwrapped
Mary Swan

Shrinkwrapped began life in the Autumn of 1997. I had approached Southampton MIND to find a suitable drop-in group locally with whom I could begin the first stage of the project. They suggested the Cafe Club, a Thursday afternoon drop-in situated in the centre of Southampton. A meeting was arranged between myself, the workers at the drop-in, and members who were interested in working on a project about mental illness. This first meeting was a community drama workers' dream; almost the whole club turned out, and what began as an outline from me about the possibilities of a project like this, turned quickly into an energetic debate about the issues surrounding mental illness. Many of the group told their life stories, many recounted the horrors of bad hospitals, most had angry first hand experiences of social stigma and ignorance towards the mentally ill. I couldn't write their words fast enough and simply listened, amazed at their openness and honesty. This was clearly not going to be a project that could hold its punches - these people were angry, and wanted to tell their stories.

The next time I went to the Cafe Club, a core group had been formed to work on the project. There were six members of this group, three women and three men, all in various

stages of recovery. In the following month we met once a week to discuss how the project should evolve. From the outset the group were very clear that whilst interested in theatre and performance, none of them were interested in acting. Within this group were three accomplished poets, and a visual artist, therefore it was decided that the group would tell their stories, write poetry and basically provide the raw material from which myself and two actors would devise the show, the group acting as technical advisors.

After a month of fleshing out the potential audience for a show like this, it became clear that the group were interested in sharing their experiences in order to encourage those who felt isolated by their illness. Time and again the group expressed the loneliness of experiencing their first psychosis, and the fear rooted in the widespread ignorance of what it really means to be mentally ill. Therefore the group decided that the show should tour other drop-in centres, and ideally be seen by healthcare professionals. This meant that in devising the show we could be as accurate as possible to the groups' experiences, without having to explain everything to an audience not aware of the routine of medication or the experience of hospital wards. It also provided a means by which we could directly contact other groups in the area and offer them the opportunity to become involved in future work.

For the next five months, until the actors arrived in March, I met with the group each week to collect their experiences and views. The transcripts from these sessions would form the base material for the show. In order to give the group as much editorial control as possible, and to retain a principle of confidentiality, I would tape our conversations and transcribe them without the names. Each member was given a copy of the previous week's transcript, and had the opportunity to remove any information before distribution. Through the winter the attendance at the meetings varied, as did the mood. The mentally ill are affected more than most by the dark, cold days, but always the members of the group were passionate about the project. In the absence of a weekly therapist, family and close friends, a group can develop a relationship that supports and sustains during the darkest days. To be a part of this was the most profoundly moving part of the project for me.

In February it was time to cast the actors. The group had decided that to reflect their experiences fully, we should cast a woman able to play mid-thirties to middle age, and a man able to play late teens to mid-thirties. The group and I had also decided that they should have had some contact with mental health service users, and experience of working in the community.

I found two wonderful actors in the shape of Jeannie Lewis and Jez Thomas. Both had a lot of experience working in the community, and a clear interest in the project. Ideally I would have taken the group to the audition, after all, these were the people who would have to interpret their darkest hours, but finances didn't allow, and they had to trust me with the decision - not without giving me a long list of requirements first, I might add!!!

As soon as the actors had been contracted I sent them copies of the transcripts seen and cleared by the group. The transcripts did not convey the enormous amount of humour the group had, and the laughter that had punctuated many of our discussions. It was clear that with a limited amount of rehearsal time, the finished show couldn't possibly reflect every issue the discussions had raised. Therefore I asked the group to prioritise the areas that they felt the show should explore. This produced a list with its own set of documents: the relevant pieces of transcript, parts of the mental health act, details of prescribed medication, and the action

159

taken by healthcare professionals (if applicable). I had also collected from the group - and those at the drop-in not directly involved- over thirty poems for use in the show if needed. Clearly the group had not provided *all* this information, by Christmas I felt they had furnished me with as much first hand experience as possible on subjects like medication. It had also become clear that the piece would benefit from some cold, hard statistics, and these would have to be researched. I talked to the local Citizens Advice Bureau's disability expert about the Welfare State's attitude toward mental illness, and the National Schizophrenic Associations' advocacy service about the legal minefield surrounding the issue. All this information was intended to provide factual back up, if needed, to the issues discussed in the piece. So far I hadn't talked to appropriate healthcare professionals, and although the group was adamant that they should not be involved, I was curious as to why service users were uniformly so unimpressed with them. I approached the Department of Psychiatry at the local hospital to arrange a performance on the rehabilitation ward or a visit to the ward and a chat, or just a meeting with one of the staff. The efforts taken to avoid contact with me were quite stunning, and when I eventually spoke to the manager of the ward, I was told that a performance would be impossible, this was disappointing but expected. However I was also told that under no circumstances could I visit the ward (despite the fact that I could have masqueraded as a visitor), and that a simple meeting with one of the staff was out of the question. That was that, I attempted to plead otherwise and pointed out that to contribute to the project would simply result in a more balanced viewpoint, but I got nowhere. I had always thought that the hospital wards and staff were given a rough deal by the Cafe Club, but they expected this reaction, and it was my turn to experience the frustration and bewildering attitudes of some healthcare professionals toward the mentally ill.

It had always been an intention to involve the group in the creative process as much as possible, and since they were not performing, the logical step was to involve them in rehearsals. It was imperative that the group had *real* ownership of the piece, and since they had provided almost all the material, they should have full editorial control. The only way to achieve this was to involve them in the rehearsal process. Obviously, meeting and understanding the group was vital for the actors, and a timetable was arranged with the group to enable them to be present at half of the rehearsals. This timetabling gave myself and the actors enough opportunity to interpret the material into a theatrical form, whilst allowing the group to halt any forays into work that were completely off the mark.

Each visit the group made to rehearsals, we would show them more material that we had devised and were happy with, giving them the opportunity to cut it from the show or change it. One particular rehearsal springs to mind as an example; we were attempting to devise a sequence illustrating the feelings encountered during depression. Jeannie, Jez and myself had decided this was best done with movement and vocal noises. We had the beginning of the sequence, the creeping negative feelings were not that difficult to interpret into movement, however we were unable to find a satisfactory physical metaphor to relate the sheer energy of the height of an illness that leaves its victim inert. The Cafe Club arrived at the rehearsal, and we showed them what we had and explained the problem. One of the women in the group had been battling depression for many years, she turned to me and smiled; 'It's very simple Mary, it's a roller-coaster!'

Popular Theatre Process

At this stage we were looking to create a show of roughly forty-five minutes in length, and had found the convention of a mythical fairy story to couch the piece in. This invented story was used to convey a positive message - it concerned a boy's fight with a dragon - the message being that to face one's dragon, demon or illness is a lifelong battle, and one that only the brave can stomach. One central image had appeared long before the rehearsal process and had given the piece its title; the group had been discussing their frustrating experiences with psychiatrists - the image of a patient being wrapped in meaningless terms to the point of suffocation came clearly from the transcript. Searching for a title one evening, and exploring the possibilities of the slang words for psychiatrists; *Shrinkwrapped* was christened.

The shrink wrapping image gave myself and the actors a central point from which to devise outwards. We showed the Cafe Club the sequence involving the shrink wrapping at the second rehearsal they attended. It was a straightforward scene; a psychiatrist fires questions at a clearly uncomfortable patient whilst walking in circles around him. After a number of revolutions the psychiatrist (representing an uncaring state system) begins to wrap the patient in clear plastic. The unfortunate individual is left struggling, visible under the plastic, fixed to his chair by the mummifying wrapping.

As rehearsals continued and the actors began to forge a relationship with the group, the slow realisation began with them that these stories belonged to individual members. This was demonstrated when we first showed the group the opening monologues of the show, at the beginning of the second week. These monologues were the life stories of two of the group, a brother and sister, who had both battled with mental illness for some time. For Jeannie and Jez, this was an epiphany. Of course they knew that the transcripts were the real-life experiences of the group, but somehow the reality that you are telling someone their *own* life story, never reaches clarity until you actually tell it from the stage.

I had been struggling for some time to find a way to involve the Cafe Club in the performances. Recording their voices was one thing, but I felt they should be *present* at the shows as more than just passive audience members. It became clear that the group should lead discussions, opening up the possibilities for questions relating to their experiences, and not just the show.

At the first show the group attended, they were nervous about the discussion following. However it was the reaction to the piece from the audience that was so astounding, we had figured that some of what we had produced would not translate fully, and that because these were personal experiences, there was always the possibility that it simply isn't like that for anyone else. We were proved emphatically wrong. Whenever someone shares, what they feel might be a unique, personal experience for the first time, there is always that sense of danger that it really might be unique! If that experience is shared and brought into the open, the relief from those who have shared it is huge! And it was this wave of recognition and relief that greeted much of *Shrinkwrapped*. For the group this gave them the boost of confidence they needed to brave the discussions. Most of the time, the audiences were interested in how we decided what we should include, and more often than not, would ask why we had not covered an illness or consequence common amongst service users. In the case of self-harm (the most often cited omission) the answer was easy, none of the group had direct experience, and it was a decision taken long ago that anything the group had no first

hand experience of, would not be included. Many also felt that the show could have been more positive.

The final performance of the show was a fine example of how close the group felt to the piece. The show that evening was performed before an invited audience of friends, families, social services representatives, local councillors, artists from the area and Southampton's Members of Parliament. Faced with this mixed bag of an audience, the Cafe Club were slightly apprehensive, as I was. How would audience members with no direct experience of mental health problems react to the piece? The moments of humour in the show were largely self-effacing, as is the humour of the Cafe Club, but would this be misinterpreted as tasteless? This new demographic was fascinating and worrying. The local press were also attending to write a review, and I was concerned that the show would be looked on as an isolated event, and not as the tentative beginnings of a much longer project.

The discussion following this show saw the Cafe Club use this opportunity to urge - in a firm, but gentle manner - the MPs and council representatives to look at services available to sufferers in Southampton. The confidence with which the Cafe Club fielded questions from the audience was stunning, and a testament to the personal journey that some of them had taken through the process of the project.

Inventing a Process

One of the arts of popular theatre practice is the art of creating process. What does this look like?

It looks like pausing to reflect and plan between every session. It looks like adapting long known exercises, or basic exercises, to specifically serve the needs of the group, the needs of the creative process within which we find ourselves.

It means avoiding recipes. It means knowing as many participatory exercises as possible from which to choose. It means adapting exercises to the specific situation, the specific theme, the specific group (its needs and abilities and cultural conditions). It means inventing exercises.

It means deeply recognising the agenda of the project, the agenda of the participants, the long view and the short view.

It means asking questions. Questions such as:
- What do we know about where we want to go in the long run? How much time do we have to get there?
- Do we need to get there in a straight line? Would a detour deepen our work?
- What skills do we need to develop, strengthen, to get there?
- What perspectives do we need to explore in order to get there?
- What don't we know about where we want to get? How might we find out?
- What content do we need to discover in order to get there? How might we find that content? Research with others? Stories from ourselves? Analysis of stories we have told/haven't yet told?

Each answer will lead to a set of conditions which the process we are facilitating or participating in should address. Each answer leads to a series of possibilities, for inventing exercises, reframing others, putting conditions upon them, and for sequencing them.

Theatre is an art form. Art forms have, on one hand, a set of conditions, disciplines and approaches. On the other, they express the previously unknowable, and our job in popular theatre is to make the most of these creative possibilities. We choose to use popular theatre because of its potential for reaching depths of human experience, because of its holistic nature - it combines and allows us to express our passions, our insights, our knowledge, our ideas. We aim to harness these human qualities in the most flexible and responsive way. Here is an example:

> Sculpting is a theatrical process and form which is used by theatre artists from many different branches of theatre practice. Various versions of sculpting are used in much contemporary popular theatre practice. The form offers the power of theatrical metaphor.
>
> In Vancouver, a group of women interested in investigating ways that theatre could assist women to address the deep and often immobilising divisions in the women's movement got together on a weekly basis for several months. The project was called *Transforming Dangerous Spaces*.[11] One sculpting exercise proved very powerful. On one hand it used the basic principles of sculpting. On the other, it was designed specifically for this group at a particular stage of its development, at a particular stage of the investigation.
>
> Following relaxation and memory/imaging exercises, and framed in the context of experiences in women's action work, the group brainstormed responses to our three words: transformation, dangerous, and space.
>
> ' In small groups create a sculpture which expresses dangerous space.'
> 'Now create a sculpture of that space transformed to a state you would wish for it.'
> 'Now explore the transformation, the journey from the first to the second sculpture.'
> 'Explore duration - how long does the journey take?'
> 'Explore direction - is the path which you take from the first to the second state direct, circuitous, other?'
> 'Explore the movement qualities (smooth, jerky, melting, darting, etc) of the transformation. Try lots of variations. Show one. Experience it.'
> Observers and participants unpack discoveries and experiences.

This is a basic exercise, melded with another and adapted to embrace the content and context of this particular popular theatre process at that particular moment in its process. For the most part, the activity was planned between the previous workshop session and the one where it was used. The way the project was sequenced, timed and the way the new elements were introduced, were adapted as the group worked, as needs shifted, as the journey was experienced, evaluated, and revealed.

Later in the same popular theatre-based process, the group wanted to 'go deeper' than they felt they had to date. The facilitators believed that this meant that we, facilitators and participants, were 'letting dangerous moments go by', remaining silent rather than confronting some of the very issues we said we were there to address.

We understood the potential to 'go deeper' was missed as we silently observed others in action, as we kept our responses, emotional and intellectual, to ourselves.

By this time the group had worked with action/reaction and offer/yield exercises. We had built skills in playing objectives and structuring playable improvised realistic scenes. We had worked with a variety of fabrics within sculptures.

'Think back to a dangerous moment during our work together, a moment where you believe we could have 'gone deeper', but didn't. Write a phrase that someone said or could have said, or thought but did not say, in that moment. Put the paper in the hat.'

We set up an exercise similar to one pursued in an earlier meeting: a person picks a line from the hat, says it, a second person responds, a short scene ensues: offer/yield. This time the lines were selected from 'dangerous moments'.

However, there was more to it. In response to facilitators' analysis that we weren't 'going deeper' because of the very structure of dramatic exercises; the element of performance, even within this *process oriented* project, made room for silent observers. We were not culpable for our silence. We could hide, even though we said we wanted to 'go deeper'.

We asked the rest of the group to stand in a circle, all holding on to a long piece of fabric, in a circle around the pair. After the first exchange – the 'dangerous moment' line and the response - the rest of us responded by physicalising, 'instant sculpturing' our response to the exchange. In relation to one another and to the central exchange, linked by a circle of fabric.

Suddenly we expressed the multiple reactions to moments of confrontation - challenges, appeasements, expressions of self in the midst of 'dangerous territory': moments of privilege, moments of anger, moments of racism. Suddenly even our silences were recorded, the meanings of our silences, our withdrawals as well as our enthusiasms.

This fusion of exercises was built out of deep investigation of group feedback, facilitator observation, passing comments, personal and group analysis of what's working and what's not, and the opportunity to wonder aloud, in depth, about what was helping/hindering us to move onwards. The process was invented out of a combination of the known theatrical forms and application of theatre style and symbol to the immediate circumstance. We would never evade one another at this level again. We went deeper and faced the consequences. There is more work to do.

Questioning Some Assumptions about Process

In Canada some popular theatre workers, in reaction to a long period of playing 'only' a facilitator's role with community players who have little previous theatre experience, are exploring ways to reinvest in the art form, to allow their skills, and those of other theatre artists, to be more evident in the work. In some cases, this exploration is

leading to a review of the timing and levels of interaction of artists and community members at various stages in a popular theatre process. In other cases, it leads to a revision of the 'who does the work'. In part, this adjustment in the relations of artist and community member is a response to dissatisfaction with the proliferation of role play type work, of forum theatre at its most basic; artists are asking: how do we reinvest in the power of theatre? How do we more fully incorporate the power of the visual, the aural, the heightened theatrical moment, into this work? How do we move past television realism. How do we use all the powers of the theatre if we do not allow the 'trained artist' into the performance? Some interesting projects are emerging, interesting hybrids, powerful theatre that is grounded in community expression and collaboration, that embraces the theatre artist in a new way.

Others are discovering that the process of self and group development, named as 'morale building and group building' in Kidd's popular theatre process model, is not, as is often seen, a relatively brief 'warm up' period in a popular theatre process, but rather, the entire project. They have found that too short a time given to initial steps in popular theatre process, too quick a run through trust and group development towards the 'issue identification' stage, is in fact disempowering, creating the opposite of the desired affect.

Negotiating Critical Awareness and Ownership: community drama within a self-advocacy group for adults with learning difficulties
Sheila Preston

The self-advocacy context
I undertook a drama project with members of a self-advocacy project for people with learning difficulties. People labelled as having learning difficulties who, it must be said, represent diverse groups of people, often find themselves marginalised within our society which places hierarchies over what is 'normal' and therefore acceptable socially. I found that those I worked with often found themselves deemed unable to live independently; they became recipients of sexual harassment and abuse, and were often ignored, and spoken *for* and *about* by parents and professionals. Generally they were lacking in opportunities for making their own decisions about their lives. As a result of these experiences these people felt marginalised. Although they might not have articulated this marginalisation in the way I have, it was clear that they seemed often extremely lacking in confidence, felt unable to articulate their views and opinions, and generally seemed to feel less important than others in their lives.

Within the self-advocacy group I joined in with meetings and, when appropriate, facilitated drama within the group over eight months. The group have specific aims relating to self-advocacy which direct their focus:
1. Learn to stand up for yourselves

2. Find out different ways to get what you want
3. Try to get more people to come to the meetings
4. Arrange days to talk about different issues
5. Find out who is the right person to talk to about our private lives (April 1997)

Within the sessions I noticed the difficulties that some individuals had in dealing with powerful people and 'standing up for themselves'. Whilst in a role play and able to state their needs, anxieties and concerns to, for instance, a housing officer, people very easily backed down, unsure of their position, displaying a lack of self belief and confidence in speaking up for themselves when tackled or challenged. During my time with the group, Mark, their supporter left the group and was replaced by Richard whom the group played a part in employing. This change in group membership seriously affected the stability of the group who felt sad and unsettled by their supporter leaving. Finally in December 1997, the group was forced to close due to lack of funding. This has presented a problem for the members of the group who had been attending for some years. It struck me how vulnerable this group was in having to rely on the organisation to provide their space.

What now follows, arising out of this context, is an analysis drawing on two examples of how drama was utilised within this group attempting to do two things: to facilitate the development of critical consciousness amongst a group, as well as enabling significant ownership of the process by the group. The first example, 'the chair drama' represents an attempt by the facilitators to raise critical awareness around power and the organisation of groups with a view to the group critically exploring their own set up. The second example, 'the shoe drama', explores how issues of prejudice emerged from the group without any intervention from the facilitator who then structured this into drama activity in an attempt to stimulate a critical interrogation of a personal issue.

The 'chair' drama (from my diary entries at the time)

The group enter the space and are surprised to see a pile of chairs in the middle of the room. Adrian laughs and says it is like a motorway pile up. The other members giggle and look surprised but curious of our bizarre actions. Suzanne and Charlotte arrive. Both are between seventeen and twenty years and have a very different impact on the group - Suzanne seems renowned for her outspokenness, always having something to say, and Charlotte, new to the group, is much quieter and seems shy. We tell the group that we have made a drama to show them.

Within this drama Mark and I have a fight for power, to be 'in charge' and arrange chairs which will privilege each other. The person in charge gets to dictate the layout of the chairs, and own a piece of paper. The other person feels that they have no power as a result so attempts to take power for themselves. They do this by rearranging the chairs to suit themselves, and in effect, take away the other person's power. Through this drama six arrangements of power through the chairs become illuminated and none is satisfactory. At the end, both characters negotiate and realise that they can both see the paper, and have equal power, if they have a circle of chairs and place the paper in the centre.

166

Mark and I run through the drama once. The group laugh at our comical attempts to be in charge. At the end we ask the group what was happening. The group seem to find it easy to point towards the conflict that Mark and I were having to be 'in charge'. We keep asking questions to stimulate the group to think about the drama.

We then run the drama again, this time we try to bring the group into the drama, to try to get them to experience the lack of power in the set ups. The group therefore have a position in the drama, from one of the chairs. From their positions within the set ups the group are then encouraged to discuss who has the power or is 'in charge'. Again we run through each setting, and stop to discuss, and deepen specific discussion.

In response to my asking 'Who's in charge?' Mark or I were generally pointed out as in charge if we were sat anywhere in the room, seemingly regardless of the room lay out. In one instance the group decided that those sitting at the front seemed to be in charge as this was like a 'school lesson' and at another point the three men in the group were all sitting by chance in a diagonal line with their arms crossed. One of the female members of the group, Charlotte, pointed to these men as being in power. Suzanne, who sat at the back of a line of chairs, said she felt like China has been feeling, not in charge. (This session happened on the day when Hong Kong was handed back to China.) I noticed that others might be called out as in charge if their body language was looking more authoritative than others, for example sitting with arms folded. With the last image in the circle, most people said they felt equal to everyone else apart from Malcom who insisted that he was in charge! The paper was placed in the middle and was interpreted by the group as 'instructions'. One person suggested that we tear the paper to give everyone an equal chance.

From this we can see that firstly the focus of analysis was determined by myself when I asked 'who's in power?' In relation to the drama, there were potentially several areas for analysis: the chair lay out, and the meaning of the piece of paper. When we invited the group into the dramatic space, their positions became subject to analysis. Each member was able to deconstruct and analyse the power within the drama which seemed generally focused on the positions held by the people in the drama. Before this, the group did not make much analysis of the facilitators and the chairs. When the group were participating in the drama this seemed to change, each person experienced a different vantage point in the room, and analysis of 'who holds the power' went beyond the obvious person in charge with the paper at the front. Power *relationships* started to be identified by the group. The line of men become powerful because of their relationship to one another as men, the space that they occupy in the room. The female gender of the person making the interpretation is significant also. The joint capabilities of the group in making a sophisticated analysis seemed impressive. The sense of the 'drama', its fiction and its structure, provided a necessary prompt which enabled the group to participate so enthusiastically and become drawn into the discourse.

However, within the 'real' space of the group meeting, the group ended up either reproducing the power hierarchies that they had critiqued or tended to drift into how things should be, rather than how it is. Although I feel that I had become really aware of the power contradictions in the group, I was not sure the group had. The sessions were often in reality, like the chair drama, a constant battle for power on the part of some

167

members in the group. Suzanne often wanted to dominate and talk about her topic of interest for the week, Malcolm wanted to do drama, only his version of drama would be to do it on his own. I had noticed that lately, Maria and Adrian would sit quietly while Mark or I tried to challenge someone like Malcolm who would be trying to demand the time of all the group.

Therefore whilst the drama prompted some critical analysis by the group through some sharp observations of people's positions within 'spaces' within the fiction, these insights did not seem to translate themselves into any overt awareness and change of their current relationships to people in the real world. I could have made the group aware of their contradictions, but I was aware of my powerful role and did not want to silence the group.

Alongside the question of whether the issues explored in the drama transfer themselves to power relations in the group, there are delicate issues about intervention. A challenge by a facilitator may enable critical reflection, but can also disempower the group to whom the facilitator is trying to hand over power and decision making.

The second example happened seven months into the project when the new worker, Richard, was present. We had just begun a meeting and were informally chatting about events in the week when Charlotte suddenly blurted out that she had been shoplifting. After questioning by the facilitators it turned out that she had not been shoplifting at all. Apparently she had seen some shoes in a box, and had picked it up. Before she could sit down to try them on, the store manager walked over to her and took the box from her. This had confused Charlotte who felt that she had been guilty of shoplifting.

Richard and I asked the group what they thought of the situation - did they think that Charlotte had been shoplifting? Suzanne replied that she had, and responded 'she shouldn't have'. Before we could take this any further it became necessary to ensure that the group understood that she hadn't shoplifted. In role, the scenario was enacted with myself as Charlotte and Richard playing the store manager. When asked if this is what happened Charlotte said 'yes!' On seeing the drama the group then agreed for themselves that Charlotte hadn't shoplifted. We then tried out ways that Charlotte could have responded to the store manager in order to 'stand up for herself'. Various members acted out responses. Suzanne had a go and, when accosted, she said in her usual assertive manner 'do you mind, I'd like to try these on - I might buy them.' The store manager then backs down and said sorry. Charlotte eventually tried her response saying quietly when challenged 'I would like to try them on'.

After Charlotte's revelation, other issues around prejudice started to evolve in the group. For the first time, people began identifying scenarios to work on that directly addressed people's prejudice towards them. Through facilitation these personal issues were re-created into social scenarios that required action to be taken by the group. In this instance, individuals raised issues within the group without prompting by the facilitator. The facilitators' role was to structure this into drama so that the oppression could be viewed, critiqued collectively and challenged. The facilitators' input was necessary, firstly to ensure agreement of the oppression - that Charlotte wasn't shoplifting, and secondly to create, through questioning, a critical analysis of the situation by the group. Finally the facilitators created the environment for changes to be rehearsed.

Summary

Through a working case study, we can see that the practice of a critical community drama intervention is complex and dependent on many factors which may relate to: the social context where such a process occurs, the diverse relationships between the people that operate within it, and importantly, the readiness of a group to embark on critical reflections of their reality.

Both issues of conscientisation and ownership of the means of production are necessary conditions for participants to be able to 'name their world' and act within it. However the processes can easily become contradictory and undermine each other.

Interventions such as the 'chair drama', a structure that may foster critical consciousness through debate can contradict, or even work against, aims of participation and ownership. Although the subject was felt appropriate and drawn from the reality of the group, the content and form were decided by the facilitator, and the group were encouraged to give their analysis of the drama afterwards. Participation and ownership of the piece was therefore limited. In the struggle to get the group to engage critically with their social realities, the facilitators may have been in danger of disempowering, and taking the control of setting the agenda for the sessions away from the group and their potential collective decision making. A contradiction thus emerges between the macro intentions of social critique, and the impact of this agenda on the group's development. Jenny Corbett asserts people's need to connect with others as an essential starting point:

> It seems inappropriate to talk about independence without recognising the significance of our inter-dependency. We all need to connect to others, if we are to become active citizens. . . We learn about ourselves through connectedness to others. (93)

So how did the group understand the self-advocacy group, and did they perceive this need for interconnectedness? It is impossible for me to speculate too deeply on the group's motivations. From my perspective there seemed a need to locate the personal within a framework connected to the lives and experiences of the group. This connectedness happened between those in the room with those who share the label of having learning difficulties. We can see how Charlotte's revelations sparked off many other similar instances of prejudice. The need for interconnectedness goes beyond people identifying with each other through their label.

If both participation and ownership over the process is a priority, a critical process can be hard to stimulate. Within such a framework a group may consider issues and subjects seemingly unrelated to self-advocacy and unconnected to their social positioning. Control over the content and the running of the group would be the choice of the group. Whether this process is democratic and/or critical is dependent on the awareness of participants within the group.

Within this process both agendas were felt to be vital. With the 'shoe drama' it can be seen that a member in the group raised a personal, potentially critical social issue of prejudice. On this occasion the group had full ownership over the content of the session and were chatting about all sorts of things. However, for this experience to be moved from a personal, sad story where the individual really thought that she had done something wrong,

onto a critical level where the actions of others are questioned, intervention by a facilitator was necessary. So although the session seemed to raise themes of prejudice quite spontaneously, they would have remained on the individual level if it had not been for intervention. With 'the chair drama' although defined by the facilitators, the group were enabled to engage critically outside of their immediate, personal world.

It has not been my intention to advocate one practice above the other but rather, to highlight the difficulties and contradictions ever present when faced with the necessary processes of facilitating groups to *both* name their worlds and transform themselves as citizens.

Communities, community educators and theatre artists committed to the use of theatre for change in community, are continuously re-evaluating process, in light of context, social need and intention. Not a formula. A live, creative and critical response to social conditions and the urgent need for social change.

Community In(ter)vention

There is a further important function for popular theatre, especially relevant to work in 'developed' countries such as Canada and Britain; that is the function of creating community. Many people in these countries today do not feel themselves to be a part of any kind of community and many experience this as a serious lack, leading to crises of identity and alienation from any kind of social process. Popular theatre processes can be a means to enable people to feel part of a collective, and thus rediscover capacities which isolation and the atomic family have atrophied. In this way rather than being a theatre *for* development project as popular theatre might be in societies where community is still an active force, the project operates as theatre *as* development; the catalyst from which later self-development initiatives can evolve.

Women's Theatre and Creativity Centre
Chantel Wagschal in Conversation with Tessa Mendel

December 1998

The Women's Theatre and Creativity Centre came into being in September 1995 when director Tessa Mendel chose to begin an organisation with the goal of 'reconnecting art and community.' Now in its fourth year in Halifax, the Centre has offered workshops on personal creativity and performance, theatre of the oppressed, clowning, spirituality, poetry, acting/improv, masks, creative writing, voice and storytelling. The Centre has offered other programs including Popular Theatre Facilitator Training, Art and Performance events, and the production and performance of two large-scale plays, as well as numerous collaborations with other community organisations in Nova Scotia.

Throughout its work, the Centre has been guided by its initial mandate: 'We believe that to connect women with their creativity is an empowering and significant action, and that theatre and other art expressions need to be based in community in order to be an integral

part of our lives and our choices.' This article explores the challenges involved in this endeavour through a dialogue between founder and director Tessa Mendel and steering committee member, facilitator and writer, Chantel Wagschal.

Although much has been written about the process involved in the creation of specific projects, there is little information available about the creation and development of a popular theatre organisation itself. This is our focus for the article. We've taken a practical, rather than theoretical approach, in the hope that others starting out will benefit from becoming aware of the challenges involved. Those in organisations already formed will hopefully find it useful to reflect on some of the issues raised here.

Chantal Wagschal:
>
> Let's talk about your initial vision for the Centre.

Tessa Mendel:
>
> I guess it was a multi-layered vision initially. It was certainly about a place where people could come and explore their creativity in a supportive context. I remember thinking: there are YWCAs or gyms in small communities; there should be a creativity centre in every community. I thought of it very much as a place, initially. Like a house with a performance space downstairs and people having meetings upstairs, and a poetry reading going on in one room and an art class going on - that kind of thing. It was always important to me that it was about change, personal and social. It was important that it wasn't only creativity as a process, but that there were also performances or sharings or whatever, coming out of the work.
>
> And I think that as the idea clarified, it became clear to me that I would feel comfortable doing this work with women, and that other women would feel comfortable doing this work together. To some extent, it just seemed like a natural organic decision to make from where I was at that time in my life, and it grew to be a necessary part of it. There was something about women gathering that made it a very particular kind of thing. Another part of the vision was that it would be a community of some sort, built around values of collective sharing, equality, honouring of the people, that kind of thing. Those are the significant elements of the vision that I started with.

Chantal:
>
> What was it that inspired this vision for you, and what brought you to this place in your life where you were willing to make it happen?

Tessa:
>
> In a way it was a response to my own background of directing in professional theatre and of doing popular theatre, which was often about creating plays looking at problem issues with specific community groups. I wanted to use theatre in a more holistic kind of way. The kind of social issue theatre I was doing was more hard-line. It was about the issues, not so much about the people, not so much about growth. So part of it was my own personal excitement and exploration of what to me were new ideas about how to use theatre in a different kind of way, a way that could be both joyful and also more creatively mysterious. I was interested in

exploring how people create a piece with words and any elements to express something that's important for them to express in the moment.

Chantal:

In a kind of spontaneous expression.

Tessa:

Yeah, that kind of spontaneous - and trying to play a little bit with: what's the relationship with me and the people I'm doing it with; what is it that we're experiencing together? Those kinds of things.

Chantal:

What did you want the benefits of the Centre to be for the people who got involved?

Tessa:

Well, I thought it would be a place where people could grow, certainly in terms of the development of their creative skills; but more essentially, in their development as people and as a community. And where people could feel safe to express things they hadn't been expressing before and to explore things.

Chantal:

How did you start the Centre?

Tessa:

The starting point for it all was coming up with some objectives and writing out guidelines for how I thought we would work. Those early guidelines were: it would be open to all women, there would be some sort of steering committee formed to make decisions about what we would do, that kind of thing. I met with a small group of women who I thought might be interested. They suggested other women, and I set up meetings with them. I probably talked with about fifty people. I would explain my ideas and then I kept revising the objectives based on their input. I had about sixteen women who wanted to be on the first steering committee. I got us a space, which happened to be across the hall from my apartment...

Chantal:

Convenient.

Tessa:

Yeah, convenient in some ways. And I designed an initial programme which included a once-weekly personal creativity workshop and a couple of Boal Theatre of the Oppressed and Rainbow of Desire workshops for weekends. I fixed a date for an open house, printed a brochure, mailed it out to everybody I could think of, did a press release, and we started with our first steering committee meeting.

Chantal:

What was that like? ·

Tessa:

I remember being wildly excited and terrified because I've never really been a meeting and organisation kind of person. I had no idea what you were supposed to do. I talked to people and asked, 'what's the structure?' During that first meeting, we set up what was going to happen at the open house. There would be some people playing, singing or making a speech, and other people would bring food, etc. So in our first month (this is now Sept. '95), we had the open house in our small workshop space, and it was just packed! Women were lining up on the stairs to come in. Then we started the first workshop, which was full. It was a very exciting beginning for us.

Chantal:

Sounds great.

Tessa:

Yeah, it was fun. People were tremendously positive about the idea and there was a real feeling of possibility. And the truth is that people don't have that very often. It's not often that things get started and people think, 'maybe this will actually make a change, maybe I can really get excited about this'. So it was very nice and positive.

Chantal:

What did you do about money at that point?

Tessa:

I had saved up enough personally to survive for a while, thinking that no money might come in. Our rent was very little, perhaps $250 a month, and the first year it was coming out of people's workshop payments. We did a benefit that December, which raised $500. We did another one at the end of the year. Occasionally, we got small workshop grants from the government - I think we've had two in total. And we got a few small donations, but everything helped at that point. Our costs were minimal. We just had the small rent, I was covering the phone, and when there was enough money, a small fee for me. Gradually that got more consistent. We had a policy that nobody would be turned away because they couldn't pay; instead, they might do an exchange of volunteer hours or give something to the Centre in a different kind of way. We've had a lot of people benefit from that. As well, a number of women regularly try to subsidize workshops for women who can't pay.

I think financial things are important to talk about because people always want to know how to do it. I started with the belief: do it first, worry about money second. And I think there's something to be said for that, because people so often don't do things because there's not enough money, and there isn't enough money, and there won't be enough money! On the other hand, you need to know your own limitations, because if you find that you're giving out and not getting back, after a time you do get resentful. It's important to be honest about what your boundaries are; you set them and try to live with them. But too often we let lack of money

stop us from what we need to do, and for sure it is better to have done it, even though it's now been three years of financial struggle. I find that the Centre does not draw a high percentage of people who are interested in administration. That is certainly a weak area of mine, especially fund-raising and financial management. So we have not applied for as many grants as we might have, and we were refused a charitable number on the bizarre basis that we're discriminatory in gender and that we're doing political propaganda! We are still fighting that, it's important to note. But that had an effect. We have no operating funding, and there's always the danger when that happens that you're relying on women who can pay. That is something you have to continually consider-is that changing the nature of what you do? At least for the facilitators of workshops, there has been some regular pay of a small nature, although the whole administrative area is run voluntarily, which a lot of people just wouldn't be okay with.

Chantal:

Right. Let's look at some of the structural considerations - how you work and how it was set up at the beginning.

Tessa:

Well, there was me who was the founding director and obviously tremendously involved. Then there were a number of women on the steering committee. The steering committee has always been an active and supportive steering committee. It hasn't been an initiating kind of steering committee. When we first started, I tried to set up a system of smaller committees within it. The amount of people who would actually organize things was small, so trying to do separate committees - it felt like I needed to be on every one. Eventually, we evolved into a 'steering committee - only' kind of structure. It's open to any woman who wants to come, and people come and go. We try not to have people feeling guilty and oppressed by the burden of the work. The imbalance of the workload is an ongoing problem. Obviously it happens in any organisation, it's only that in many organisations that imbalance is made acceptable by the fact that the people doing most of the work are getting paid. If they're not, then they need to be getting something. Artists, for example, might get an opportunity to do their work. They can try an idea here, it's a place where they can initiate things, which is certainly what one of the benefits for me was. That imbalance of too much work falling on too few people is certainly a difficult one, and not easy to find a way to resolve. I don't know what you feel about that.

Chantal:

Yeah, it's tough. I guess, ideally, I feel that the situation should be people volunteering to do what they want to do, and if nobody volunteers, then it doesn't fly.

Tessa:

Right. I guess because this came from one person's idea, even though I consciously was working hard to have a collective thing happening, it did mean that initially nobody was as invested in it as I was. I think we've gradually been moving there. Initially, people had very high expectations, and I totally went in over my head trying to meet them. In our second session, we had lots of guest workshop facilitators, I was doing two full-time programmes, one of which was leading to a play, and I was covering all of the ongoing administration myself. It

was too much. And it does take time to establish that stuff - people don't know how to volunteer and they don't know what the needs are until they're part of it. Those kinds of things take time to grow. But eventually we had to recognise that people's expectations were too high given the amount of work they wanted to do. In other words, what they thought their rights were, in terms of the Centre, weren't necessarily backed up by the responsibilities they were willing to take. Through the second year, we started to acknowledge that. What you're saying about 'if people don't volunteer it doesn't happen', is perhaps an issue that we're ready to look at right now, but with a bit of fear that maybe then there won't be anything happening.

Chantal:

I think that's an important demon to face.

Tessa:

So do I. And a tricky one.

Chantal:

But I think it is a good sign. I think it's a sign of things moving in the direction of honesty and authenticity. Nobody's forcing it. No one person is providing the entire will for the whole thing, which must be draining.

Tessa:

It certainly has been. But there has been a gradual progression away from that.

Chantal:

Let's talk about some of the specific projects. Let's start with the ones I know absolutely nothing about!

Tessa:

Sure. There's the whole part of the Centre which is about the ongoingness of it: the developmental stuff, the workshops, the community-building and how we work as an organisation. But an awful lot of the Centre's story is in the larger projects we did which took a lot of focus and energy. The first year, we began with a personal creative development workshop. Then we went on to a second section which was a creative performance twelve-week workshop. We ended with a number of performance pieces that we put together called *Weaving Strands*. And we had quite an interesting mix of people right across the whole spectrum of experience. Some women had never done anything performance-wise before, while some were poets or songwriters, etc. What was exciting for me, what took a lot of my energy and thought-focus that first year, was exploring this thing that we call creativity. I wanted to know, 'what is this expression that can come out of a totally personal and kind of pure and in the moment kind of thing?' It's almost difficult for me to try to capture, because now it seems much clearer to me but at the time, I felt it was very mysterious. There was a tremendous freedom and support for whatever you felt you wanted to express. We were learning to trust those first instincts and just go with them. Some pieces became sort of semi-collective, but there was always one person who was the initiator of the piece and who was its primary guide. My

interest was, once we've started doing that kind of work, what is the connection between that and making it a performance that we could share in a larger context? What happens to the pieces when you rehearse them and shape them? And that's what we did with *Weaving Strands*. We chose certain ones to work on which we felt could go in that direction, and we ended with a very diverse piece including clown movement, poetry movement, and highly ritualistic performance pieces. It was quite different from a normal theatre experience. That was a very positive experience for the people involved, because some people had never done anything like that, and it felt like a very safe and positive structure to do the work.

Chantal:

Did you do any major projects in your second year?

Tessa:

We did two very interesting projects. The first one was called *Home At Last*. It was done with a playwright, Christopher Heide. He came to me with his mother's journals which he discovered after her death. She had been a British Canadian war bride and he wanted to explore her story, and other women's stories of the same thing, and how they related to larger themes of home and exile for us in the next generation, and to themes of ageing. I've always felt that one of the things the Centre can do is work with community people and with artists and try to find different ways to bridge that gap. Because we have such a structured way of working - it's either a community play, in which case we think of it in a certain kind of way, or it's a professional thing, which is again very separate in terms of the connection with the audience and what it means to people and things like that. So it was very interesting finding dynamic processes that would echo our belief that the process is not separate from the product, that it's not like these people go through a lovely process that's really powerful for them but the product isn't good; whereas the other people go through something where the process isn't important, but the product is wonderful. We tried to find a way where the two could come together. We started with her journal and him meeting with women who were originally war brides and getting them to write journal entries. Then he also met with older women at the Centre and had them respond to some of those entries with entries of their own. Out of that he structured a play. So we had all the women's journal entries, and then also dramatised pieces that were back in time, and eventually we worked with a small group of the war brides, other elderly women who came to the Centre, actors, and community members. There were about thirty people involved. It was a wonderful experience. We did it at the Maritime Museum of the Atlantic, which was great because you could see the sea outside where they had come in, and also because it was a non-theatre venue, so it broke that kind of barrier. We did two evening performances and the response was incredible. There were many war brides and people with similar experiences in the audience, and we were more than sold out. People were very moved by it. And it seemed to me that we had achieved something of that incredible experience of seeing people talk about their own experience right there, backed up by the strength of the actors, and at times I thought we found a really wonderful balance.

Then in the spring - my god, we were working hard! We did our next project which was a three-part workshop building a forum rainbow piece to take to the Festival of Theatre of the Oppressed in Toronto. And that was with a group of women and you were involved with that.

Chantal:

Yes, I was one of them.

Tessa:

I had done many forum pieces but never a full play that actually tried to deal in depth with how to use forum and rainbow in a more sophisticated way. And the response at the festival was very good. A number of people told me that the structure we were using with *Prisma* was the most interesting way they'd seen rainbow used. It was a positive project in lots of different ways. Do you want to talk about what your experience of that was?

Chantal:

Well, that was the first time I'd really encountered Boal. My first-year acting professor was into it a bit, but it didn't really filter into our training. I remember being really excited that there was something that combined theatre and activism, because that's what I was interested in, and I didn't want to be a normal actor going around doing auditions. It opened up a new world for me. I found the workshop very powerful because of the way we dealt head-on with the painful issues around racism. So often, things are smoothed over with political correctness or they just don't come up, but the workshop gave us a place where we could struggle with it. And it was pretty raw.

Tessa:

Yes, that's right. It's really difficult to build a safe enough context that people can actually bring up these things honestly. I think that's a really good point. The issue at the beginning, about who was going to be included in the workshop, arose because there were more people who wanted to do the workshop than there were spaces available. We were doing it on a first-come, first-serve basis, but there had been some confusion about what was the first day that people could register. Some people just assumed that a place would be kept for them. One of the ways that issue was framed was: whether people who had done a lot of work and workshops, but hadn't officially registered should have precedence over new women coming in, women of colour, and women bringing experiences of different forms of oppression. It was important for them to have a space to work through some of that, and also for us at the Centre to be dealing with it. That issue of who gets in, of trying to be inclusive but not being able to include everybody simply because of numbers became really difficult.

Chantal:

How did you decide?

Tessa:

We went with the first-come, first-serve, and just stuck with that, but with an awareness that it was important to be more inclusive and allow new people to take part in the workshops.

Chantal:

Do you think inclusivity is a real priority for the steering committee?

Tessa:

Yes, I do. A year ago, we did a 'where are we now' exercise, and the two areas we chose to focus on were: finding some way to separate the artistic and administrative functions, and reaching out to diverse communities. And I think that those are, for our ongoing health, two of the major issues.

Chantal:

It seems to me that there is no real push behind that.

Tessa:

There have been times when that has been a real priority, but you're right. Certainly some of the women most interested in reaching out are not coming now. That's the thing - it reflects who's there. Anybody can be there, but on the other hand, we also have responsibility to make sure some people are there. It's like these things that say 'we're open to everyone', but only certain people would consider that to apply to them. You have to take an active response; it can't be passive.

Our most representative times were with *Prisma*. The ramifications of that 'who gets in' thing were positive for *Prisma* in that we did have a very dynamic and positive group. For the Centre, though, it was a bit more problematic, because several of the women who didn't get into the workshop felt personally betrayed by me. And what emerged from that for me was that their expectations of me were unrealistic. They were using terminology like I was 'a mother abandoning her children'. This upset me quite a lot. I felt guilty, but also angry, and it showed me that there was too much focus on me at that point. I don't think that was incidental to the fact that this was the period when I really started to burn out.

Chantal:

How does the Centre respond when very needy or psychologically unhealthy women join?

Tessa:

It's a good question and I'm not sure that I really know how to answer it. I think that if you are trying to build some kind of a community, there is strength in the group; that between you, the group has some ways of dealing with it. And that's one of the reasons why you want to avoid having one person being responsible for everything, because it can get nasty. I also had some women who were going through major things like break-ups, who felt that their work at the Centre was related to that because it got them in touch with their feelings and that kind of thing. I had one woman say, 'you're on my husband's hit-list.' Another woman whose piece hadn't been included in a performance said she felt suicidal and implied that it was my fault. So that's the thing, if you take too much power - a lot of things that come up are about power and power-sharing, and those issues will be there. You just need to lay them on the table openly. On the whole, I feel like if we can work with anybody, we should. Where are people supposed to go for help, or to have people work with them even if they are having a difficult time? It should be part of our mandate to work in a way that can be beneficial to as many people as possible.

Popular Theatre Process

Chantal:

Have you ever turned anyone away?

Tessa:

No, I don't think so.

Chantal:

Just men.

Tessa:

Yeah. Just men, as you say. It's a women's centre thing and we've had people not understand why and have problems with it, and I understand that. Personally, I believe that it's an important thing to start working with your own community and then to reach out beyond that. And we have included men in some of our projects: we did a popular theatre training programme, and we invited men to take part in that; the first full play we did had a male playwright; we've had a male workshop facilitator. We try to be women-centred as opposed to women-exclusive, but the workshops are by and large women-only, and some of the sharings have been as well. We have had many performance events with both women and men invited which have been very positive experiences. We also tried to get a project going with a Men for Change group, and I still have an interest in doing that.

Chantal:

You mentioned that after *Prisma*, you started to burn out. Let's talk about that.

Tessa:

I think that with the combination of me having got too wildly excited and involved, and this being my total dream, I became very obsessive about my work. Also, not being able to set any boundaries on my work, I got myself exhausted pretty quickly, almost by the end of the first year. And then into the second year, although I was able to continue the work for a reasonable amount of time at still an intense level, I was finding it increasingly difficult to cope. Still not being able to set limits, I then started having trouble sleeping, and at that point, had to draw back for health reasons. That was a very difficult time for me, because I couldn't understand how this could be happening. I felt like a failure because I was having this problem when I couldn't see why I should. I was doing the work I wanted to do and that I believed in, and outwardly everything was going well-it was just that the personal cost was too high. We all talk about burnout, and we know that it is prevalent, but I certainly had no idea what a strong and powerful experience it can be if you really allow it to go the full distance. And I think that it is something that needs to be looked at. When resources feel limited; that is, money, and people's energies and things like that, how do you create an organisation that is healthy for everyone? It feels like it always has to feed on someone. I know it doesn't have to be that way, but how do you do the other? I don't know many examples of it. In terms of how we've evolved with the structure, we've tried to shift to a just doing the administration for your own project kind of approach. Nevertheless, people end up having to do a lot of volunteer work just to keep the

organisation alive. It's a problem, and we don't want to become oppressive in that we're using people.

In the third year, with this burnout thing, we didn't do a major project. We did an ongoing creativity workshop and a popular theatre facilitator training programme which you and other women were involved in. Then that spring I took a break, and you and two other women were acting co-ordinators during that time. That was one of our solutions, to see if we could do this devolving of power a little bit. What was that experience like for you?

Chantal:

It was good. I enjoyed it. Although I have to say it did have the feeling that we were interning in your absence, and when you come back, it dissolves. It was definitely power shared, but it felt more like filling up your vacuum, so I think the 'Tessa as burning energy of the Centre' has been strongly established. But it was a good experience.

Tessa:

Did you feel that it was quite a big job with the three of you doing it?

Chantal:

It was work, but we had a nice camaraderie and we shared the shitty work amongst the three of us. We did mostly what we wanted to do, which was design and give the workshops that we wanted to give. It had a different energy for those months. I think some of the women on the steering committee had a bit of trouble with having three young women in leadership. There was a sense of waiting until you came back before really initiating anything. That was the sense I had. I don't remember it being an awful lot of work, but I had been pretty firm about what I would and wouldn't do. I got overwhelmed the previous December, and after that I made sure that wouldn't happen again. So I didn't experience the time we were co-ordinators as an overly busy time at all. I enjoyed it.

Tessa:

But it is interesting that none of you have wanted to continue in that capacity or in a shared capacity.

Chantal:

Right. I think that is partially just where our lives are going at the moment, as opposed to any real comment on the experience itself.

Tessa:

It seems to me that the people who enjoy doing the work do not necessarily like doing the administration; they are not natural administrators.

Chantal:

That's true.

Tessa:

So now I am only willing to do enough administration to do the work I'm interested in doing. I'm not willing to administrate on behalf of everybody else's projects. And that might seem selfish, but I feel like I've put in my time doing that.

Chantal:

I don't think it's selfish. I think we assume there has to be all this administrative work, and I don't think there does.

Tessa:

I guess that brings us to where we are now. In the fall of our fourth year, I came back and started just the one project, in keeping with this new idea of not being so centrally administratively heavy. It was a play creation project on women and health. And the project itself is fine, as indeed all of our projects have been. There have never been issues around the value of the projects. But some of the women involved with this project, who are on the steering committee as well, have felt anxious about the direction of the Centre. I can't decide whether this is a healthy thing - that we're being more laid-back and that it's reflecting what you say, that it's better for people to do what they want to do and to volunteer as much as they want to, and if less happens that's fine. Or whether, as some of the women feel, 'hey, our original vision seemed to include a lot more happening, and in fact we were doing that for several years, and how do we get that back?' Indeed they've said that to me. In other words, they've experienced this not having such a heavy agenda as being a frightening or a negative thing.

So right now we are at an interesting point. I feel like we're talking as if all of it comes from me, but lots of the work has been taken on by steering committee members and other women in the community. All of our benefits have been planned by other people aside from me, including quite large performance events. And we've got a reflections retreat day planned for next month, which was somebody else's initiative which they have followed through with and planned. I have a feeling that is going to be a time of reckoning, and that there will be tension between those two points of view: your 'what do people want to do and that's what should be happening', and their 'how do we find that excitement and energy again?' And most people don't think that structurally about it. So they might re-vision what they would like it to be, but the bridge between that and 'how do we make that work, what does that cost and who is willing to put in that cost' is quite a different issue. One is what you want, the other is what are you willing to do to bring it into being.

Personally, I feel like I'm still in process of trying to figure this out. As I said to you earlier, the projects we have done met my personal goals in terms of my work and my exploration in my work even though the organisation has been fraught with more personal difficulties than I anticipated. The actual work has been the work I wanted to do. What I want right now, I don't really know. I think I have to be clear about separating what I would like for the Centre, what I'm willing to give to the Centre just because I would like it to continue, and what I want for me. And whether they coincide. It's hard to be completely honest about that because for a long time, I didn't even make a separation between the Centre and myself.

Chantal:

That also explains, I think, why other people had difficulty making that separation, as symbolised by, like you said, your work space and your living space being together.

Tessa:

Do you think I haven't done enough to share power?

Chantal:

I think the whole paradigm of sharing power is fucked up. I think if we approach it from that angle, it's still with the assumption that you've got it and you're doling it out. I think we've got to break out of the whole thing.

Tessa:

But how do we break out of it? I must admit that I still don't know how to make an organisation work without having to pay people. I don't know how to have it work in a non-oppressive way that's not about power, although I believe in a different kind of way.

Chantal:

I think it is the difference between willing something and allowing something. With the Centre, I really think someone has to have the guts to stand up and say: are we necessary, are we fulfilling a real goal and are we wanted? Because until that bottom line that we're all assuming is there is really answered, there's no point. Everything is going to be a constant push. Everything has to come from that source. As an artist, you try to find the source for a work. I wonder, what is the source for the Centre? It can't be you, because you're human! There's got to be some kind of need, or spiritual something - just the bottom-line assumptions that we smooth over, and I think that's why we're having trouble with all the top stuff.

Tessa:

I think that's a good point.

Chantal:

I think if I bring that up at the retreat, it could be tough.

Tessa:

No, I think it has to be. If we're going to do this thing, we should be really honest.

Chantal:

I agree.

Epilogue
October 1999

On January 9, 1999, members of the WTCC steering committee met for a Reflections and Envisioning Day. During that time, words such as: 'transformation', 'growth', 'creative process', and 'healing' were used to describe the Centre's influence in our lives. The group

expressed a strong desire to see its work continue. Members want to 'open up', to bring new women into the Centre, and to reach out to diverse ethnic communities. We recognised and explored the conflict between this desire for expansion and our current low energy level. The group resolved to be more realistic in the face of this dilemma: we accepted maintenance over growth, for now.

Since then, we have cut back on the number of projects. Steering committee meetings have continued and a publication of women's writing has been organised. Tessa is doing much less, as other women have felt empowered to do the work themselves. The main energy for the Centre is currently coming from other women, and although Tessa wants to maintain her connection with the Centre, she does not currently see herself coming back as the central link. Chantel is taking a break from the organisational aspects of the Centre. There have been no definitive resolutions since Dec. 1998, but we are still going. The work and the struggle to articulate and achieve our vision continue.

Owning (up to) the Process

The major issue confronting practitioners of popular theatre today is that of ownership: the ownership of the process. The rhetoric of participation is on the lips of all who work in any area of culture or development, but the reality is often much harder to achieve. Popular theatre is about strategies that enable people to make their own theatre; to take the process into their own hands. In all the most common types of popular theatre, this is the crux. At what point does the facilitator/*animateur*/director withdraw from the process? The actor/teacher strives to keep the class addressing the theme as they perceive it. A successful outcome and therefore future funding may depend upon it. But in doing so, how many opportunities for children to name their own world for themselves may be lost? Similarly the theatre for development worker's project brief will have probably given precise guidelines about what topics are to be encompassed within the confines of the project so that although the by now almost automatic participatory phase is undertaken, only those community responses which can be related to the agenda are recorded and used as material from which to develop improvisations. At its worst, this attempt to control the process results in the failure of the whole project, as in the case of the many health education projects which have attempted to confront the spread of HIV/AIDS by means of clinical, information-based approaches, rather than by exploring the cultural factors which promote its spread in the context of the life stories and patterns revealed by the community members themselves. Equally, if participation is a privilege accorded to only one section, one race, or one gender in a given community, the very divisiveness of the participation may be compounding rather than confronting the problem.

Popular Theatre Process is not a Technique

It is a journey of invention. It is a theatrically informed improvisation which is created in response to deep listening, a listening that is vulnerable, that is informed by, but not slave to, theatrical, cultural, and development understandings, concepts, considerations, and intentions.

6 Dialogue on Issues

Tim Prentki:

When considering the relationship of the popular theatre process to the whole question of communities and who the process is for, typically practices today, in the so-called developed world anyway, seem to involve particular special interest groups collected together as such by their circumstances maybe, whether it's voluntary, or compulsory like school-kids, prisoners or people in hospital, or else by ethnicity; people who collect together as a particular ethnic group, a minority group within the wider society. So do you think there's something intrinsically within the popular theatre process that makes it more amenable to certain kinds of groupings of people than others? Or is it a process that's equally available to any social group?

Jan Selman:

I think it's equally available but there's a question of desire. What groups? Who wants to enter into such a process? Typically it's a group that feels a need for something, has something to say or is looking for a way through their current situation - but in fact I think in practice if people get in a room and have an experience that theatre can provide, an experience of 'hey I'm tapping something I didn't know about myself or deeper than I knew I felt' with others sharing with them, there's a power that they're interested in that they may not have realised they had. So I don't think the form is connected intrinsically to certain kinds of groups so much as human-beings who are looking for something else.

Tim:

Is it more that the practitioner or facilitator is on the lookout for likely groups because it's actually easier to engage in the process if you've got a group that feels itself to be a community rather than having to start maybe further back in some sense using the process to help develop notions of community?

Jan:

Well, I think that's apparently easier and in some ways you can move faster because there you are right in some kind of issue at least of identity if not of more pressing urgency, but on the other hand I think in Canada, and I assume in Britain, there is a sense of lack of belongingness that would be very interesting to approach. I am reminded of some work I did this year where people weren't already a group - to gather they would have been women who were interested in looking at women's issues but they weren't already necessarily allied to a group. And in some of our work, participants kept identifying and reidentifying with the *outsider*, the person who was looking for a group, rather than who had one. And these are people who were already identifying loosely with 'the women's movement', social activists. But when we did various kinds of stories and said 'where do

185

you fit in this?' typically they chose positions near the newcomer to a group, someone who didn't know the rules, or the newcomer to a group who wanted to make things happen but was excluded or who didn't know how to make the wheels turn. And that struck a great chord in myself. Here at the age of forty-five I feel like a young kid on the edge of some secret that I don't know a lot about. So I think there's a search for places where there's an opportunity to build communities more than friendships, places where you feel comfortable, where you feel you can take some risks, where you are known.

Tim:

So we're sort of back a bit with this thing about the safe space, part of what this process offers is a space where you can test things out and in this case part of that testing out, if I understand you right, is testing out whether you are able to belong in this particular grouping.

Jan:

I think that's part of it. Don't you think that theatre can do more than that? I guess I'm hoping that theatre can be more than a safe space; maybe safe in order to reveal.

Tim:

Could be safe in order to be dangerous. When I say 'safe' I don't mean a bland space I mean a space where in fact you can take risks about what you reveal. And maybe indeed, how you reveal it. But part of getting to the stage where you might feel you could do that is through testing out the people you are trying to work with. And that testing out is conducted sometimes by theatrical means.

Jan:

OK. Then a question I have is: are we in a social state where in fact we feel very unsafe and so we are needing these kind of spaces?

Tim:

Obviously it's difficult to generalise but I would say a lot of people do. A lot of people feel they are normally in unsafe spaces and cannot reveal things. That may be for all kinds of cultural, historical, social, economic, racist, classist, sexist reasons. Or it may be not so much unsafe necessarily as simply having nowhere as a space for these things to happen. Living in an increasingly fragmented world where perhaps your place of work is a solitary computerised work-station rather than a working community, and your experience of communal living may extend no further than at most a family structure.

Jan:

The geographic relocation of families, and individuals from families, is also adding to that fragmentation.

Dialogue on Issues

Tim:

You have such a habit of mobility; of changing and redefining relationships at quite a bewildering speed, perhaps in a way that human-beings have never had to before, that this can become almost a place to slow down and start locating yourself in relation to others beyond the ones or twos you might otherwise deal with.

Jan:

So we're talking in part about belonging and exclusion, and in the sense that more people than we think feel excluded. We talk about groups that are excluded from the mainstream and I start thinking back to the question: does this process offer something for a lot of people? I'm wondering if the very people who are seen as included by some of these 'excluded groups' are actually in a state of feeling entirely excluded from whatever they think it is.

Tim:

That's right. I think you've revealed a paradox there. The process is typically seen as being of greatest use to the socially excluded, but the people who are coming to that conclusion - the controllers of the discourse - are themselves in a terrible state of self-exclusion. By one measurement perhaps the people who are most in need of structures and strategies that could give them an experience of communal being are the people who are determining that popular theatre is a 'good thing' for the 'socially excluded' who by virtue of the label of being lumped together as 'socially excluded' are in fact more of a community than they are.

Jan:

As long as we're not straying into the 'I must be oppressed too' territory, which is tempting in any of this work because one gets tired of being viewed only as the favoured or the privileged, especially if you feel a lack of belonging. We're into tricky territory but I think useful.

Tim:

Because in a sense the deprivations of the privileged are felt to be more in the psychological rather than the social area, then you can get into a silly sort of binary position where popular theatre is a process for the oppressed and the oppressors should be in therapy. And I don't think that's very helpful because it doesn't produce any condition of dialogue.

Jan:

The other thing we've talked a lot about is the tantalising quality of live theatre in all this, and the notion that an audience could be a community, however briefly. I don't think we're accomplishing that very much, except in very prescribed groups such as a small, isolated community. But it's very tempting, both through the notion: how participatory could the theatre event be even if it is in a big gathering place like a formal theatre, is there some way to make more of the fact that still sometimes people come together alive

and sit all together in groups of two, four or six hundred in order to be there together. What's that about?

Tim:

I think this is fascinating and also quite disappointing in the sense that where people feel themselves to be members of a community perhaps because of the smallness of the scale as you say, perhaps at the sort of village level, and most of that community goes to the theatre, they will respond as a community. But unfortunately in my experience of the mainstream where people go to a 'theatre', and for the duration of the performance might be described as a community, they do not react to the theatre event or experience the presence of each other as a community. They speak at the interval to somebody they already know and they go back to their house afterwards. You could really only talk about them operating as a community in terms of their physical proximity to each other.

Jan:

Sometimes they laugh together.

Tim:

I'd say that's a fairly minimal response. But, as you say, shouldn't it be capable of achieving more? Otherwise it's just at the same quite primitive level as the response for a sporting event. In our societies the large-scale attendance at sports events shows the need to feel a part of, even if it's only temporarily, something you might call a community. And certainly in British society the sort of demonstrable fanaticism of a football supporter goes far beyond any intellectual interest in the sport and actually answers some sort of deep-seated need to feel a part of something. Presumably, at least in part, because the rest of your time you don't feel a part of anything. And somehow theatre ought to be able, to put it crudely, to cash in on that feeling but do something more interesting with it than a sporting event manages.

Jan:

What do you think a few little strands of ways forward to do that are? To catch the buzz of sport. What are we doing wrong? What might move us there? Do you see any bits and pieces of that happening?

Tim:

I think very little. I can really only think in recent years of particular events that have generated a lot of emotion and brought people together anyway which have then had theatre taking place as a means of adding to or making a contribution to that event. The most obvious cases in British society have been demonstrations about road building, environmental destruction or the women's movement's peace camp at Greenham Common. That was a camp that was set up as a protest, as a peace camp, but during the course of its lifetime at various different times, certain sorts of theatre and performance activities took place. Both, I think, to enable that community to feel a strong sense of identity and also, at times, in more of an advocacy and publicity role.

188

Dialogue on Issues

Jan:

We're back into the consciousness-raising notion of that kind of use of theatre.

Tim:

I think so. The limitation both of that and the less radical, less politicised event of the community play which is another example of what we were saying about almost creating a community to engage in a theatre process but neither of those things have had any sustainability.

Jan:

I want to take up with you sustainability in that regard because on the one hand if we look at things in that light, have we ever done anything that counted? And it seems to me that act of protest about the cruise missiles, however short- or long-term, served many more people than ever went there. At the same time I believe we are way further ahead than if that protest had not happened, that consciousness was not raised.

Tim:

I don't dispute what you're saying in the slightest. I just didn't want to overstate the role of theatre in that process.

Jan:

So in this case the theatre part capitalised on something that was already there and would have been just as strong without it. It gets the media out. The agitprop which is a real, live function of this theatre.

Tim:

It's a medium that's attractive to other media; maybe that's something that's not sufficiently explored although the parades, street-theatre end of popular theatre frequently has that as an element. Media will cover it because it's an event so there's a particular theatrical reason for the communication of an issue. But we are now in the area of communicating issues which is fine but is perhaps not where we started from in this conversation, which was considering the function of popular theatre as a community maker.

Jan:

I was reflecting on the popular theatre I've done over the years; how much more impactful it has been in a much smaller room where fewer people are having a more in-depth experience as audience, as well as participants. Scale matters.

Tim:

Maybe that even becomes part of the definition of popular theatre in a so-called developed society; that it is something that happens to, with and for a small number of people. Either because it's an issue that is located in a particular kind of community or if

it's not specifically issue-based, the discourses, the relationships, the emotional unveilings are particular and almost private to a smallish group of people.

Jan:

A homogenous group of people?

Tim:

You're raising a big issue again. There must be a degree of homogeneity or what has brought them together in the first place? There have been spectacular examples in third world contexts of large numbers of people engaging in popular theatre events; a sort of mass mobilisation of consciousness that's quite hard to imagine anymore in North America or Europe.

Jan:

But maybe it bears looking at just to keep asking the question: do we have any role to play in mass movements or indeed in terms of what's our larger community?

Tim:

It's hard to think of any other art form that's going to provide an arena for that question. Either we simply give in and say 'there's no such thing as a larger community anymore' or we have to invest the role of exploring what that larger community may be in popular theatre.

Jan:

It's ironic at a time of larger and larger communities if we believe that globalisation is in any way to do with the connecting of human beings which it may not be, larger and larger ways of organising the world's societies - let's put it that way - that we actually question whether there are any things we have in common, enough to draw large groups of people together anymore.

Tim:

Once you introduce globalisation into the discussion, then I immediately want to ask: on whose terms? And if you're talking about welding people into larger blocks the globalisers are setting the terms for that identification. You can be part of a large grouping provided you're all drinking Coca-Cola or you're all wearing Nike trainers. That's your passport into the global community.

Jan:

At the same time one of the features of Canada right now, and I think Britain too, is that what was once a more homogenous identity, though of course with *major* excluded elements, is no longer. We have to do some work either about what we have in common despite our differences or about how much can we enjoy our differences. And find a strength in our differences. It seems to me popular theatre can have some role in that.

Tim:

I think you're right. And in the context of specifically globalisation I think popular theatre can, if it can bring people together in the way you're hoping and feeling it should, then one of the consequences of that bringing together is to create a group with some force, with some social power, that could start determining the terms on which it is going to take globalisation: whose globalisation? Which bits of globalisation? Whereas as atomised individuals if you have a choice at all, it's a choice between rejecting the global economy or being swallowed up by it. But you certainly don't have the possibility of a discriminating or critical relationship to global forces which I would hope popular theatre might enable people to achieve.

Jan:

I like the idea. I guess speaking as a Canadian I am struck by two things: one is the idea of John Ralston Saul who talks about our economic identity; in Canadian terms it's better to duck and hide around the edges than to be out in the Free Trade world. How can we play in the globalisation story as an extremely small player?

Tim:

The strategy that we're discussing here may be essentially the same but we're talking in one breath on the macro economic level and in another on the micro community level. But it's still the same idea of forming some sort of power block that is at least significant enough to mitigate some of the influences of globalisation. Maybe the macro economic level is an analogy for what we're asking popular theatre to do. If, for instance, there is some sort of failure of representation between a certain area of a local community and its council, whereas individuals writing letters to councillors are unlikely to have any effect, some sort of popular theatre manifestation, indication that this is a shared anxiety, shared resistance, might actually produce a change in circumstance.

Jan:

Related to our differences, and how finding alliances despite our differences might make us stronger, I think popular theatre has a role to play because right now we're very good at organising into communities of extreme self-interest and we're extremely bad at finding anything in common with the guy of a different colour, age or something.

Tim:

You've moved us on very usefully to the question popular theatre workers need to ask themselves with increasing urgency: who are our allies? Who can we work with? The impact of popular theatre process is only felt significantly at times and in places where popular theatre has allied itself with larger social movements. We are destined to remain socially peripheral or significant only as therapy for as long as we fail to make those partnerships and identify those allies.

Jan:

I'd like to go in two directions from here; one is to partnerships and alliances with other popular movements etc.; the other is onto popular theatre as a tool to bridge difference in order to strengthen alliances. I think popular theatre that might be incredibly useful to an extremely divided society where people who should be my ally, who are my ally on many, many matters both of resistance and action, we get all stopped up because we're a different race or different language or we've disagreed on something else.

Tim:

How would you bring such people together in the first place so they would ever be exposed to the same process?

Jan:

It's hard to answer out of context. Sometimes we can find enough reason to get in the same room, not just among the activist community but also the generally socially concerned. Whereas we've tended over this last decade to go off to our separate corners and get very small groups who are as homogenous as possible working together because we can trust each other. Groups have become stronger for that but it's now very urgent that we reach out a little broader. Is this coalition politics? I don't know. It's striking me particularly in my zone, it's a women's movement that is fractured in twenty different pieces and it's not that every woman is my sister but huge numbers of women share all sorts of political aims and we're not working together because right now we're off in our own zones saying we can't deal with each other because of racist problems or we can't deal with each other because you're privileged and I'm not. I think those things are true but we also have to come back together sometimes and work on certain things.

Tim:

Absolutely. And that kind of sectarianism is very self-defeating. I'm struck by the contrast between the picture you're painting which is a fair representation of recent years and things like the discourses of marketing and advertising where advertisers are particularly successful at persuading people that they are members of a certain kind of group; they bring a quite disparate set of people together as consumers. So if they can do it, why can't we? Why are we, as you say, so hung up on difference? The more urgent imperative of similarity is lost.

Jan:

We're shooting ourselves in the foot constantly. However, if you stick with the women's movement for example, it's very easy as a white, privileged, educated woman saying this and so I feel ready to move there more urgently than some of my sisters who have said we need to leave you alone for a while to work among ourselves. And it's not that I don't need to work on myself, it's that they have been the leaders. Black women in Canada, or native women in Canada have led the way, saying: 'actually right now you're not my sister . . .' And so I say this with great caution.

Tim:

And your caution raises another related aspect here which brings in the potential use of popular video. You are starting to refer to people who perhaps through circumstance are not going to be able to get together with people who they do share the most with. And it may be that a First Nations Mohawk living in northern Québec might usefully have things to interact about with a Navaho in Arizona but they're not going to do that except that video might be a means by which a kind of solidarity might be achieved. Theatre processes might be involved in each case in putting together something but then video could be the connecting, the cementing medium.

Jan:

I'm really keen about that idea. On the other hand, I think something important about theatre is about its liveness - you and I with huge differences get in the same room and use processes that ask us to keep speaking to each other; keep inventing, retrying, reforming, requestioning - that is at the heart of what the issue is. We are divided and we are choosing to stay and see if there is something we can agree about, so we can move forward on those things. Some of that is going to happen when we are in the same room. Some of that can happen through theatre. Some of that can happen through the fact that my friend down the road went and did that rather than I did but I don't want to forego something I deeply believe in which is that human beings in the same room, flesh and blood, are vital and we are moving away from that constantly; of actually getting there together and working through something. It's one of the ways popular theatre can work beyond homogenous communities.

Tim:

I share that feeling and any doubt I'm feeling, as you say, is tied up in the practicalities of how you achieve that.

Jan:

I see a lot of doubt on your face!

Tim:

I suppose I feel that *realpolitik* means that those who tend to control the funds, the means by which people can come together, have vested interests in them not coming together. And that we must be very inventive in ways to overcome those obstacles, to resist those pressures to be fractured. For instance it may well be that joint action from Ford car workers in Dagenham and Detroit would actually put a kind of pressure on the management that it would not welcome and it therefore engages in whatever strategies it can to prevent that coming together occurring. I'm linking this back to what we were saying earlier on globalisation. The people, to use an old-fashioned, socialist phrase, need to take hold of the tools of the globaliser if they are to be able to recreate globalisation on their own terms. I'm really just looking at the sheer mechanics of bringing people together and envisaging that there might be a group of people, of the small homogenous type you were referring to earlier, might be searching for commonalties, solidarity with

another group that in the reality of their physical, material circumstances they are never going to connect with live.

Jan:

I think I'm making two points. One is that popular theatre has tended to work with homogeneity in the first world and it doesn't need to; and the second point is that there is some urgency in Canada, I think, to take real action on a big scale; to move on from our various separatenesses.

Tim:

All I would add into that is that it is a daunting task for a number of reasons, one of which is that there are powerful forces at work to try and keep people in fragmented groups and only on their terms, such as as consumers, are they interested in people having an identification beyond the small or localised group. But that's not to say that popular theatre workers have to give in to that agenda.

Jan:

In fact, I think we have so much work to do that we are far from dangerous.

Funding

The relationship of the arts to structures of funding is a larger subject than can usefully be analysed here. It raises fundamental questions about the function of art in a materialist, consumer society; whether it is necessary; who should pay for it. There are, however, specific issues in the case of popular theatre which increasingly seeks funding from sources that are more concerned with social benefit than artistic achievement. These sources require popular theatre practitioners to be clear about their objectives and capable of evaluating the intended outcomes in ways which do not apply to mainstream theatre. Appeals to enhance the quality of life or develop creative potential do not cut much ice with agencies concerned with the specifics of environmental protection or primary health care. In the long perspective this notion of the effectiveness of popular theatre being measured in terms of outcomes for social health may restore to the theatre some of its ancient energy and power which was lost when it ceased to be a means of celebrating community identity or debating alternative structures for living and degenerated into a leisure activity for a consumer society. Willingly or not, popular theatre now has to address such questions as for whom is this project intended? What role has the community/target group played in the formation of the criteria? How does the theatre group know if the aims have been met? Claims are made in order to secure funding and these are then tested against measurable outcomes in order that organisations which are usually accountable to the public can monitor the effectiveness of the ways in which they have spent taxpayers' or donors' money.

Whilst there may be gains in clarity of intention and outcome forced upon the popular theatre worker as a result of having to put forward funding proposals, there are also dangers and limitations arising from these financial realities. Funders are almost always tied to the idea of a project which has a precise timeline. Very few are prepared to respond to requests for open-ended, renewable funding over an extended period. Consequently most activity is conceived in terms of rapid impact, one shot efforts that are necessarily very crude in terms of their effect as a cultural intervention. Sustainable change at the level of deep structures requires an approach in which the practitioner is able to engage in a thorough, dialogical research process that can tap into the resources for self-development within a community. The acknowledgement of this need within short projects usually comes in the form of a commitment that the practitioner offers training for trainers. But even here shortness of exposure results in the handing on of techniques rather than the education of the community resource persons in the whole ethos of self-development and the practice of indigenous knowledge.

There is thus a tendency for the aims of the funders to act as the gatekeepers of popular theatre. This may happen overtly in so far as each agency has its own agenda to which proposals must conform: either as a response to declared priorities or, in the case of bodies that receive their grants from governments, according to the usually unstated but nevertheless understood ideological frameworks within which those governments operate. But equally it may happen as a consequence of self-censorship. Companies form the mental habit of guessing what will find favour with the funder and gradually lose the capacity to think outside those prescribed discourses. Once the popular theatre worker ceases to think the unthinkable, then it is absolutely certain that popular theatre will cease to represent the realities of those whose ideas or very existence constitute a threat to those who exert political control in our societies. So long as projects with such groups as ethnic minorities, travellers, prisoners, the homeless, are set up with the intention of enabling them to assimilate themselves into mainstream society, then they are to be welcomed and supported. However, if a project is intended to support or celebrate the independent identity or lifestyle of groups which are, perhaps of their own volition, excluded from dominant society, it is likely to be a more difficult task to find any public organisation prepared to offer financial support. Consequently, popular theatre either fails to work with many of those sectors of society most in need of its interventions, or proposals have to be framed in ways which allow for the creation of an 'official' set of aims and outcomes for the funding body while simultaneously developing an 'unofficial' set which may be to do with the empowerment of those who exist in opposition to, or outside of, the dominant discourse. In most instances this is likely to be a strategy that will only be successful once with any given source of funds.

In Britain the history of state subsidy for the arts demonstrates their extreme vulnerability to changing ideologies and economic discourses. The flowering of socially committed arts in the 1960s was largely funded out of the surplus of economic boom. When the cycle entered recession 'luxury' spending was the first to go at national and local governments levels. Where local government stood out against

government policies, as in the case of the Greater London Council, it was disbanded and replaced by central control. Perhaps the most prominent casualty of these changes was the Theatre in Education movement which became a victim of government education reforms. The removal of the running of schools from local education authorities (LEAs) to be replaced by a separate board of governors for each school meant that the LEA lost the capacity to set up a schools tour for a TIE company within its area. Attempting to co-ordinate bookings with individual schools at a time when new governors were paranoid about their budgets proved too much for many companies whose difficulties were swiftly compounded by the exclusion of drama from the National Curriculum at primary level. The introduction of the National Curriculum meant effectively that schools were being run by the national government through the agency of a governing board, thereby enabling the fiction of democratic participation and choice to be foisted onto the unsuspecting public. TIE survives due to the vision and determination of those companies who have refused to be thwarted by the political and economic climate and have been prepared to engage teachers in dialogues about the effectiveness of theatre as an educative process. But the lesson is clear. Unless popular theatre - in whatever form - can demonstrate its essential function as a means of social and individual self-development, it will fall victim to political machination and artistic fashion.

The large-scale funding bodies such as the European Social Fund, the Arts Council and the British Council are sited too far from the point of contact with the communities most able to benefit from popular theatre. In most cases the journey to and from the bureaucratic centre is too hazardous and uncertain for groups from the margins to be able to undertake with any hope of success. Yet this is the moment when such organisations are shifting their policies markedly towards popular theatre. The Arts Council talks today about targeting the socially excluded in any new funds which it will administer from the Lottery, and the British Council has lately endorsed a central role for theatre for development in discharging its cultural obligations to the countries in which it operates. Now is the time for popular theatre practitioners to widen the criteria for their projects explicitly into the realm of culture and to advocate long-term applications of theatre aimed at enabling a community to address deep rooted barriers to its development such as gender and power inequalities.

Impact Assessment

Jan:

> We know assessment is important to our survival as a field, as well as to our own understanding of what we are doing, but there are a lot of problems.

Tim:

> Obviously if you're in receipt of money, whether that's public money or foundation sponsorship, people are going to want, even before you embark on that work, as part of your proposal, to know there will be monitoring and evaluation, to know that the

declared outcomes have taken place. It arouses two contrary feelings in me. On the one hand I'm sympathetic to the notion that we ought to be accountable and that if we can't measure the impact of popular theatre processes on people's lives, then what right have we got to take up people's time, money, and space?

Jan:

And indeed, why are we even doing it? Because we do want to change the world.

Tim:

We do want to change the world. How do we know if we've changed it? On the other hand, not all impacts can be assessed. Not all outcomes can be measured. Therefore in project funded work this produces a great bias towards work which is short-term and has easily measurable outcomes. So we see a tendency towards health-related activities. For instance if you've got an immunisation programme, if numbers being immunised after the process have gone up, you can say: 'there's your measurable outcome'. That's fine. But if that area of work is absorbing all the possible funding, then some of the more interesting but more difficult work, in terms of measurement, maybe more general issues to do with culture, identity, gender, power...

Jan:

These require a willingness to take action in your life long-term which is very hard to see short-term. One does this to some degree on the faith that an experience of positive, collective problem-solving and identifying of action, is a good thing whether we do it tomorrow, or whether we simply know in the future we have the capacity to do that. What do we measure?

Tim:

It's very difficult to mount a case among people who are determined to seek concrete outcomes but you know when you see it in people whether an impact has been registered.

Jan:

A couple of things come to mind when I think about this. One is, we talk about partnerships and partnerships with education and development kinds of agencies, in part we should say we think some of this is your job because you know more about this; you're part of the field. Maybe we need to hear more from those experts about what are some ways to measure that we haven't thought about. The other thing that occurs to me is that this field has moved from one that has tended to train each other on the job, in the field, but in the last decade in Canada we've started to see popular theatre programmes move into institutions such as universities. Here different expertises come together and the job is to 'research'.

Tim:

We could learn a lot from various areas of sociological research for a start. Sociologists and the funders of sociology departments are prepared to put in long-term projects to measure effects in social groups and yet none of that money, as far as I am aware, is ever made available to popular theatre workers.

Jan:

So there may well be another set of partnerships that we need to work on - interesting researchers in this area.

Tim:

I think the future for popular theatre is certainly multi-disciplinary; maybe it always was but even more so in the future and, as you say, the ability to make alliances, form partnerships with areas that have cognate but thus far distinct expertise. If we're going to punch our weight within institutions of higher education that will only happen as part of a regional conglomerate of like-minded areas and what those areas are is by no means the same in every institution because a lot of it is a question of like-minded people getting together. In some places they may prove to be geographers, somewhere else anthropologists, somewhere else economists; so there isn't a blueprint but there is definitely a need to locate this work within other related discourses.

Jan:

Which takes quite a bit of education because theatre is often seen as airy-fairy, self-indulgent, those kinds of things; so to be seen as serious is going to take some time. The other thing is to collect what actually has been done and to disseminate projects that in some cases have been around for quite a while now.

Networking/Partnerships

As a consequence of working predominantly at the local, small-scale level with targeted groups on specific, topical issues, popular theatre groups and practitioners have found considerable difficulty in forming and maintaining effective networks through which to share their practices. Yet networking is a vital aspect in advancing the craft of popular theatre and in breaking down the sense of isolation and powerlessness which can easily demoralise those who work alone or in small groups. Most of the history and development of popular theatre has been in the informal sectors of society and therefore it has operated outside acknowledged institutions of education or culture. Narrow in its scope and local in its ambition, popular theatre has been notoriously vulnerable to marginalisation among scholars and policy-makers alike. Today, however, international solidarity and awareness are crucial in the struggle to combat globalisation. Popular theatre workers need to be skilled in using the same weapons in defence of local cultures that are used against communities by the globalising agencies of the mass media, banks and transnational corporations. It is

frequently at the outer margins of the globe that strategies of resistance are most refined so that communities beyond the reach of globalisation often have much to teach those who are already suffering cultural alienation and crises of identity. Sharing is urgent and vital: not to homogenise and to erect models but to offer common purposes and to celebrate effective self-development.

It is usually the case that cultural intervention through popular theatre is most effective in situations where it forms part of a broader strategy of grass roots action. Within such a framework its particular qualities of collectivity and representation make it an ideal focus for aspects of a movement which require advocacy or the adoption of a higher profile in communicating with outside bodies. However, for such a process to be effective it is necessary for popular theatre workers to communicate their purposes and intentions clearly to the other sectors engaged in the action. Dialogue is vital in networking, inducing collective responsibility and avoiding the replication of the top-down communication networks which characterise the monological behaviour of globalisation. There are examples from all over the globe of popular theatre being used in concert with other forms of activism to protest against the abuse of the powerful and to advocate for the marginal: the street-theatre protests against the political violence of Pinochet's police in Chile; the parades and improvisations at the heart of the 'people power' movement in the Philippines which overthrew Marcos; closer to home some of the theatrical strategies adopted by the Greenham Women in evicting the US Air Force's cruise missiles and the attempts of the Newbury bypass protesters to halt the road. Most famously and oft-quoted is the example of the Kamiriithu Community Educational and Cultural Centre which built its own theatre and then performed its own plays in it until suppressed by the Kenyan government (Kerr).

Popular theatre at its most effective is firmly embedded within a popular culture which articulates a demand for dialogue between the centre and the margins; a demand that local knowledge and local wisdom be respected and acted upon by organisations which claim to represent the opinions of ordinary people. Ultimately popular theatre must migrate out of the ghettos of 'fringe', 'alternative' and 'small-scale' and announce itself as the new mainstream. The paradigm shift is much more than a matter of language. The issues that popular theatre addresses are no longer marginal. They are, rather, the means by which human society survives and changes. The conventional way of describing theatre in terms of a mainstream/alternative binary has outlived any usefulness it might once have possessed. It belongs to the conceptual frameworks of colonialism which views the world as composed of a few centres and many margins. Once this binary has been dissolved, we can begin to imagine that we are emerging into a period that is truly and properly post-colonial.

Part of this process of redrawing the map of popular theatre is announced by the surge of interest in the phenomenon known as cultural rights and the accompanying assertion that these form an integral part of the freedoms that march under the banner of human rights. Culture is no longer perceived as the prerogative of a class that can afford to purchase it, have the education to appreciate it and the self-importance to reproduce its accomplishments in the forms of art. Culture is now the means through which all people in all social conditions strive to make meaning out of their lives: the

ways in which we all attempt to make sense of our encounters with the physical, psychological and social environment. All humans should have the right to express freely and without fear those meanings since the compulsion to articulate meaning takes its place in the hierarchy of human needs. Popular theatre is at once a means of agitating for cultural rights, celebrating cultural rights and a cultural right in and of itself. As the English playwright Arnold Wesker once wrote: 'Not to be a poet is the worst of all our miseries.' (4)

Popular theatre works to facilitate independence, to assist communities in a process of building a capacity for autonomous self-development. Participatory and democratic, its principles are at odds with those of globalisation. It provides a means by which those whose indigenous culture is threatened by outside intervention can, through the agency of fiction, create a space in which to articulate that culture and to examine the social bases of communities on terms of their own devising. Slowly, painfully it is beginning to be understood that local knowledge, like rare species of insects and plants, contains the wisdom born of long adaptation to specific circumstances. In destroying it the globalisers may well eliminate those qualities in human existence necessary for its survival. This is not a matter of appealing to nostalgic or romantic notions of community, it is rather an attempt to articulate the human condition at this historical moment. Far from enjoying a post-colonial period of world development, the present time is witnessing the most extreme, far-reaching manifestation of colonialism yet devised. In the interests of financial gain, a tiny group of people is now working to colonise all the peoples of the earth: not with armies but with ideologies. It is not their lands that are being colonised but their minds, for the weapon of the coloniser is culture and the images and myths that go towards creating the desires by which people become the slaves of others' dreams. This is the enormity of the task confronting the popular theatre movement.

Bibliography

Arden, J and D'Arcy, M. 'Playwrights on Picket'. *To Present the Pretence*. J. Arden. London: Methuen, 1977.

Baker, H., Draper, J., and Fairbairn, B., ed. *Dignity and Growth: Citizen Participation in Social Change*. Calgary: Detselig, 1992.

Baker, W.B. 'An Experiment'. *Food for Thought* 15.1 (1954): 22-27.

Bappa, Salihu and Etherton, Michael. 'Popular Theatre: Voice of the Oppressed'. *Commonwealth* 25.4 (Feb 1983): 24-35.

Beder, H. 'Mapping the Terrain'. *Convergence* 24: 3-8.

Bell, D. *The End of Ideology*. Glencoe, Ill: Free Press, 1960.

Brookes, Chris. *A Public Nuisance: A History of the Mummers Troupe*. St. John's: University of Newfoundland, 1988.

Brookfield, S. *Adult Learners, Adult Education and the Community*. New York: Teachers College, Columbia University, 1984.

Butterwick, S. *Learning Liberation*. Unpublished M.A. Thesis, University of British Columbia, 1987.

Cairns, A. and Williams, C., eds. *Constitutionalism, Citizenship and Society in Canada*. Toronto: University of Toronto, 1985.

Canadian Theatre Review 53 Winter 1987.

Carr, E.H. *The New Society*. Boston: Beacon Press, 1951.

Chambers, C. *The Story of Unity Theatre*. London: Lawrence, 1989. 140-141.

Coady, M.M. *Masters of Their Own Destiny*. NY: Harper, 1939.

Corbett, E.A. *We Have With Us Tonight*. Toronto: Ryerson, 1957.

Corbett, Jenny. *Bad-Mouthing: the Language of Special Needs*. London: Falmer, 1996.

Creating Bridges. Videotape. Dir. Penny Joy and Robin J. Hood. Media Network Society, 1988. 28 min.

Diamond, Elin. 'Mimesis, Mimicry, and the "True-Real"'. *Acting Out*. Eds. Lynda Hart and Peggy Phelan. Ann Arbor: University of Michigan, 1993.

Edwards, N. *The Workers Theatre*. Cardiff, 1930.

Emunah, Renee. *Acting For Real: Drama Therapy Process, Technique, and Performance*. NY: Brunner/Mazel, 1994.

Etherton, Michael. 'Development Communications: Theatre and Community Action for Change'. Keynote address. King Alfred's College. Winchester, May 17, 1996.

Filewod, Alan. *Collective Encounters: Documentary Theatre in English Canada*. Toronto: U of Toronto, 1987.

Freire, Paulo. *Cultural Action for Freedom*. Harmondsworth, England: Penguin, 1972.

___. *Pedagogy of the Oppressed*. NY: Herder & Herder, 1970.

___. *Pedagogy of the Oppressed*. NY: Continuum, 1993.

___. *The Politics of Education*. South Harvey, MA: Berger & Garvie, 1985.

Griffin, C. *Adult Education As Social Policy*. London: Croom Helm, 1987.

Gulbenkian Report. *Community Work and Social Change*. London: Longmans, 1968.

Hayden, T. *Reunion: A Memoir*. New York: Collier, 1988.

Holden, Joan. 'In Praise of Melodrama'. *ReImagining America: The Arts of Social Change*. Ed. Mark O'brien and Craig Little. New Society Publishers, 1990. 278 – 284.

Hughes, Jenny. 'Resistance and Expression: Working with Women Prisoners and Drama'. *Perspectives and Practices in Prison Theatre*. Ed. James Thompson. London: Kingsley, 1998. 44.

Jennings, Sue. *Creative Drama in Groupwork*. London: Winslow Press, 1986.

Jones, Phil. *Drama as Therapy: Theatre as Living*. London: Routledge, 1996.

Kane, Sean. *Wisdom of the Mythtellers*. Peterborough: broadview press, 1994.

Kerr, David. *African Popular Theatre*. Portsmouth: Heinemann, 1995.

Kidd, Ross. 'Popular Theatre, Conscientization, and Popular Organisation'. *Courier* 33: 21.

___. 'Popular Theatre and Political Action in Canada'. Toronto: Participatory Research Group, 1981.

Matarasso, Francois. *Use or Ornament? The Social Impact of Participation in the Arts*. Stroud, Gloucester: Comedia, 1997.

Merriam, S.B. and Cunningham, P.M., eds. *Handbook of Adult and Continuing Education*. San Francisco: Jossey-Bass, 1989.

Milson, F. *An Introduction to Community Work*. London: Routledge & Kegan Paul, 1974.

Olujic, M.B. 'The Croatian War Experience'. *Fieldwork under fire: Contemporary Studies of Violence and Survival*. Ed. C. Nordstrom and A.C.G.M. Robben. Berkeley: University of California Press, 1995.

Pammenter, D. 'Devising for TIE'. *Learning Through Theatre*. Ed. T. Jackson. London: Routledge, 1993. 61.

Roberts, H. *Culture and Adult Education*. Edmonton: University of Alberta, 1982.

Robson, W.A. *Welfare State and Welfare Society*. London: Allen and Unwin, 1976.

Rubenson, K. 'The Sociology of Adult Education.' *Handbook of Adult and Continuing Education*. Ed. S. B. Merriam and P.M. Cunningham. San Francisco: Jossey-Bass, 1989.

Salutin, Rick and Theatre Passe Muraille. *1837: The Farmer's Revolt*. Toronto: Lorimer, 1976.

Salverson, Julie. 'Performing Emergency: Witnessing, Popular Theatre, and the Lie of the Literal'. *Theatre Topics* 6.2 (1996):181 - 191.

Samuel, MacColl and Cosgrove, eds. *Theatre of the Left 1880-1935*. London: Routledge, 1985. 254.

Schutzman, Mady. 'Canadian Roundtable: An Interview'. *Playing Boal: Theatre, Therapy, Activism*. Ed. Mady Schutzman and Jan Cohen-Cruz. NY: Routledge, 1994.

Selman, G., P. Dampier, M. Selman and M. Cooke, eds. *The Foundation of Adult Education in Canada*. Toronto: Thompson, 1998.

Selman, M. 'Philosophical Considerations'. *The Foundation of Adult Education in Canada*. Eds. Selman, G., P. Dampier, M. Selman and M. Cooke. Toronto: Thompson, 1998.

Simon, Roger I. and Armitage-Simon, Wendy. 'Teaching Risky Stories: Remembering Mass Destruction Through Children's Literature'. *English Quarterly* 28.1 (1995).

Simon, Roger I., Rosenberg, Sharon. and Eppert, Claudia. *Between Hope and Despair: Pedagogy and the Rememberance of Historical Trauma*. Latham, Maryland: Rowman and Littlefield, 2000

Stabler, E. *Founders*. Edmonton: U of Alberta, 1987.

Starhawk. *Dreaming the Dark*. Boston: Beacon Press, 1982.

Stourac, R. and McCreedy, K. *Theatre as a Weapon*. London: Routledge, 1986. 30, 201.

Thomas, T. 'A Propertyless Theatre for a Propertyless Class'. *History Workshop Journal* Nov 1977: 113.

Truman, Harry S. *Documents on American Foreign Relations*. Connecticut: Princeton University Press, 1967.

Twenty-fifth Street Theatre. *Paper Wheat*. Saskatoon: Western Producing, 1982.

UNESCO. *Learning to Be*. Paris: Harrap, 1972.

Weber, Betty Nance and Heinen, Hubert. *Bertolt Brecht, political and literary practice*. Athens: University of Georgia, 1980.

Wesker, Arnold. *Words as Definitions of Experience*. London: Writers and Readers Publishing Cooperative, 1976.

Wharf, Brian and Clague, Michael, eds. *Community Organizing: Canadian Experiences*. Toronto: Oxford UP, 1997.

Wharam, Ted. 'The Building Blocks of Drama Therapy'. *Dramatherapy: Theory and Practice* 2. Ed. Sue Jennings. London: Tavistock/Routledge, 1992. 82 - 96.

Wikan, Unni. 'Beyond the Words: The Power of Resonance'. *American Ethnologist* 19 (3), (1992): 460-482.

Willett, John, ed and trans. *Brecht on Theatre*. London: Methuen, 1974.

Yalom, I.D. *The Theory and Practice of Group Psychotherapy*. NY: Basic, 1995.

Endnotes

1 Julie Salverson is a playwright and producer who has worked in popular theatre since the early 1980s. She teaches at the Department of Drama, Queen's University, Kingston, Ontario, Canada and has recently completed a doctoral thesis about ethics, performance and testimony. Further discussion of this project can be found in Simon, Rosenberg, Eppert.

2 The authors of this book are indebted to Gordon Selman for his extensive assistance with the formation of this chapter.

3 This term was apparently created at an international meeting of adult education researchers in 1988 in Leeds, England.

4 See John McGrath's *The Bone Won't Break* for background on this provocative story.

5 See the last chapter of Alan Filewod's *Collective Encounters* for more about this interactive work by Catalyst Theatre.

6 Kadi Purru thanks the members of the Estonian community theatre group in Vancouver: Armas Kivisild, Aino Lepp, Leida Nurmsoo, Dagmar Ohman, Helle Sepp and Marje Suurkask for their collaboration and contributions to this article.

7 Lisa Sokil extends her thanks to Lib Spry for her flow chart of popular theatre process.

8 All quoted text is taken from the performance script *Running Through the Devil's Club*, by Deborah Hurford et al., a collaboration in association with Azimuth Theatre, 1994.

9 David Diamond is Artistic and Managing Director/Joker of Headlines Theatre. Founded in 1981 in Vancouver BC, Canada, Headlines has become a world leader in developing issue-based theatre in a community context.

10 Exercise descriptions can be found in David Diamond's *Joker's Guide to Theatre for Living* available through Headlines Theatre, #323-350 East 2nd Ave, Vancouver BC, V5T 4R8. e-mail: <info@headlinestheatre.com>

11 *Transforming Dangerous Spaces* was facilitated by Shauna Butterwick, Sheila James, Jan Selman and Caroline White. Vancouver, Canada, 1999-2000, financed by the University of British Columbia Hampton Fund.